MARRAKESH AND THE MOUNTAINS

MARRAKESH AND THE MOUNTAINS

Landscape, Urban Planning, and Identity
in the Medieval Maghrib

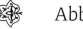 Abbey Stockstill

THE PENNSYLVANIA STATE UNIVERSITY PRESS
UNIVERSITY PARK, PENNSYLVANIA

Library of Congress Cataloging-in-Publication Data

Names: Stockstill, Abbey, author.
Title: Marrakesh and the mountains : landscape, urban
 planning, and identity in the medieval Maghrib / Abbey
 Stockstill.
Description: University Park, Pennsylvania :
 The Pennsylvania State University Press, [2024] |
 Includes bibliographical references and index.
Summary: "Explores the foundation and development of
 Marrakesh during the Almoravid and Almohad dynasties,
 drawing upon recent work in archaeology, urban studies,
 and landscape preservation"—Provided by publisher.
Identifiers: LCCN 2023047078 | ISBN 9780271096766
 (cloth)
Subjects: LCSH: City planning—Morocco—Marrakech—
 History—To 1500. | Islamic architecture—Morocco—
 Marrakech—History—To 1500. | Architecture,
 Medieval—Morocco—Marrakech. | Almoravides—
 Morocco—Marrakech—History. | Almohades—
 Morocco—Marrakech—History. | Marrakech (Morocco)—
 Buildings, structures, etc.
Classification: LCC NA9274.7.M37 S76 2024 |
 DDC 711/.4096464—dc23/eng/20231103
LC record available at https://lccn.loc.gov/2023047078

for my Mother
Travel companion, research assistant, lover of gardens and ruins
All of my passion I learned from you

CONTENTS

DESPITE THE NAME on the front cover, this book is in fact the product of a generous and brilliant community, and that it is in your hands is as much thanks to their time and energy as it is to my own efforts. Any insights or new ideas are the result of continued conversations, debate, and shared scholarship with these colleagues. Any errors are entirely my own.

The research and production of this book would not have been possible without the generous support of the Barakat Trust, the International Center for Medieval Art, the American Institute for Maghrib Studies, Dumbarton Oaks Museum and Research Library, and my home institution of Southern Methodist University. I am also deeply grateful for the help of Ashley Whitt in reproducing many of the diagrams and drawings for this book and to Mathilde Montpetit for her detailed review of the bibliography and transliterations. The team at Penn State University Press—Jesús Escobar, Ellie Goodman, Maddie Caso, and Laura Reed-Morrisson—has shepherded this book through the entire production process, and would not be in your hands without them.

To those who read and commented on early drafts of this work—Amira Bennison, Abigail Balbale, Cynthia Robinson—thank you for your time and sage advice. I am also deeply indebted to the feedback I received in various presentations and lectures on this material from Patrice Cressier, Elizabeth Fentress, Maribel Fierro, David King, Dede Ruggles, and Marina Rustow. I would especially like to thank Gülru Necipoğlu and David Roxburgh at Harvard for their continued advice and support at every stage of this lifelong process of discovery.

I would still be lost in the Marrakesh madina were it not for the generous time and guidance from my Moroccan colleagues Khalid Bensrhir, Abdullah Fili, Azzedine Kara, Aicha Knidiri, Noureddine Nachouane, Hassan Radoine, Ahmed Skounti, and the late Mohamed Mezzine. *Shukrān bizaʿaf wa Allah yabarak fīk.*

To the coven of women who have supported me with their friendship, intelligence, and joie de vivre—Denva Gallant, my writing partner, who has read every page of this book in one form or another; Wendy Sepponen, with whom I have celebrated every victory and mourned every loss; and Adrien Smith Harrall, my kindred spirit and the sister I never had—thank you all.

To my parents, Dean and Debbie Stockstill, who always encouraged me to be curious and embrace a sense of adventure, thank you for your unending love and support. I would never have had the courage to leap had I not known you would be there to catch me if I needed you.

And lastly, I cannot express the love and gratitude I have for my husband and partner, Leon Straub, who never doubted me even when I doubted myself. Thank you for not complaining at my early morning writing sessions, for walking the dog while I finished my thoughts, for reminding me to sit up straight at my desk. Thank you for continuing to ask me questions about this book, even when I was angry about it, and for listening as I tried to explain the chaos in my head. *Ich liebe dich*.

THIS BOOK DRAWS upon Arabic, French, and Spanish resources and makes reference to places and names from all three languages. The Arabic terms and titles of Arabic sources have been transliterated, with their diacritics, following the guidelines of the *International Journal of Middle Eastern Studies*, which allows readers to reconstruct the original spelling. Names and places in Arabic follow a simplified transliteration format, using only the diacritics for ʿayn (ʿ) and *hamza* (ʾ). Although place names, particularly in Morocco, adopt a wide variety of spellings, I have tried to remain consistent in their transliteration according to the above schema. Thus, for example, Marrakesh is spelled with an *s* rather than a *c*, as is more common in French and Spanish, and I use the term ʿAlawid rather than Alaouite to refer to the reigning dynasty of Morocco.

Where possible, this text distinguishes between the use of the term "Almohad," defining the religious movement that prompted the dynasty's rise, and "Muʾminid," which refers to the efforts of ʿAbd al-Muʾmin and his descendants in translating this movement into an imperial apparatus. The Arabic sources do not do this. It is a contemporary intervention, but the past use of the singular term "Almohad" has perhaps overemphasized the role Almohad*ism* plays in the establishment of a dynastic program at the expense of exploring other sociological currents at work. This has also led to a general tendency to essentialize the beliefs of the earlier Muʾminid caliphs, which were quite distinct from those of their descendants in the latter part of the period.

Introduction

If one were to say that Marrakesh is perfect, it is not due to the perfection of one of its parts, but of its whole.

—Attributed to ʿABD AL-WAHID AL-MARRAKUSHI (d. after 1224)

The palaces, madrasas, and mosques of Marrakesh do not declare themselves to the visitor as distinct landmarks so much as fold themselves within the dense urban plan, appearing suddenly as one turns the corner. Monumental minarets act as navigational beacons within the *madīna*, whose encircling walls set the medieval city apart from the striking landscape that surrounds it. Set in a subtle depression known as the Haouz Basin, Marrakesh is framed to the south by the heights of the High Atlas Mountains, part of the triad of mountain ranges that border the southern edges of modern Morocco (fig. 1). The impact of this dramatic landscape, and the city's relationship to it, was not lost upon medieval authors. Al-Idrisi (d. 1165), the twelfth-century geographer associated with the court of Roger II in Sicily, devoted more space in his geography to the landscape surrounding Marrakesh than to the city itself. He writes of the Atlas Mountains as having fertile terrain, filled with a variety of fruiting trees and cold, clear water, and a landscape dotted with fortified castles. His descriptions of Marrakesh focus more on how the water from the Atlas was brought into the city to irrigate the ground so successfully that its inhabitants had built their own lush gardens without any need for a well. The built environment is reduced to a single sentence: "The roads are large, the public places vast, the buildings tall, the markets furnished with diverse and well-stocked merchandise."[1]

The contours of this impressive metropolis were shaped over approximately a century in the transition between two empires that used Marrakesh as their capital: the Almoravids (r. 1040–1147) and the Almohads (r. 1147–1269). The Almoravids, who founded the city in 1070, established Marrakesh as an informal military encampment, taking an ad hoc approach to the organization of dynastic monuments and civic projects. The city was loosely organized into quarters associated with tribal divisions, framing the Almoravids and their associates as first among equals. This approach, however, would ultimately circumscribe their dynastic authority by highlighting their paradoxical relationship with power and identity, bringing their social differences to the fore and subverting the social contract by which they claimed their right to rule. By contrast, their competitors (and ultimate successors), the Almohads, sought to formalize the imperial relationship with Marrakesh in a direct response to the perceived failures of the recent past, creating large-scale public works and highly mediated arenas of public interaction. Separated from the general populace by elite districts tangential to the walled city, the Almohad court occupied an interstitial space between an urbanized imperial present and rural tribal

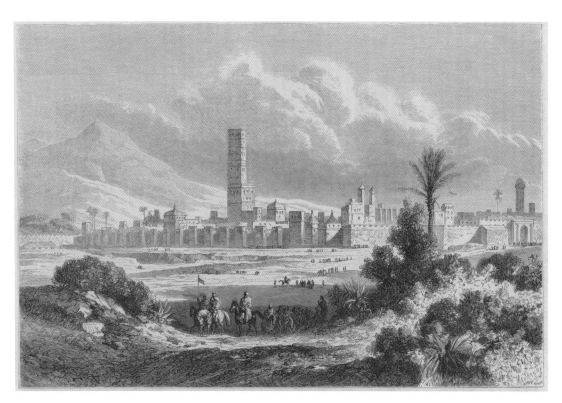

FIGURE 1

A. de Bérard, "Vue de la Ville de Maroc." From *Le tour du monde: Nouveau journal des voyages* (Paris: Hachette, 1860), 213. Houghton Library, Harvard University.

past. Under both dynasties, negotiation with the landscape formed the primary mode of architectural and urban communication, along with an ever-present awareness of what that landscape embodied: the complex tensions and mediation between the various tribes that peopled the extreme Islamic west, or Maghrib al-Aqsa. The development of Marrakesh is thus directly related to each dynasty's connection to its ethnic identity as expressed through its relationship to the surrounding landscape, interweaving imperial models of authority with the *genius loci* of their capital city.

Conventional scholarship has viewed the monuments of early Marrakesh in isolation or in unfavorable comparison with the more lavish monuments on the Iberian Peninsula, but as al-Marrakushi's description of the city tells us, the key to understanding this city is in thinking interrelationally. This book broadens the analysis of Marrakesh's architecture, exploring these monuments' interactions with one another by attending to their awareness and manipulation of the landscape and to the imperial and religious ceremonies that tangibly linked the monuments into a cohesive whole. Postmedieval interventions have obscured much of Marrakesh's original outlines, but utilizing archaeological and archival sources can help recover the twelfth-century version of the city. The city's surrounding geography thus emerges as a principal actor in how Marrakesh functioned for each of its ruling

dynasties. This is particularly true in the case of the Almohads. The Atlas Mountains provided a visual touchstone for the Almohads' identity, as part of the Masmuda tribe, and their authority, which derived from those tribal relationships. Far from their traditional characterization as being unreceptive to western Mediterranean aesthetic traditions, the Almohads selectively integrated these with references to their tribal homeland to create a new and distinctly North African visual idiom. Tracing this process, *Marrakesh and the Mountains* integrates Marrakesh into the context of urbanism in the wider Islamic world, on par with hallmarks of the early medieval period such as Fez, Kairouan, and Córdoba.

THE ALMORAVIDS AND THE ALMOHADS, DYNASTIC COUSINS RATHER THAN TWINS

The Almoravids and the Almohads are inevitably linked to each other as the "Berber dynasties" in both the classical historiographies of the period as well as in modern attempts to unpack them. Certain parallels in their demographic descriptions, as well as in the outlines of their historical trajectories, have led to a general conflation of their roles and contributions to the Maghrib. Even efforts to tease the two apart, including this volume, have inevitably turned to a comparative approach as a way to substantiate the two dynastic profiles. It is not my purpose here to fully break from this tradition, as the nature of the historical sources and the architectural overlap at Marrakesh would make such a distinction both anachronistic and superficial. Rather, I wish to distinguish where and how the Almoravids and Almohads intersect in their historical and architectural trajectories and where they diverge, in order to reframe the parameters by which we understand these dynasties. Crossing disciplinary and geographical boundaries, the dynasties refuse to fit within traditional

scholarly confines, which has made them a subject of both fascination and frustration for generations of scholars. Part of the challenge in discussing these dynasties is the deep complexity of their social context, a network of tribal ties that can, on the surface, appear impenetrable and frequently contradictory. As such, the categorical descriptions of each dynasty bear a great deal of similarity to one another when stripped of this context. Both dynasties rose to prominence on a wave of religious devotion and reformism, the Almoravids through a militant form of Malikism and the Almohads through their own interpretation of Ghazalian thought and unitarian principles. Each dynasty then built its elite ranks from the tribal confederations that formed the earliest adopters of its reforms. The Almoravids grew out of the nomadic, Sahara-based Sanhaja confederation, and the Almohads from the Atlas-dwelling, pastoral Masmuda. Their origins among rural, non-Arabic-speaking communities contributed to the historical impression of the Islamic west's sudden emergence onto the political scene, with the newcomers frequently characterized as uncouth and fanatical in contrast to their Andalusi counterparts.[2]

But perhaps the most striking, and certainly the most historiographically impactful, connection between the dynasties is the role that they played in Ibn Khaldun's (d. 1406) theorization of history, a link that would go on to inform generations of scholars in their explorations of the period. Ibn Khaldun's model framed the dynastic trajectories of the Almoravids and the Almohads as the inevitable consequence of a dissolving social cohesion that stemmed directly from their increasing urbanization and contact with the more decadent branches of intellectual life, as embodied by the culture of al-Andalus. In his conception, both the Almoravids' and the Almohads' imperial strength derived from their

sense of *aṣabiyya* (often loosely translated as "tribal solidarity"), a fundamentally social and ethnic form of connection that resonated with twentieth-century scholars in its purportedly secular, rationalist tone. Much of the scholarship from this modern period, primarily Franco- and Hispanophone, adopted this model in discussions and dissections of the medieval era, seeing in its trajectory a fundamentally inferior social experiment that collapsed after a brief show of brute force over the more sophisticated Andalusi Arabic-inflected *ṭāʾifa* ("party" or "faction") states. This perspective is inextricable from the project of nineteenth- and twentieth-century colonialism, which saw in this historical narrative the justification for a European presence on the African continent. The study of the Almoravid and Almohad empires became folded into a dichotomy that depicted "intermixed Andalusians as proto-Spaniards, European and secular, and . . . Berbers as fanatical interlopers who are distinct ethnically, linguistically, and culturally."[3]

Apart from the religious fervor that fueled their rise to power, the most notable quality linking the Almoravids and the Almohads is their historiographic identification as the two "Berber" dynasties of the Islamic west. This characterization presupposes an ethnocentric sociological model that underwrites the ways in which each dynasty organized and communicated authority, a model that has its roots in the readings (and rereadings) of Ibn Khaldun as the primary social theorist of the period. But the term "Berber" is a semantically ambiguous one, referring to different communities and means of kinship within different eras and (in its earliest forms) applied by communities external to those to which it referred. By the time Ibn Khaldun was writing his monumental seven-volume *Kitāb al-ʿibar* (Book of examples), which

famously theorized a cyclical model of history based upon the events of the Almoravid and Almohad periods, the Berbers appear to have constituted a distinctive people in terms of political ideologies and social organization, although there is little to suggest a universal Berber identity among the various tribes. The concept of a singular definition of "Berber" is a profoundly modern invention, inflected with the intonations of colonialism and postcolonial nationalism in its usage, which has in turn been reflected back onto the medieval period. This has created something of a methodological paradox for those scholars of the period who attempt to answer the question of the role a Berber identity played within these dynasties; repeatedly alluded to in the sources, its conceptual outlines nevertheless remain indefinite, prompting a general trend of either placing too much emphasis on its role or ignoring it entirely.

Historian Ramzi Rouighi has recently approached the issue from a historically constructivist view. In doing so, he has conceptualized Berberization as a historical process that rejects the extrapolation of the present back onto the past.[4] He painstakingly traces the emergence of "Berber" as a category through the Arabic sources, beginning with the Islamic conquest in the seventh century and coalescing in Ibn Khaldun's *Kitāb al-ʿibar*. The term appears almost exclusively as an externally derived and politically motivated moniker until well into the medieval era. Against the background of competition among the petty kingdoms (*mulūk al-ṭawāʾif*) of the Iberian Peninsula (ca. 1009–31), comparisons in the literature of kingdoms ruled by Arab descendants and those with rulers of non-Arab Maghribi extraction led to a "new form of elite identity politics [that] envisioned 'Berber' and 'Arab' as alternative ideological articulations of dynastic domination."[5] It is not until the rise

of the Almohads that we see a concerted effort, originating in the Maghrib, to promote specific dialects or customs on an imperial scale. The Almohads wrote in the dialect of the Masmuda tribe (which made up the core of their ranks) and organized the governmental structure under a tribal logic. As Rouighi points out, the span of their empire created the conditions for an unprecedented scale of political integration and rhetorical unity, and even if practical conditions prevented complete ideological purity, the promotion of "Berber" as a category developed a more widespread public consciousness.[6] It is therefore possible to talk about "Berber" as a generative category for the Almoravid and Almohad periods, albeit not with the universalizing interpretation that is often associated with it today.

Recent scholarship has attempted to unpack the colonialist legacy of this characterization, teasing apart the relationships not only between the Almoravids and the Almohads but also between both dynasties and their Andalusi and Maghribi subjects. Maribel Fierro, Pascal Buresi, Amira Bennison, Mehdi Ghouirgate, and others have contributed significantly to this effort, approaching primary sources with a critical eye toward the generational biases built into frequently contradictory narratives.[7] Their work has contextualized the Almoravids and Almohads within intersecting traditions of religion, language, anthropology, and economy. What is more, they have clarified for modern audiences the social forces at play in the medieval Maghrib, a daunting prospect for the casual observer who is new to the tribal politics and the intermittent course of Islamization in the region. They have, in short, begun the long process of recovering the historical role of these two dynasties from centuries of political and academic appropriation, offering a more nuanced view of each as a distinct actor in its own right.

This effort has been even more challenging within the realm of architectural history, frustrated by the state of preservation of the majority of Almoravid and Almohad sites. On the Iberian Peninsula, their urban contributions were frequently folded into later efforts at expansion and renovation, although they were, on occasion, destroyed entirely in the program of de-Islamization after the expulsion of Muslims and Jews from Spain in 1492. Similarly, in the Maghrib, the sites suffered waves of successive dynastic appropriation or destruction, making the process of picking apart the medieval elements of their architecture a sometimes impossible challenge. What this has left to the architectural record is an uneven and incomplete idea of the focus of Almoravid and Almohad architecture, one understandably biased toward those monuments that are left to us. Much of the twentieth-century French and Spanish scholarship on the subject was dedicated to a comprehensive catalog of the remaining sites, their various states of disrepair, and formalist descriptions of their materiality, construction, and ornamental techniques. Aided by concurrent archaeological investigations, midcentury scholars such as Henri Terrasse, Henri Basset, Gaston Deverdun, and Jacques Meunié wrote the definitive volumes on the archaeology and architecture of Almoravid and Almohad sites.[8] These works remain invaluable for their documentary quality, but many of their conclusions regarding the artistic merits and contributions of the period remain couched in a moralizing framework that equated ornamental decadence with intellectual and artistic superiority, a narrative that consistently put the Maghribi material in a lower tier of sophistication. Recent scholarship from art historians like Mariam Rosser-Owen, Cynthia Robinson, María Marcos Cobaleda, and Susana Calvo Capilla has made

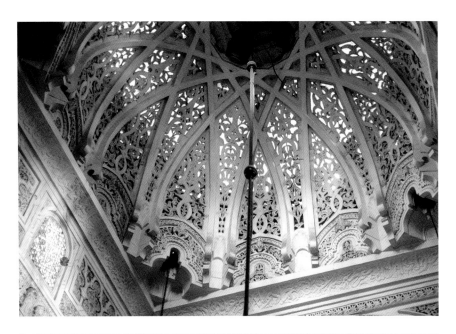

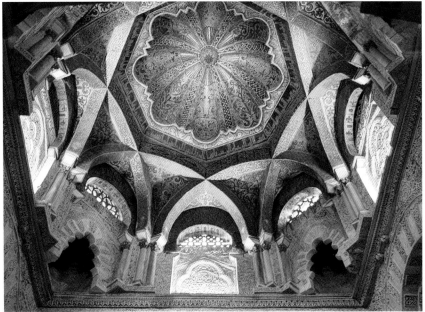

FIGURE 2 (*top*)
Dome in front of the mihrab at the Great Mosque of Tlemcen, ca. 1136. Photo: B. O'Kane / Alamy Stock Photo.

FIGURE 3 (*bottom*)
Dome in front of the mihrab at the Great Mosque of Córdoba, ca. 962–66. Photo: WHPics / Alamy Stock Photo.

significant progress in approaching Almoravid and Almohad architecture with a greater degree of agency and nuance, contextualizing it within the wide and fluid network of referents available.[9] Engaging critically with ornamental and structural elements as well as their metaphysical and political theorizations, this new generation of scholarship has revealed the sophistication and innovative experimentation of each dynasty.

What is more, the subtle differences between the two open a window onto how they engaged with the process of Islamization in their communities, leading each dynasty to a distinctive architectural program. The Almoravids, who adopted a Maliki form of Sunnism and professed at least nominal allegiance to the Abbasid caliphate in Baghdad, certainly drew from the ornamental vocabulary of their eastern sponsors. Much has been made of their use of muqarnas in interstitial cupolas and the central nave ceiling at the Qarawiyyin Mosque, as well as their use of a geometric form of interlaced strapwork known as *girih* (most notably in the Qubbat al-Barudiyyin; see fig. 13), which Yasser Tabbaa has interpreted as a definitive Abbasid homage within the Almoravid oeuvre.[10] But the Almoravids also looked to Córdoba and to the precedents set by the so-called Spanish Umayyad caliphate (r. 929–1031), which had established some of the most recognizable and lasting ornamental and architectural forms in the region. This was subtle at times, as in the use of ribbed or fluted domes in front of the mihrab, such as at the Almoravid congregational mosque at Tlemcen (see figs. 2, 3). At other times it was more direct, such as in the use of spolia taken directly from Córdoba and installed at iconographically charged points in Almoravid mosques.[11] Yet—contrary to the historiographical narrative of Berber primitivism—the Almoravids were

also patrons of artistic innovation. The same Tlemcen mosque, for example, features the first use of pierced stucco in the construction of a dome, crafted in lush vegetal forms to create a forested effect within the architectural space.[12] Cynthia Robinson has posited a philosophical lens of interpretation for this effect, arguing for a rationalist invitation to contemplate the divine, inspired by the work of Andalusi philosopher Ibn Bajja (d. 1139).[13] What is clear from this brief analysis is that the Almoravid corpus of visual references had multiple sources and was multivalent in semiotic and mimetic signification. Almoravid architecture could be triumphalist, deferential, and rich in exegetical potential and aesthetic preference. Frequently, these qualities could be found within the same site, as at the Tlemcen mosque, establishing a complex and occasionally contradictory network of references.

The Almoravids' successors, the Almohads and the Mu'minid dynasty based on their movement, drew upon a similar codex of artistic precedents, and yet their architecture marks a decisive interlude in a general preference for Andalusi vegetal ornament in its various forms across the Andalusi and Maghribi regions. While still referencing Córdoba in particular ways—primarily through the orientation of their mosques and in certain ceremonial practices, discussed further in chapter 2—the Almohads' architecture rejects much of the luxurious materiality and explicitly paradisiacal references of the Andalusi caliphate. In the extant examples of Almohad-era architecture, much of the interior space is stripped back to an almost austere simplicity. Featuring whitewashed plaster-covered walls and solid brick piers, ornamental application is almost exclusively reserved for the most ideologically charged areas, such as in front of the mihrab.[14] Where vegetal ornament does occur, it is abstracted to the barest hint of leaves

and vines, concordant with the ample geometric strapwork ornamenting the rest of the surface. Far more proliferative is the geometric ornament that highlights these spaces—six- and eight-pointed star motifs, connected by interlaced strapwork, that exhibit a preference for straight lines and negative space (fig. 4). While these motifs create structure around the mihrab, the ceilings are also hierarchically defined through increasingly ornate arch typologies, moving from clearly pointed horseshoe forms to polylobed arches and, finally, to lambrequin types as one moves through the space toward the qibla transept (fig. 5). Extensive use of muqarnas ceilings with fluted cells further heightens the intensely geometric program that defines the ornamental preferences of Almohad-era architecture. Much of this program has been read in light of the Almohad doctrine's emphasis on *tawḥīd*, or unity, rooted in the absolute oneness and abstract incomprehensibility of God. The use of highly geometric forms interspersed with the occasional vegetal design, with leaves stripped to their most bare, represents the intellectual

FIGURE 5
View from the southeastern corner of the Kutubiyya Mosque, with the Kutubiyya's hierarchical arch typologies. Lambrequin arches frame the qibla transept and the two aisles at either end of the mosque, while polylobed arches highlight the horizontal axis of the qibla transept, and slightly pointed horseshoe arches occupy the rest of the hypostyle space. Photo: author.

process by which the Almohad faithful divested the concept of God from any representative qualities, an exercise explicitly rejecting the accusations of anthropomorphism they had levied against their Almoravid predecessors.[15]

The metaphysical and intellectual reading of the Almoravid- and Almohad-era architecture discussed above has a strong basis in the profusion of philosophical literature from the period, which guides the historian to a number of conclusions regarding the medieval Maghrib. First, the common characterization of North Africa in the eleventh and twelfth centuries as an intellectual backwater is clearly a misconception, created by a diffusion model that posits Baghdad and, to a lesser extent, al-Andalus as the undisputed arbiters of enlightened thought. The presence of scholars working in and around the Almoravid and Almohad courts indicates an active participation in the intellectual disputes of the day, and many of these scholars contributed their own sophisticated understandings of the issues as they related to Maghribi society. Even when such scholars were not openly embraced within the courtly sphere, as was the case with Ibn Bajja, the diffuse and hardly hegemonic nature of both empires opens the door to a refined, philosophical reading of their architectural ornament. Second, scholars (and art historians in particular) must acknowledge the multivalent application of architectural references within both periods, for while both the Almoravids and the Almohads may have looked to Baghdad and Córdoba for inspiration, the reception of those motifs and even directly spoliated goods can hardly be interpreted as passive. For example, the elegant and intricate carved wooden minbar commissioned by the Almoravids from Córdoba, and later relocated to the Almohad Kutubiyya Mosque, carries with it a host of interpretive possibilities (fig. 6). Its Andalusi craftsmanship, widely admired

by historical observers such as Ibn Sammak (d. after 1381; who described its "perfect accomplishment"), speaks to the Almoravids' and Almohads' high regard for the skilled tradition of the Iberian Peninsula.[16] But the minbar's materiality, crafted from a variety of woods imported from as far away as Senegal and the Levant, also speaks to the impressive extent of the Almoravid empire and trading network.[17] More than a straightforward adoption of Andalusi motifs (though these are present in the vegetal carvings that recall Córdoban ivories), the minbar expresses a new synthesis of ornament, texture, and locality that made use of those motifs to express something entirely new. The minbar takes on additional layers of meaning when it becomes spoliated under the Almohads, relocated from its original setting in the Almoravid Masjid al-Siqaya to the new Almohad congregational mosque known as the Kutubiyya, both located in Marrakesh. Triumphalism is certainly present, but there is also a degree of practicality and adaptation that is both a long-standing tradition within the Maghrib and a particular hallmark of Almohad-era architecture.

The Almoravids and their Almohad successors were masters of this multivalent mode of communication through an architectural medium, refashioning visual precedents for a distinctly Maghribi audience. Their sensitive treatment of ornamental and structural schemas supported and reiterated the religious and social reforms that underlay their dynastic claims to authority and legitimacy, as has been made evident through the recent scholarship of the period. Yet this scholarly approach has largely remained framed through the formalist methodologies of the earliest theorizations of this material, relying on the aesthetics of individual monuments as the ultimate expression of specific identities. This approach has attempted,

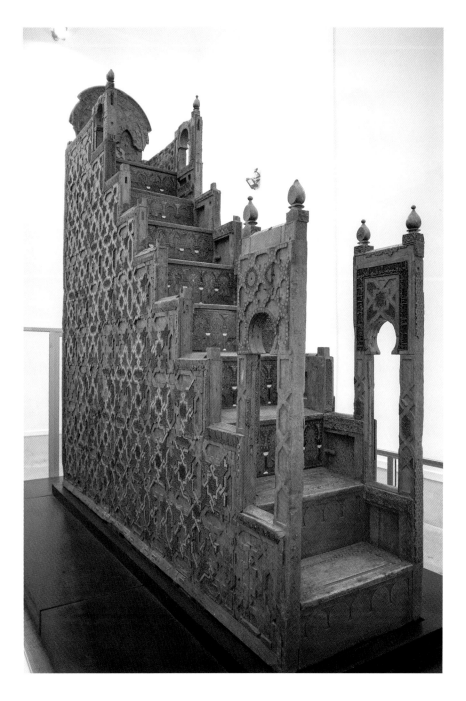

relatively successfully, to rehabilitate our understanding of philosophical and religious thinking of the period as a generative force within the architectural sphere of the Maghrib. It is inherently limited, however, by the available source

FIGURE 6
The Almoravid minbar from the Kutubiyya Mosque, now housed in the Badiʿ Palace Museum, Marrakesh. Photo: author.

material, the majority of which falls under the category of religious spaces, apart from a few remnants of palatial or military constructions hidden within larger trans-dynastic sites. The extant architectural record from this period primarily consists of mosques and their attendant architectural elements—ablution fountains, minarets, mihrab renovations—which, from our historical vantage, may skew us toward thinking of the Almoravids and the Almohads as excessively concerned with spiritual practice. To follow through with this logic would be to fall into the trap of conceiving of their versions of Islam as diametrically opposed to other conceptual categories, most significantly those of the "secular" or "social," when the historical phenomenon of the Islamic world suggests otherwise. As described by intellectual historian Shahab Ahmed, Islam "is a field of meaning where truth is constituted, arranged, and lived in terms not of categories constituted by mutual exclusion, but rather by categories of mutual inter-sorption and inter-locution that run athwart and conceptually frustrate the religious/secular binary or religion/culture division."[18] In other words, we must approach the architecture of this period as inherently polysemous, expressive not only of particular theological ideas but of an entire multitude of societal experiences.

To do so, this volume steps away from the individual architectural monuments as enclosed spaces of architectural expression to look at the interrelated ways in which those monuments interact with one another as well as the landscape around them. An urban perspective resists unilateral definition while acknowledging the legal and rhetorical framework that religious and philosophical literature from the period can provide. Without disregarding the sensitive and detailed analysis provided by the ornamental schemas of each dynasty's architecture,

expanding the perspective outward to look at the urban plan allows us to include no longer extant monuments and sites attested by the historical and archaeological record. As shall be discussed in the following chapters, while the mosques of the Almoravid and Almohad eras have received significant attention for their extant remains, their capital city was populated even further by palaces, gardens, complex hydraulic works, and public squares. These spaces were enlivened by rituals and ceremonies that encoded the religious milieu characteristic of the period with specific references to traditions only tangentially related to an Islamic context. Intervening centuries of destruction, expansion, and renovation may make uncovering these spaces a complicated endeavor, but it is no less vital to our understanding of the period. The morphological development of Marrakesh reveals distinctive approaches taken by the Almoravids and the Almohads that go beyond the spiritual or religious needs of their communities to highlight other dimensions of their respective dynastic identities. If the architectural vocabulary of the period was inherently communicative on a variety of levels, as recent scholarship suggests, then so too were the very identities that they expressed.

MARRAKESH AS AN ARCHETYPE: THE ISLAMIC CITY IN QUESTION

As the stage for these multivalent modes of communication on an imperial scale, Marrakesh bears the archaeological and morphological remnants of each dynasty's approach to the urban project. The generational shifts between the two dynasties are born out physically as the mosques, palaces, and public spaces shift location and orientation. Marrakesh thus participates in a long-running scholarly debate surrounding urbanism in the Islamic world, the

role the city played as a locus of identity and culture, and the ways in which social organization was reflected in urban morphology. The concept of the "Islamic city"—that is, a city whose fundamental organizational principle is rooted in Islamic tradition—is one that has been widely debated among historians and rightly criticized for its origins in an Orientalist worldview.[19] And yet it persists as an analytical category for understanding the interconnected phenomena of the appearance and spread of Islam as a major religious and social category and the exponential growth and development of new cities and urban networks under various Islamic polities. Marrakesh, despite its marginal status among the larger and more well-studied cities of the Islamic world, stands at the crux of this debate, acting as both an archetype of the Islamic city model and a product of its theorization.

Beginning in the 1920s, the French Orientalist school of Algiers published a number of essays that constructed a checklist for what constituted the Islamic city, which was followed by a series of monographic studies that confirmed those characteristics.[20] Within this model, a market (*suq*) and a congregational mosque operated in a gravitational equilibrium, forming the core of the city with other, smaller networks expanding away from them. Occasionally a hammam also formed a locus of social gathering, while the relationship of administrative centers to the mosque-market hybrid disclosed relative degrees of confidence or anxiety in their own political authority.[21] The rest of the city was loosely organized into residential quarters grouped by trade or what the French scholars termed "ethnicity," referring to the tribal or geographic origin (based on patronymics) of their occupants.[22] This structure formed the antithesis of what Max Weber termed the *Gemeinde* of Europe, describing autonomous urban communes that conformed to an ideal type. The effect was to create a mode of societal comparison between the colonial powers and the Mediterranean regions they controlled, justifying their "civilizing" intervention.[23]

Among the monographs that detailed this dynamic was Gaston Deverdun's *Marrakech des origines à 1912*, which charted the city's major monuments by dynasty, interspersed with historical overviews of the sources.[24] The closing date of his work, 1912, marked the year that Marrakesh was officially absorbed into the French Protectorate of Morocco, and the following year saw the establishment of the *ville nouvelle* under the guidance of Resident-General Hubert Lyautey. With the aid of urban planner and designer Henri Prost, the *ville nouvelle*, known as Guéliz, employed a radiating grid plan and imposed a height restriction on all new constructions. No building was to be taller than four floors (or the approximate height of a palm tree) so as to maintain the medieval profile of the metropolitan skyline and to avoid competing with the silhouette of the Kutubiyya Mosque's monumental minaret (fig. 7).[25] This mandate had the effect of creating an economic and social segregation at Marrakesh between the wealthier French expatriates and tourists and the poorer local Moroccan inhabitants, who were siloed into the old town, which retained the designation of *madīna* and was preserved as a time capsule of an imagined Orientalist past.[26] Simultaneously, this preservation of the historic core of Marrakesh created the perfect venue for the French scholars of the region to test their theories of the Islamic city.

The resulting scholarship took specificities of place, time, and social context for granted, constructing an abstract concept full of generalizations about cities in the Islamic world. Moreover, these theories often conflated the

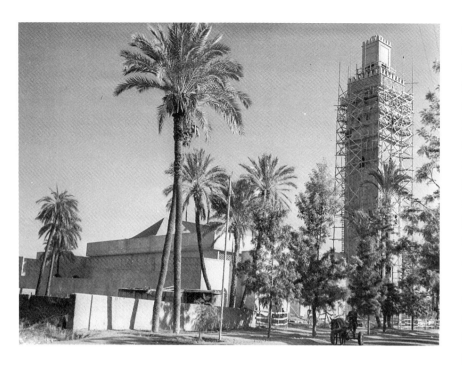

FIGURE 7
The Kutubiyya minaret under repair,
ca. 1930s. École nationale d'Archi-
tecture, Rabat.

medieval past with a colonized present, uncriti-
cally accepting a singular urban form "at one
long historic moment without unpacking the
various causes of that particular outcome."[27] The
model was applied to cities as diverse as Cairo
and Aleppo, which not only had experienced
stark urban changes under Ottoman rule but
had emerged from vastly different foundational
circumstances. The examples that informed the
model—nearly all of which were based in the
Maghrib—were both small in number and eccen-
tric in character. In response, modern schol-
arship has faced a choice: to reject the model
outright as ethnocentric; to accept the model as
a useful category of analysis, albeit to varying
degrees of accuracy; or, as has been suggested
by Dale Eickelman, to recognize that categories
of urban-ness are not universally translatable.[28]
What is described as "urban" (ḥaḍarīya) in the
Maghrib does not necessarily carry the same
implications of social difference or distinction

as it does in the Levant or in Europe. While there
may be certain parallels or coincidental occur-
rences, the role of those elements is particular
to an audience of a given time and place. As a
case study for urbanism in the Islamic world,
Marrakesh carries the historiographical weight
of serving as the basis for its theorization and
development in keeping with colonial-era ideas
about how such a city should appear. Deeply con-
textualizing its origins outside of this model and
its comparative tendencies offers a path forward
for a more nuanced and expansive reading of the
city.

As an experiment in medieval imperial
urbanism, Marrakesh integrated established
expectations of what a city needed to do within
the function of an empire and newer social and
philosophical attitudes about the city's role
in identity formation. Although few authors
contemporary to either dynasty explicitly dis-
cussed the dynamics of the city, its rulers, and
its inhabitants, the later theorizations of Ibn
Khaldun can provide some insight into the inher-
ent contradictions at play. The close relationship
between Khaldunian thought and the urban
experiment at Marrakesh is what marks the city
yet again as a particularly important example
in the wider history of urbanism in the Islamic
world. Historians have rightly interrogated the
outsized influence of Ibn Khaldun's work on the
scholarly understanding of the period, arguing
that it posits a priori a coherent social structure
in which large-scale state formation is doomed
to fail. This, in turn, established a deterministic
trajectory that elided the political and historical
complexities of the period.[29] But with regard to
the study of medieval Maghribi urbanism, and in
particular its effect on shifting social networks,
Ibn Khaldun outlines the delicate negotiations
and inherent contradictions that faced both
the Almoravids and the Almohads by explicitly

linking the landscape with the character and priorities of their respective social groupings.

The opening of Ibn Khaldun's *Kitāb al-ʿibar*, commonly known as the *Muqaddima* (Introduction), describes the geographic scope of his project as such: "Our main concern is with the Maghrib, the home [*waṭan*] of the Berbers, and the Arab home countries [*awṭān*] in the east."[30] The term *waṭan* is frequently translated in a premodern sense as "homeland," although in modern parlance it carries more loaded connotations of nationalism. In the twelfth century, however, it was used in reference to the emotional, physical, and social attachments that people felt to their place of birth, ancestral home, or place of residence.[31] Whereas other terms were used to describe political boundaries or the physical qualities of land, *waṭan* was reserved for the relationship between human beings and nature, a connection that fundamentally implied nourishment of both body and soul. That relationship could be determined by an intrinsic kinship to a place, developed through the kinds of intimate geographic and topographic knowledge that come from farming, herding, or traversing a particular landscape over generations. It could also, however, express a more conscious relationship to the land, a relationship established by choice rather than circumstance, such as the incorporation of land through conquest and resettlement. The concept of the *waṭan* had been formalized in early Islamic belles-lettres (*adab*) as the natural habitat of a given people; originally describing the bedouin life of the Arabian Peninsula, Ibn Khaldun here transposes it to the (semi)nomadic life of the Berbers.[32] In doing so, he declares the Maghrib their definitive homeland, and he goes on to detail the homelands of each specific Berber tribe, locating the Almoravid Sanhaja in the Saharan desert and the Almohad Masmuda in the Atlas Mountains.

A deep connection with one's *waṭan* also established a strong sense of camaraderie, a deep connection that Ibn Khaldun argued was imperative for developing the movement that would bring a ruler to power. Known as *aṣabiyya*, it is frequently translated as "esprit de corps" or even "proto-nationalism," although neither of these fully encompasses the social principles embodied by the term. The notion of *aṣabiyya* as a structural paradigm is a rather fraught one in Islamic philosophy. In its pre-Islamic connotations, the term had an ambiguous meaning that reflected the sort of blind allegiance to a clan group that threatened any supra-tribal collective, and the concept was therefore condemned by the Prophet Muhammad as a danger to the early Islamic community. And yet by the fourteenth century, Ibn Khaldun considered it the primary agent of political change in the Islamic west as social cohesion waxed and waned. The term expressed both bonds of consanguinity and elected subscription to a particular group, allowing for at least a degree of social expansion. But its inherently unstable and dialectical nature means that while it allows for group cohesion in ethnic environments, it impairs the centralization of power needed for large-scale imperial endeavors in areas with multiple social and ethnic groups. Historians have debated elsewhere the role *aṣabiyya* played in the administration of both the Almoravid and Almohad empires, but the general consensus is that the earlier Almoravids were hampered by their *aṣabiyya*, unable to supersede clan divisions as their empire expanded.[33] By comparison, the Almohads were more successful in translating *aṣabiyya* from an explicitly ethnosocial category to a religious one through the recognition of their founder, Ibn Tumart, as the *mahdī*, an apocalyptic figure meant to redeem Muslims before the end of days. Ibn Tumart organized his followers

by tribal categories, but they were all bound together by his particular brand of Islam, in a deliberate echo of the narrative of Muhammad and the early believers.[34]

These relationships needed to be continually reinforced, whether through performance, literature, or art. According to Ibn Khaldun's theorization of the social contract, aṣabiyya could be corroded through the trappings of urban life, where exposure to alternate customs and ways of living might supplant those patterns that had initially generated imperial authority and strength.[35] The nurturing aspect of the waṭan could and would fade over time, which is why one's removal from it caused feelings of depression, sickness, or madness.[36] The physical environment that is defined by the waṭan should be understood as the active agent in determining the qualities that make up aṣabiyya. Climate, topography, and landscape shape the principles by which a society lives, creating the ideological boundaries of what it means to belong. Waṭan and aṣabiyya, then, are more than parallels of each other; they are mutually reinforcing. Though both concepts are mutable within an individual, a dynasty, or even a culture more broadly, they admit an inevitable relationship between the landscape and a code of social mores. To leave the waṭan is to abandon the ideals and practices that created a community in the first place. It may be this understanding of how social structures were determined that led to Ibn Khaldun's model of empire in the fourteenth century, which he based on the Almoravids and the Almohads. In that model, a dynasty's initial power stems from its moral conviction—a strength of aṣabiyya that results from inhabiting the synchronistic environment. As the dynasty grows, imperial expansion results in an abandonment of (or at least a diminishing attention to) the waṭan, leading to a discordance between environment and moral authority that ultimately ends in a fall from power. Khaldun's model enunciated the specific kind of anxiety that appears during times of political instability and transition, the sense that one's waṭan is at risk, a feeling that could be ameliorated through acts of connection and recollection. At the dynastic level, this is most directly expressed through architecture, whether materially, structurally, or spatially. Marrakesh, in its shift between the Almoravid and Almohad periods, reveals the active development of a city designed for such recollection in an effort to maintain social stability on the imperial scale.

IBN TUMART AS A SOURCE OF SOCIAL CRITIQUE

One of the central figures of this work is, without a doubt, Ibn Tumart (d. 1130). Despite having no dynastic position within either the Almoravid or the Almohad empire, his relationship to them would have profound consequences for the way in which we understand the city of Marrakesh and each dynasty's relationship to its capital city. His life and teachings occupy the interstitial space between the transition from one era to another, and he thus provides modern scholars with the best literary source material to contextualize the philosophical and social underpinnings of each. There are certainly historiographical hurdles to overcome in relying on such a contentious and clearly ideological figure to explicate multiple generations' worth of architectural and civic construction, and I am by no means suggesting a one-to-one correlation between Ibn Tumart's critiques and the architectural choices of two powerful dynasties. But Ibn Tumart was known as a keen observer of Maghribi society in the twelfth century, and his philosophy grants us a unique insight into the cultural and sociological undercurrents that motivated these dynasties. Couching his particular brand of religious

reformism in explicitly ethnosocial rhetoric, Ibn Tumart tapped into the complexities of Berber politics and made explicit certain expectations and norms that had heretofore been only implicit from the perspective of historical sources. His critique of the Almoravids—and his founding of the Almohad movement that toppled them—places him at the crucial point of transition between the two, and in many ways, the evolution of Marrakesh can be mapped through the concepts that Ibn Tumart highlights in his warnings and proscriptions to both.

The early details of Ibn Tumart's life can only be reconstructed from later Almohad hagiographies and thus bear a distinct political bias. The general framework, though, suggests a figure conscious of the socio-religious dynamics surrounding him. Born around 1080 in the village of Igliz to the Hargha tribe, a subsidiary of the larger Masmuda confederation that occupied the High Atlas and Anti-Atlas Mountains in the southwest part of what is today Morocco, Ibn Tumart's early life was characterized by a marked propensity for religious learning in a family already known for piety and devotion. Among the Hargha, Ibn Tumart's family was known as isarghīnen—a term that, in the Masmuda dialect, alluded to sharifian ancestry.[37] This traditional role of religious and spiritual leadership was taken up by Ibn Tumart, who earned a reputation for spending long hours in the mosque at prayer and in study, on hand to light the candles at dusk and earning the nickname "Asafu," a Masmuda term meaning "a lover of light."[38] His early aptitude is undoubtedly part of the hagiographical model of Mahdism—the millenarian and eschatological tradition of a righteous religious reformer sent to purify Islam before the end of days. Following in this tradition, upon reaching maturity, Ibn Tumart left his mountain village for Aghmat, then the

largest town in the region and considered a local center of religious learning. From there, he made the journey to al-Andalus, stopping in Córdoba and Almería, where he was likely exposed to the teachings and political leanings of Ibn Hazm's (d. 1064) Zahiri followers as well as the tumultuous activities of Andalusian Sufism under Ibn al-ʿArif (d. 1141).[39] Both of these figures were heavily influenced by the philosopher al-Ghazali (d. 1111), the Persian scholar who is said to have had the greatest effect on Ibn Tumart's ideas and to have been his tutor upon the latter's arrival in the Mashriq around 1108. Here, the sources and secondary scholarship are at odds, as the timelines of the pair's meeting are hard to match up. Anecdotally, al-Ghazali is said to have urged Ibn Tumart to overthrow the Almoravids after learning of their hostile reaction to al-Ghazali's famous text Iḥyāʾ ʿulūm al-dīn (The revival of the religious sciences), which had been publicly burned in al-Andalus.[40] However, by the time Ibn Tumart is said to have arrived in Baghdad, al-Ghazali had supposedly retired to Tus, near the border of present-day Afghanistan. This chronological problem has been tackled by numerous scholars over the years, who have suggested everything from a chance meeting in Alexandria to a journey entirely fabricated by Ibn Tumart.[41]

A meeting between al-Ghazali and Ibn Tumart, whether apocryphal or not, serves two functions within Ibn Tumart's hagiography among the Almohads. First, this account contributes to the future Mahdi's prophetic background, establishing a journey of enlightenment that granted him intellectual and spiritual legitimacy through a lineage of respected thinkers from both al-Andalus and the Mashriq. As Mercedes García-Arenal has pointed out, the narrative of Ibn Tumart and al-Ghazali's meeting speaks to the desire of Ibn Tumart and his followers to

"stake a claim to Ghazalian thought, and . . . the reverential prestige which then attached to the figure of al-Ghazali in the Maghrib."[42] Second, Ibn Tumart's purported travels reveal the degree to which he and his doctrine were in the process of capturing a specific cultural, spiritual, and political moment of anxiety and frustration. In teasing apart his influences and background through the lens of a scholarly journey, what is revealed is someone who was exceedingly sensitive to moods of societal critique and change, moods that would propel Ibn Tumart's movement toward its successful conclusion of overthrowing the Almoravids. The activities of Ibn Hazm, although predating Ibn Tumart's arrival on the Iberian Peninsula, nevertheless left an indelible mark on the region's discourse on Maliki thought, and the literalist critique of Maliki ʿulamāʾ was taken to heart by the young Maghribi scholar. Under this particular strain of Zahirism, the practice of consensus (ijmāʿ) among Maliki scholars was deemed an insufficient rubric for interpreting the law as laid out in the Qurʾan and hadith, leading inevitably to societal corruption and waywardness.[43] This critique coincided with the rise of Andalusian Sufism in the eleventh and early twelfth centuries, in which the doctrine of illumination by divine will (maʿrīfa, often translated as "gnosis") superseded that of knowledge acquired through study and legal discourse.[44] One could, through asceticism and emulation of the Prophet Muhammad, attain a state of spiritual enlightenment through communication with the divine will, which then allowed the enlightened person to interpret and guide the faithful. This enlightened figure was known as the quṭb al-zamān, the "axis of the age," proposed as the spiritual center of gravity for an entire generation of Muslims. The ultimate such figure was the Mahdi, who was predicted to come in the year 500 of the Hijri calendar (1106

in the Gregorian), the same year in which Ibn Tumart was supposed to have undertaken his educational travels.[45]

In his writings and teachings, al-Ghazali touched upon each of these issues as part of his critique of the uṣūl al-fiqh (sources of jurisprudence or law) in the hands of the ʿulamāʾ, and he interwove them with the juridical impulse toward corrective action. Central to his thesis was the ḥisba "al-amr bi-l-maʿrūf wa-l-nahy ʿan al-munkar," the Qurʾanic precept to "command right and forbid wrong."[46] Although this ḥisba informed numerous schools of thought, including the mainstream Maliki ʿulamāʾ in the Islamic west, al-Ghazali's interpretation was innovative in its insistence that it was compulsory for all Muslims—so long as they were legally of age and could reasonably carry out the responsibility— to enact the practice. Al-Ghazali dismisses the idea that one needs permission from the ruler or the courts in determining how and when to carry out the ḥisba, and in fact he muses at length over the necessity to speak out against unjust rulership; though it may ultimately be an ineffective exercise due to the imbalance of power, it is nevertheless virtuous to do so.[47] In this expression of the ḥisba, al-Ghazali equates both the commanding of right and the forbidding of wrong as mutually incumbent upon all Muslims, regardless of social status, a philosophical model in which silence (in either case) has no place. Dissent thus becomes an ethical duty, and it was this element of al-Ghazali's work that made him such a polemical author in the Maghrib. Taken up by both political reformers as well as the Andalusian Sufis, the ḥisba was interwoven with an increasingly eschatological outlook, creating a climate of moralistic activism (frequently couched in the vocabulary of jihad) that railed against the status quo.[48] This expression of the ḥisba would eventually form the foundations of

Ibn Tumart's own doctrine as he returned to the Maghrib and began preaching an ascetic and reformist brand of Islam.

Ibn Tumart—his teachings and the development of Almohadism—was thus very much a product of his era, although the interweaving of each of these disparate elements added up to something much greater. In addition to these various schools of nonconformist thought, Ibn Tumart also acquired an education in Ashʿari legal tradition, which included *fiqh* along with *uṣūl al-dīn* (principles of religion) and *uṣūl al-hadīth* (the principles of hadith). Ibn Tumart's teacher in this respect was likely Abu Bakr Muhammad al-Turtushi (d. 1126), a preeminent Maliki jurist and ascetic in Alexandria who himself had been a student of al-Ghazali's (even though he later renounced his teacher's work). It may have been while in Egypt that Ibn Tumart was first exposed to al-Ghazali's understanding of the *ḥisba* and integrated it into the more esoteric elements of his "search for knowledge" (*ṭalab al-ʿilm*).[49] Social reform, activism, and an eschatological mysticism combined with a profound knowledge of the Qur'an and hadith to coalesce around a revived conception of monotheism, the eternal oneness of God, or *tawḥīd*. This doctrine of *tawḥīd* would form the basis for Ibn Tumart's reformist movement and the name of his followers, the Almohads (*al-muwaḥḥidūn*, frequently translated as "unitarians"). It is important to interject here that the chronology surrounding the development of Ibn Tumart's doctrine (*ʿaqīda*) is complicated by the series of revisions and recensions of the source texts of his teachings. There are references to *tawḥīd* in al-Baydhaq's (d. after 1164) memoirs as a disciple of Ibn Tumart's, though these were written under the reign of ʿAbd al-Muʾmin and reflect a preoccupation with the legitimacy of the new dynasty more than metaphysics. Even Ibn Tumart's own writings on the subject, compiled in the text known as *Aʿazz mā yuṭlab* (The greatest object of desire), only come to us through an 1184 recension, a good fifty years after Ibn Tumart's death and, again, possibly manipulated for political consistency at the height of the Muʾminid era.[50] As received, the debates surrounding the oneness of God are framed to target the Almoravids as anthropomorphists who took literally the Qur'anic descriptions of God as having human attributes, a heretical position.[51] From this perspective, the Almoravids were incapable of inferring the allegorical nature of such descriptions, relying overmuch on Maliki jurists rather than developing their own practice of logical and rational thinking. While there is undoubtedly a polemical nature to the versions of the texts that are extant, at their core they express Ibn Tumart's keen interest in developing his followers' skills to assess what was "right" and "wrong" in following the *ḥisba*. In other words, commanding right and forbidding wrong were personal obligations decreed in the Qur'an, but how was the average Muslim to determine what that meant in any given situation?

Ibn Tumart's doctrine advocated personal responsibility as the pathway to a just and ethical society, a moral imperative to carry out the *ḥisba* on an individual level as well as on a structural one, ensuring consistent action throughout. This could not be carried out solely by an elite class of jurists and scholars (although under ʿAbd al-Muʾmin, just such a class of Almohad theologian-administrators was incorporated into the caliphal retinue). Rather, it required a practical framework of applicable knowledge in order to shape the juridical principles that would form a truly Almohad society. This was the guiding force behind one of Ibn Tumart's most famous axioms, "Understanding is the mother of ability" (*al-idrāk umm al-istiṭāʿa*).[52] Less concerned with

a metaphysical sort of knowledge, Ibn Tumart urged instead the cultivation of logical reasoning in order to accept the responsibility of action within Islamic doctrine as outlined in the Qur'an. In understanding the ethical principles of the law, a good Muslim is thereby enjoined to action, framed as the "ability" to command good and forbid evil. This ability was determined through ten aspects outlined in the law—number, goods, tools, money, feelings, strength, understanding, intelligence, knowledge, and choice—the absence of any of which would negate the responsibility associated with the precepts of the *ḥisba*.[53] Those who remained ignorant through poverty, circumstance, or mental acuity were excused from their responsibilities, but the counterbalance to this was the absolute necessity for those who *did* understand to act in accordance with the law and promote it to their utmost ability. Action thereby becomes an integral part of the Almohad doctrine, and social critique becomes the right of every devout and capable Muslim rather than a select class of learned jurists.

Aware of the difficulties in overcoming this threshold of ignorance—especially in a population like the Masmuda, many of whom were pastoral herders in the Atlas with little access to formalized religious education—Ibn Tumart was careful and deliberate in the application of his doctrine to his followers. He developed two versions of his *aqīda* to be memorized, known as *murshīda*s ("spiritual guides"): the first a series of Qur'anic references that accorded with the central Almohad tenets, and the second a more elaborate form phrased as a rational proof for those intellectually initiated. The former avoids the use of abstract terms and begins with a version of the *shahāda* (profession of faith, literally "testimony" or "witness") that positively affirms God's existence before embarking on a series

of negatively framed qualifications to illustrate the futility of trying to describe the divine. The first *murshīda* thus implicates its speaker in understanding without taxing the intellect with complex logical exercises. The latter *murshīda* appears as a rational proof of God's existence, followed by a series of human conditions implicated in the statement of God's existence, such as worship and devotion, littered with Qur'anic quotations.[54] Both emphasized Ibn Tumart's message of *tawḥīd* and were composed as didactic works not only in Arabic but in the Berber language as well (likely a linguistic antecedent of the modern Tashelhiyt).[55] Described in the medieval Arabic sources as the *lisān al-gharbī* (the "western" or "occidental" language), this particular variant of the Berber language was specifically directed toward the Masmuda tribes. As has been noted by philologist Mohamed Meouak, the attention to this fact by Arab-speaking authors—the bilingualism of Ibn Tumart's preaching and writing—indicates his particular attention to the general population of the Maghrib al-Aqsa beyond the typical concerns of the sociopolitical elites.[56] Those authors who documented the life and lessons of Ibn Tumart, both under the Muʾminid dynasty and afterward, appear aware of the political potential of these populations in the success or downfall of dynastic ambitions, and of course no one was more explicit in the connection between political power and tribal relationships in the Maghrib than Ibn Khaldun, as discussed above. But Ibn Tumart appears to have been keenly aware of this in his own time, making a point of using both Arabic and *al-lisān al-gharbī* to spread his message, which had the effect not only of reaching a greater number of people but of cementing his core tenets of understanding and responsibility as well. Language would not be a barrier to entry in his philosophy.

Returning to the Maghrib after his sojourn abroad, Ibn Tumart became infamous for his strict adherence to his activist doctrine, frequently inspiring violent public disruptions to economic and civic livelihoods. His foundational social critique, however, appeared to garner him an avid following even as it became increasingly untenable for him to remain in urban areas. After a tense encounter with the Almoravid emir, Ibn Tumart sought refuge among his Masmuda tribesmen and returned to Igliz, where he established a *ribāṭ*, a type of (frequently rural) educational center that also served as a point of communication and exchange and was typically associated with a specific tribe.[57] While the village of Igliz was located in the Sous Valley on the southern side of the Atlas foothills, the *ribāṭ* occupied a high promontory overlooking the village. The promontory was inaccessible on three sides, and the site takes advantage of its natural topography in its fortifications. Recent excavations led by Jean-Pierre van Staëvel and Abdallah Fili have revealed the outlines of Ibn Tumart's *ribāṭ*, a walled enclosure housing a fortress (*qaṣba*) in its southeastern corner, surrounded by residential cells and an L-shaped courtyard, with a high wall on the northern side toward the access path.[58] Van Staëvel and Fili have also discovered two caves near the complex, potential loci for a pivotal moment in the Ibn Tumart hagiography—his declaration as the Mahdi in 1121. Sources differ on whether this declaration came from Ibn Tumart himself or from his followers, and perhaps predictably, those later sources embarking on a project of anti-Almohad propaganda tend to characterize the declaration as a deliberately crafted and cynical one.[59] The general narrative, however, is that after a period of spiritual retreat and reflection in a cave near Igliz, Ibn Tumart made a speech to his followers, enjoining them to command

good and forbid evil, for the time of the Mahdi was coming if one paid attention to the signs. These signs, whether deliberately planted or subconsciously recognized, represent the culmination of independent intellectual and social trends within the figure of Ibn Tumart, granting an immediacy and vibrancy to his nascent movement. By donning the mantle of Mahdism, his creed and social critique became imbued with an aura of prophetic certainty, turning his warnings and proscriptions into a structural framework for the future Mu'minid caliphate and administration. As shall be argued throughout this book, however, these critiques should not be categorized as purely religiously or politically motivated. They most assuredly were, to some degree, but they also reflected Ibn Tumart's perceptive ability to frame his critiques in the context of the social habits uniquely adapted to the Maghrib.

From Igliz, and in what has been understood as a calque on the Prophet Muhammad's move from Mecca to Medina, Ibn Tumart gathered his followers and emigrated in 1124 to the village of Tinmal, located within the High Atlas a mere forty kilometers away from Marrakesh. This shift, from the place of his birth to that of his movement, is indicative of both practical concerns as well as symbolic ones, and the two are often intertwined in the same concurrent events. Tinmal held all the practical features of Igliz—easily defended in its location by a single mountain pass, still within Masmuda territory—but provided access to Marrakesh for the next stage of the Almohad mission: overtures to other tribes with grievances against the Almoravids and the eventual launch of jihad campaigns into the Haouz Basin. As part of this process, Ibn Tumart folded local practices of alliance and kinship into the development of an Almohad hierarchy, such that the distinctions between

tribal affiliations were subsumed under a system that operated on two simultaneous levels. The first and most apparent is the religious one, which drew upon the hierarchies established within Ibn Tumart's two *murshīda*s and distinguished between those who were new to the Almohad cause (and therefore spiritual neophytes) and those who had become the backbone of Ibn Tumart's community and were capable of communicating the message on his behalf. The second is more subtle. It justified the same hierarchies through a lens of intertribal trust and negotiation. The Masmuda would continue to form the core of the Almohad movement even as members of other tribes joined the cause, though that did not necessarily translate into homogenous representation at the top. Ibn Tumart's inner circle, known as the Council of Ten, included representatives from a variety of tribal backgrounds, including ʿAbd al-Muʾmin, representing the Zenata, and Abu Hafs ʿUmar ibn ʿAli (d. 1142), who belonged to the Almoravids' tribal confederation of the Sanhaja.[60] Allen Fromherz has argued that tribal *aṣabiyya* was intended to form the "building blocks" of a societal pyramid with the figure of the Mahdi, as a righteous guide to a just and pious community, at the top.[61]

This particular structure would be, perhaps predictably, inherently short-lived, as Ibn Tumart died in 1130 following a rout of the Almohad forces at the Battle of Buhayra. In the retreat to Tinmal, a wounded or ill Ibn Tumart gave a final sermon to his followers before embarking on a journey "that [no one] could make with [him]"; he withdrew into his house and was never seen again.[62] Even his death was shaped into legend, framed as a *ghayba*, or period of occultation, that lasted between one and three years before ʿAbd al-Muʾmin assumed leadership of the Almohad community. But rather than collapsing entirely, the Almohad movement regrouped under new leadership. Despite ʿAbd al-Muʾmin's non-Masmuda affiliation and lack of messianic charisma, the Almohads conquered Marrakesh, and the Almoravids, in 1147. The veneration of Ibn Tumart would become institutionalized under ʿAbd al-Muʾmin and his early successors, part of a program specifically geared toward maintaining Muʾminid legitimacy in the face of numerous challengers. But the central role of Ibn Tumart goes beyond the patronage of specific sites and ritual practices. The Mahdi's message and manner of social critique—of what was right, what was wrong, and how to communicate that to the people—were assimilated into the very structure of the Muʾminid imperial project.

Questions of identity, expression, and empire all find their answers within the capital city that both dynasties shared at Marrakesh. Their respective approaches to organizing and utilizing urban space reveal a distinctive shift from a more ad hoc approach under the Almoravids to a clear and delineated plan under the Muʾminids, a shift that is less about a developing understanding of urban potential than indicative of the social structure each dynasty sought to construct. The Almoravids, whose ethos of egalitarianism informed a court culture of accessibility and informality, found themselves on display in a way that highlighted fundamental differences encoded through the tribal practices of their Sanhaja (and specifically Lamtuna) elite. The urban stage cast an unflattering light on these differences, which ultimately led to a dissonance between the *aṣabiyya* of the Almoravids and their imperial ambitions. But the Muʾminids, who were perhaps wary of the paradoxical risk of setting a transhumant community within an urban model of authority, approached the project of Marrakesh with a subtle development

that blurred the lines between urban and rural. Moreover, they placed themselves—their public rituals and ceremonies—at the interstitial nexus of this liminal space, holding a particular interpretation of their dynastic identity in performative stasis. While this approach would prove relatively successful at Marrakesh, it would be difficult to execute elsewhere, revealing the limits of the Maghribi model as developed over the course of these two dynastic periods. Rooted in an urban vernacular that relied on landscape as a primary actor in the *genius loci* of the city, Marrakesh becomes inextricably tied to its locality.

This book traces the development of Marrakesh as an urban expression of power and identity over the course of the Almoravid and Almohad periods. The first chapter addresses Marrakesh's foundation and development under the Almoravid dynasty between 1040 and 1147. Although little remains of the Almoravid-era city, archaeological and historical evidence points toward an urban morphology that was extemporaneous and idiosyncratic—its shifting morphology highlighting the social paradox the Almoravids found themselves in as rulers in Marrakesh. Inherited from their Lamtuna brethren, social traditions practiced by the Almoravids—like the male face veil (*lithām*) and the public role of elite women—were distinct from the rest of the North African tribes and Arabic-speaking communities. These markers of social difference set the ruling dynasty at odds with their own egalitarian principles. Drawing upon the political philosophy of medieval Islamic writers like al-Farabi (d. 950) and Ibn Bajja, who likened the well-being of a city to a body and the ruler to its soul, I demonstrate that this uneasy relationship between the rulers and the ruled finds expression in the shape of the Almoravid city. At Marrakesh, the Almoravids created an enclosed city that showcased both their easy

accessibility and the tribal differences that set them apart from the rest of the public. The urban core was originally unwalled, an unusual decision that highlights the idiosyncratic nature of Marrakesh's early form, which remained this way until the imminent threat posed by the Almohads necessitated the construction of urban fortifications. This process coincided with the change between the two congregational mosques—first a mud-brick structure known as the Mosque of the Earthen Minaret (Masjid al Sawmaʿat al-Tub) that was later replaced by a more lavish structure known as the Mosque of the Fountain (Masjid al-Siqaya). More than just an elaboration of an existing structure, this new mosque introduced an alternate direction of prayer (*qibla*), creating two perpendicular axes whose morphology can be determined from the city's gates. The new walls also enclosed the stone fortress (*qaṣr al-hajar*) that served as the Almoravid court palace, located on the southwestern fringes of the city, creating a bipolar nexus of authority between the city's religious center and its political one. These urbanistic idiosyncrasies undermined the social contract that characterized relationships of authority in the medieval Maghrib, such that the Almoravids' authority ultimately struggled to resonate within their own capital city.

The failures of the Almoravid city were seized upon by contemporary sources, including the Almohad founder, Ibn Tumart. The second chapter thus discusses the contrasting Almohad approach to the city, conceived as a direct and calculated response to criticisms of the Almoravid dynasty. Whereas the Almoravid city sought to establish the dynasty as first among equals, the Almohad approach to urban planning employed a strict spatial hierarchy that set the figure of the ruler at a remove from the activity of the general populace. Working from a hierarchical

political structure based on the tribal networks between the various Masmuda clans, the Almohads sponsored the construction of a series of enclosed open-air spaces, taking advantage of the landscape's natural topography and its rise toward the Atlas foothills in the south. Each of these spaces was designed to frame the figure of the Almohad caliph in the guise of a ruler only tangentially connected to the city itself, occupying a liminal space in which the caliph's presence was consistently associated with practices that recalled a recent Masmuda past. Through ritual programs associated with Berber practices and temporary architecture within these walled spaces, the Almohad caliph appeared in stasis, continually emerging from the Atlas Mountains as the righteous liberator of the city without abandoning the markers of a seminomadic existence that characterized his tribal society.

This urban and ceremonial framework accomplished two aims within the Almohad imperial self-conception. First, it established a strict structural hierarchy within the city, setting the caliph at a remove from the general public except in those instances where his surroundings confirmed his authority and his origins. Integrating a system of ritual performance within those spaces that recalled the dynasty's Masmuda heritage through the manipulation of the landscape, the Almohad caliph consistently maintained the moral authority necessary within the social contract of power in the medieval Maghrib. Second, this hierarchy curbed the corrupting power of cities that would be later theorized in Ibn Khaldun's historiographical model. The Almohad additions to the city—essentially periurban spaces tangential to the walled _madīna_ itself—indicate an anxiety over abandoning their tribal origins as transhumant communities. In Ibn Khaldun's model, it is harsh living in a wild environment that breeds

the qualities essential for strong leadership—an atmosphere absent in the decadence of urban life. The Almohads understood these risks and attempted to respond to them by utilizing their urban model to make calculated visual and structural connections to their ancestral homeland in the Atlas Mountains, creating a liminal space in which they both participated in urban life and yet were distinct from it.

The third chapter explores the Almohad urban model as it was applied to the two other major cities in the Almohad empire, Seville and Rabat. The former served as the empire's capital on the Iberian Peninsula, where it already had a reputation as a wealthy agricultural and administrative center by the time of the Almohads' arrival. The construction of a new congregational mosque and palace complex, and renovations of the walls and waterworks, was standard practice under the Mu'minid dynasty. The mosque was built toward the center of urban activity, while the palace was set at a remove from the general population, occupying the fringes of the walled city itself. Yet while the structure and location of these civic and imperial projects recall the plan at Marrakesh, in Seville, they struggle to create the same clarity of hierarchy in a densely packed, preexisting urban settlement. At Rabat, this was not a problem. A new city built by the Almohads as a launching point for campaigns across the Strait of Gibraltar, Rabat featured a fortified castle (_qaṣba_) and congregational mosque constructed along the north-south axis along the left bank of the Bou Regreg River. Each of these monuments stood at the two respective highest points along the river, with a walled _madīna_ situated in the slight depression between them. At Rabat a clear manipulation of the topography and the development of an urban hierarchy emerge, and yet without the resonance of the Atlas Mountains to frame Almohad imperial

rituals, the city fails to connect to the Almohads'
social manipulation of ethnic ties and politics.
Rabat was abandoned soon after the dynasty's
fall. Neither Seville nor Rabat possessed all of
the requirements for executing a city plan that
relied upon subtle manipulations of topography
and morphology for the expression of imperial
authority and identity, two concepts interwo-
ven in the Mu'minid ethos. As such, neither
city proved to be as politically and ideologically
powerful within the Mu'minid urban program,
throwing into sharp contrast the indelible links
between landscape, authority, and identity for
the dynasty. The limited effectiveness of this
model, however, further underscores the sophis-
tication and ingenuity demonstrated at Mar-
rakesh itself.

Almoravid Foundations

The northern slopes of the Atlas Mountains descend gently into a wide, semicircular, arid basin that sits approximately 500 meters above sea level. A river known as the Wadi Tansift borders this basin to the north, beginning as a mountain spring collecting snow runoff near the Tizi-n-Tichka pass before flowing southwest, eventually emptying out into the Atlantic Ocean over a course of nearly 250 kilometers. A number of smaller tributaries feed into the Tansift—the Ourika, the Chichaoua, and the N'Fiss—which also originate as mountain streams, creating a delicate network of waterways spreading out from the mountains into the basin below. However, the inconsistent nature of these wadis—the water flow is irregular at best, and the Tansift often dries up completely during long summers—creates an unreliable landscape. Rainfall here is rare, and snowmelt from the mountains permeates only the uppermost layers of the soil, making long-term agricultural efforts beyond seasonal herding extremely difficult.[1] Though the nearby mountains remain snow-capped eight months out of the year, the basin vacillates between mild winters and extreme summers, with temperatures regularly exceeding 40°C, exacerbating already harsh conditions. Mirages across the extreme flatness of the plain, provoked by dust and the wavering distortion of the air in the heat, play optical tricks that alternatively bring the mountains closer and then push them away.

This is the Haouz Basin, home to the capital city of two dynasties that fundamentally altered the social, cultural, and political landscape of the medieval Maghrib. The earlier Almoravids, rooted in the Saharan Sanhaja (who constituted the majority of their ranks), were newcomers to this region and faced significant challenges in establishing Marrakesh as their capital. Why settle in an inland basin far away from any pre-existing major urban settlement, in a landscape that, at best, only tolerated human occupation? And how is it that their capital would become the epicenter for radical social, religious, and cultural change?

The physical outlines of Marrakesh's earliest form are blurry, a result of continuous inhabitation and the active erasure of Almoravid monuments by later dynasties (not least under the Almohads). However, by supplementing the archaeological and architectural remains with historical description and comparative analyses, a complex if imperfect picture emerges of a city at odds with its own polarity. Bounded by high walls that both constrained and defined an urban space still in flux, Almoravid Marrakesh appears both chaotic and calculated in plan. Many of the dynasty's primary foundations appear to have been either haphazard responses to external problems or calculated projects whose completion was never fully realized. That is not to say that the Almoravids were not

consciously attempting to create a capital city for their empire, but rather that what this capital was meant to do on a grander scale changed so rapidly that its physical manifestation bore the evidence of these sharp changes. Directing these shifting definitions and expectations of urban space were legal and philosophical debates governing how a city was to be defined, what was required to care for its community, and even how those communal relationships were to be negotiated. The urban fabric of the mid-eleventh through early twelfth century reveals these shifts as they occurred and thus serves as an important source for understanding the life of the city and the spread of urbanism throughout the Maghrib.

These debates are most apparent through two major themes of Almoravid life within the city. The first is the role of a wall system in alternately defining and constricting urban space, an act with consequences for legal and religious provisions. Once defined as a city (*madīna*), a designation often inextricably linked to the use of walls, the urban space was required to provide a congregational mosque (*masjid al-jāmiʿ*) that could house the entirety of the city's faithful. Rooted in a particular stipulation of Maliki law that severely discouraged the presence of more than one congregational mosque, the presence of a congregational mosque at the heart of the Almoravid city left little space for a formalized relationship between the spiritual center and the political one. The Almoravid palace was thus relegated to the southwestern quadrant of the walled city, and a warren of shops and houses appears to have sprung up in both vernacular and constructed iterations around it, obscuring any performative expanse between the two nodes of Almoravid power. The impression of impregnability and stolidity in Marrakesh's walls would ultimately prove to be an insurmountable issue for the Almoravid elite, whose need to maintain

a delicate balance between authoritative rulership and egalitarian principles was undermined by the conditions of city life in close proximity. The second theme grows out of this problem: that of ceremony and accessibility to the elite. This issue is familiar to historians of urbanism in the Islamic world. Baghdad, Cairo, and Madinat al-Zahraʾ are some of the best known and widely studied examples of dynastic relationships with urban space, and Amira Bennison has even detailed this discourse at Marrakesh under both the Almoravids and Almohads.[2] However, it must be acknowledged that these themes are intertwined, each mutually reinforcing the other's effects on urban modalities and the broader societal perspective on the Almoravids' role as a dynasty of Sanhaja origin. How urban space is approached, utilized, and mythologized poses deeply important questions for this community, integrating them into a long history of Arabized urbanization in the Maghrib while simultaneously interrogating the dynamics inherent in that process.

As the founders and early builders of Marrakesh, the Almoravids would be expected to respond to these questions, and yet the discernible remnants of the Almoravid city reveal few clear answers. Instead, the Almoravids took an ad hoc approach to urban needs as they arose, reflecting the fluctuating relationships among the dynasty, the capital city, and the surrounding tribal communities. This is not to suggest that the Almoravids were unsophisticated in their architecture—on the contrary, the existing structures and remnants suggest otherwise, characterized as they are by a rich ornamental schema and varied materiality. Yet the networks between these structures are frequently at functional and symbolic odds with one another. It is this lack of cohesive communication that Ibn Tumart would gesture toward in his criticisms of

the dynasty, criticisms frequently framed by an urban context. Without rejecting their obvious moral and propagandistic facets, these critiques also reveal a subtle and seemingly paradoxical relationship between authority, identity, and urbanism in the Maghribi sphere. Urban space, understood as a microcosm of society as a whole, needed to simultaneously reflect the principles of the ruler at its head and communicate those principles in a clear, direct manner. In the case of the Almoravids, whose social habits were too distinct from those of many of their capital's inhabitants despite their moralizing rhetoric, the city became a fragile and inherently unstable expression of a failed synthesis between the two. Ultimately, the questions raised by the Almoravid experiment are ones that, in turn, would be addressed under the Almohads (as discussed in chapter 2).

In order to understand Marrakesh's origins under the Almoravid dynasty, we have to look at the geopolitical circumstances that made the Haouz Basin such a strategic base for the nascent empire. In 1058, the Almoravids—then led by founder and Maliki theologian ʿAbd Allah ibn Yasin (d. 1059) and the chief of the Lamtuna tribe, Abu Bakr ibn ʿUmar (d. 1087)—negotiated a truce with the Masmuda tribes to cross through their homeland, the treacherous Atlas mountain passes.[3] The two groups looked to make common cause against the Zenata Berbers who controlled Fez and were effectively the guardians of land extending into the central Maghrib, a key bottleneck in connecting sub-Saharan trade routes to the Mediterranean. To establish their foothold in the Haouz, the Almoravid forces lay siege to Aghmat, a commercial center located in the Atlas foothills along the Wadi Ourika. The town was likely the most substantial settlement in the region prior to the founding of Marrakesh, and though archaeological excavations have yet

to reveal the extent of this town's pre-Almoravid built fabric, historical sources confirm that it was sufficiently large and wealthy enough to attract migrants fleeing political upheaval in al-Andalus and the eastern part of North Africa (known as Ifriqiya in the medieval period) and a substantial Jewish population as well.[4] The siege was short, resolved through negotiations with the local nobles who represented the two branches of the Masmuda that occupied Aghmat, the Warika (from which the nearby wadi takes its name) and the Haylana. There followed a period of about a decade marked by intense negotiations in which it became clear that the Almoravids intended to settle in Aghmat, not merely to garrison their troops there, which would put a substantial strain on the town's infrastructure and resources. Sometime between 1062 and 1072, the effort became too great to sustain, and the local representatives of the Warika and Haylana asked the Almoravids to settle elsewhere. Naturally, such a request must have been phrased more politely, and as it forms part of the foundation legend of Marrakesh, medieval historians have mythologized the transition from one city to the other, transforming it into a divinely ordained moment reminiscent of the Prophet Muhammad's move from Mecca to Medina. Having confessed to Abu Bakr ibn ʿUmar that Aghmat could no longer garrison the Almoravid forces, the local tribes offered him a plot of land between the tribes' territories, one apparently uninhabited except for "a few ostriches and colocynth plants, and therefore suitable for desert nomads."[5]

The historian Ibn ʿIdhari (d. after 1312) dates the foundation of Marrakesh to 1070 and depicts Abu Bakr ibn ʿUmar as toiling alongside the common laborer to erect his fortress, referred to as the Qasr al-Hajar (Palace of Stone), but a far more intriguing and unusual figure is his wife Zaynab (d. 1075).[6] The sources vary on Zaynab's

patronymic, alternately assigning her to the Nafzawi or the Hawwari clan, but both tribes were notable subsidiaries of the Masmuda, known for their adherence to Kharijite Islam. Described by Ibn ʿIdhari as a sorceress in league with the jinn, those liminal occult creatures of smokeless flame, it is more likely that Zaynab was a wealthy widow of independent means who married Abu Bakr ibn ʿUmar as part of the consolidation of Almoravid forces and the Aghmat elite.[7] In 1071, before leaving Marrakesh to combat an insurrection in Sijilmasa—and perhaps having some premonition of his own death—Abu Bakr ibn ʿUmar divorced Zaynab and left Marrakesh in the hands of his cousin and second-in-command Yusuf ibn Tashfin (d. 1106), on the condition that he marry Zaynab after the legal waiting period had passed.[8] Thus, the wealth of a prominent woman with local ties was put into the hands of the Almoravid emir who would outline much of the urban fabric of pre-Almohad Marrakesh. The authenticity or historicity of these narratives has been much debated elsewhere; the major significance of Zaynab's story here is that it reflects the process of negotiation that brought the Almoravids into the Haouz Basin. The role of the Masmuda tribes, personified in the figure of Zaynab, indicates that the Almoravid empire was won through alliance as much as military conquest, undermining Almohad and post-Almohad historians' depictions of an exaggeratedly violent regime.[9] These narratives also inextricably tie the Masmuda to the founding of Marrakesh, despite the Lamtuna origins of Abu Bakr ibn ʿUmar, Yusuf ibn Tashfin, and the Almoravids more generally. The siting of Marrakesh embeds the city within Masmuda, not Lamtuna, territory; though ostensibly on unoccupied land, its location between two Masmuda tribes and its proximity to the more established Aghmat, also a Masmuda stronghold,

predicate a relationship between Marrakesh and the tribe. It was in all likelihood Zaynab's fortune that contributed to Marrakesh's earliest foundations, and her appearance in Maghribi histories as an active political partner to both of her Almoravid husbands accentuates her connection to this formative moment in the nascent empire.[10] Furthermore, scholars such as Allen Fromherz have gone so far as to characterize Zaynab's involvement with the construction of Marrakesh as indicative of a connection in the Almoravid mindset between the *madīna* and a form of decadent femininity, exemplified through Abu Bakr ibn ʿUmar's concerns that Zaynab would not survive his desert campaigns due to the harsh climate.[11]

There is an evident discomfort with the concept of permanent settlement for the early Almoravids, one that is negotiated through their affiliation with the local Masmuda, who exhibited an established tradition of settled habitation and who would go on to form the core of the later Almohad movement. That the two points are linked through a tribal tradition is no accident and will be revisited in the next chapter. The Almoravid reliance on Masmuda support is evident in the physical form of early Marrakesh, which appears to have been little more than an exaggerated campsite under Abu Bakr ibn ʿUmar despite the construction of the Qasr al-Hajar, though Jacques Meunié's excavations suggest that even this structure should be attributed to Yusuf ibn Tashfin.[12] Following Lamtuna custom, most of early Marrakesh was populated by tents and surrounded by temporary, low-lying fortifications. Meanwhile, the Atlas-dwelling Masmuda erected mud-brick houses, in keeping with their own transhumant traditions, creating a combination of temporary and vernacular architecture. As described by Ronald Messier, "It was a curious juxtaposition

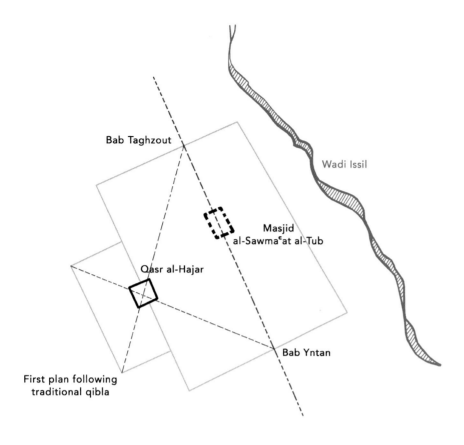

Bab Taghzout

Wadi Issil

Masjid
al-Sawmaᶜat al-Tub

Qasr al-Hajar

Bab Yntan

First plan following
traditional qibla

FIGURE 8
First plan of Marrakesh with its
original orientation. After Quentin
Wilbaux, *La médina de Marrakech:
Formation des espaces urbains d'une
ancienne capital du Maroc* (Paris:
L'Harmattan, 2001), 231.

power—the Qasr al-Hajar earthly, the mosque divine—the Almoravids put themselves on public display in the act of moving from one center to the other, positioning themselves as first among equals rather than as the guardians of a mysterious higher power.[16] This allowed them to at least pretend to lay claim to the egalitarian principles woven through Berber clan relationships and may have had its roots in the ideology espoused under the second "Rightly Guided" caliph, ʿUmar ibn al-Khattab (r. 634–44), who warned against abandoning tribal traditions in favor of permanent settlement during the early Islamic expansion campaigns.[17] The Arabs who settled in early Kufa and Basra under ʿUmar were instructed that "no one [may build] more than three rooms for himself and do not let anyone build higher houses than the other."[18] While this practice ostensibly maintained communal unity—an integral component for the early Islamic campaigns in which an Arab minority was thinly spread across the Arabian Peninsula and Levant—it had the secondary effect of setting the faithful apart from the conquered through their building practices, establishing an innate "foreignness" separating the conquered and the conquerors. A similar dynamic emerged in the early stages of Almoravid Marrakesh, albeit along tribal lines, with the area around the Qasr al-Hajar reserved for those with Lamtuna affiliation.[19] However, this relationship was not static and, as shall be explored later, Ibn Tumart would later take issue with the Almoravids' accessibility to the general public.

NODES OF POWER: THE QASR AL-HAJAR, MASJID AL-SAWMAᶜAT AL-TUB, AND THE MASJID AL-SIQAYA

As noted above, the early structure of Marrakesh was largely a mix of temporary tented structures and the vernacular mud-brick or

of the semi-sedentary becoming nomadic and the semi-nomadic becoming sedentary."[13] As the empire consolidated, the Almoravids established a more permanent presence in Marrakesh; Yusuf ibn Tashfin built a congregational mosque with a rammed earth minaret (*masjid ṣawmaʿat al-ṭūb*) in the city's northeastern quarter, creating a duocentric urban plan with the Qasr al-Hajar in the southwest, but the majority of the private dwellings remained ephemeral or rudimentary (fig. 8).[14] The result was a diffuse town with little by way of a formal plan, possibly due to the Almoravids' limited urban experience, which may have favored a haphazard and practical approach (albeit one couched in pious logic).[15] By separating the two centers of

pisé construction of Masmuda houses. In a city whose provisionality could literally be seen in its physical construction, the sole impression of permanence came from Abu Bakr ibn ʿUmar's multifunctional residence, treasury, and de facto storage facility known as the Qasr al-Hajar, or Palace of Stone. Stone was a scarce resource in the Haouz Basin, *pisé* being cheaper, more widely available, and requiring less labor. The material for Abu Bakr ibn ʿUmar's royal residence therefore required significant resources for its extraction and in its use. Al-Idrisi notes that the stone came from the hills north of the city, now known as the Djebilets (but to which al-Idrisi refers as Idjiliz).[20] The extant remnants of the palace—the southeastern angle of its fortification—reveal infill construction, with inner and outer stone masonry filled with rammed red clay, a construction technique that may have been of sub-Saharan origin, according to archaeologist Hamid Triki.[21] Durable and efficient in moderating the extreme summers in the Haouz, this method indicates at least some familiarity with stone construction, even if it was only reserved for this singular structure while the rest of the Almoravid elites constructed residences from *pisé* for their families and retainers.[22]

According to Meunié's excavations, the southern façade of the palace measured 218 meters in length, indicating quite a large palace for the size of the city in Abu Bakr ibn ʿUmar's day, and it likely formed a typical quadrangular structure.[23] Evidence remains of a monumental doorway on the western face of the structure, roughly in line with what would eventually become the city gate known as the Dar al-Makhzan. Immediately through this entrance, one entered a hallway with a lateral staircase leading to an enclosed room on the exterior side of the wall (presumably for defensive purposes) as well as a circular pathway providing access around this chamber.

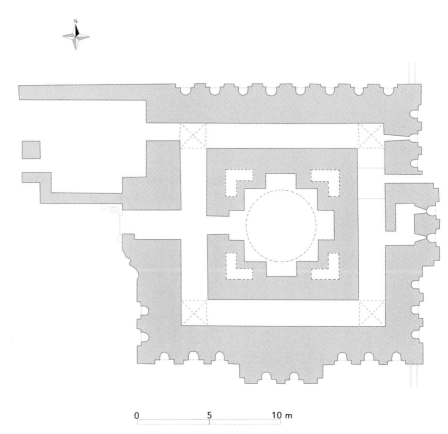

Deverdun compares this structure to that of the Qasr al-Manar at the Qalat Beni Hammad in Algeria, an eleventh-century Hammadid foundation, but notes that its appearance here, in one of Abu Bakr ibn ʿUmar's constructions, makes it unique among the Almoravid fortified palaces (*qasaba*) for which we have archaeological and architectural knowledge (fig. 9).[24]

This naturally raises the question of who was responsible for introducing this form at the Qasr al-Hajar, beyond the thorny issue of intent and patronage that attributes the structure to Abu Bakr ibn ʿUmar. The presence of fortification towers, like the one described above, hints at a more sophisticated awareness of defensive architecture than might be expected from a dynasty rooted in nomadic origins. South of

FIGURE 9
Tower reconstruction at the Qasr al-Manar of the Qalat Beni Hammad. Ashley Whitt after George Marçais, reproduced in Léon Marie Eugène de Beylié, *La Kalaa des Beni-Hammad* (Paris: E. Leroux, 1909), 44, fig. 15.

the Atlas, in Sanhaja territory, the most likely candidate for architectural inspiration is Sijilmasa, the desert oasis that formed the trade link between the Saharan gold trade and the interior of Ifriqiya. Deverdun suggests the potential for architectural similarity between Sijilmasa and Qalat Beni Hammad based on the trade routes between the former and the metropolis of Kairouan, circumstances that could provide for the movement of architectural knowledge as well as trade. And yet contemporary excavations at Sijilmasa have not revealed any stone structures of a sort similar to either the fortified *qaṣr* at Qalat Beni Hammad or the Qasr al-Hajar. The remnants of Sijilmasa are primarily mud brick, crafted from local clay in an environment without much recourse to stone quarrying. There is evidence in the suburban Suq ben Akla of a lime pit for making mortar, but it is generally accepted that this was primarily used in the construction of significant waterworks to provide much-needed irrigation to this desert city.[25] In the absence of an architectural or archaeological comparison at Sijilmasa, the construction of the Qasr al-Hajar remains an open question, but it is important to recognize that its plan and likely sophistication speak to a site that was considered vital to the security and authority of the Almoravid elite.

In addition to the singularity of its construction materials, the Qasr al-Hajar also stood out from the early form of the *madīna* with its position in the southwestern quadrant of the city, distinctly separated from the city center, which was occupied by the Almoravid congregational mosque. Though not the first monument built within the walls of Marrakesh, a congregational mosque was nevertheless a key site for the creation of a truly urban space. As described by Deverdun, early Marrakesh was "semi-sedentary, semi nomadic [in nature], where

the exercise of religion was for some time the sole urban fact, and likewise the only excuse for the nomad to become sedentary."[26] Built out of *pisé*, the mosque was known in the Arabic sources as the Masjid al-Sawmaʿat al-Tub in reference to the use of sun-dried mud brick in the construction of the mosque's minaret, which was likely the site's defining feature. Beyond this fact, there is little concrete evidence to describe the site, as it was destroyed within a single generation in favor of a more luxurious mosque befitting the Almoravid capital. Much of what can be gleaned about the mosque comes from the distinctions made between it and its successor in the sources. Its relationship to this latter mosque is noteworthy, but first we must understand the nature of, and the narrative surrounding, the first mosque's construction.

According to Ibn Abi Zarʿ's (d. 1310) *Rawḍ al-qirṭās*, the mosque was constructed under Yusuf ibn Tashfin after he was left in charge of the city by his cousin Abu Bakr ibn ʿUmar. In a narrative that directly references Ibn Hisham's description of the life of the Prophet Muhammad, Yusuf ibn Tashfin was personally involved in the construction of the mosque, hoping to "incite others to do likewise."[27] It was most likely hypostyle in plan, and it is also reasonable to assume that the mosque was constructed using *pisé* rather than mud brick, the form of earthen architecture most prevalent in the pre-Saharan region prior to the establishment of the Almoravids as a political *force majeure*. As such, the *pisé* technique was likely the construction form with which the Sanhaja would have been most familiar, outside of their own preferences for tented habitations. In general, *pisé* structures were formed on a foundation of stone, mud brick, or rubble extending to a height of approximately ten to twenty centimeters above ground level, which would help secure the walls against the

risk of collapse from damp. On top of this base, a combination of gravelly sand mixed with a small amount of clay (in a roughly 3:1 ratio) was packed within a wooden formwork held together by portable wooden struts. The most common type of formwork was the so-called climbing formwork, which could be moved up and along the wall as the structure took shape (fig. 10). As the wooden struts are removed to shift along with the climbing formwork, they leave behind the telltale putlog holes that can later be used for scaffolding, such as those seen at Sijilmasa and, indeed, in the city walls of Marrakesh (fig. 11).[28] With this method, buildings were cheap to produce, quick to construct, and, if made correctly and with the right proportions, highly durable against erosion. Indeed, the most expensive part of *pisé* construction is the formwork, which could be reused not only as the building progressed but in the construction of multiple buildings.[29] Certainly, this method was cheaper and faster than the process of digging clay, tempering it, and molding it into mud bricks. Labor figures (albeit from later sources) indicate that two or three laborers could build between 1.5 and 2.3 cubic meters of *pisé* walling in a day, while a similar number of workers would require the same amount of time merely to shape the bricks needed for a comparative volume of walling.[30] Mud brick was likely reserved for the minaret, whose height and more slender profile would have required a more stable structural technique.

Taking these figures into account, it is reasonable to assume that the Masjid al-Sawmaʿat al-Tub was built relatively quickly, efficiently, and cheaply, though we should perhaps reserve judgment on Yusuf ibn Tashfin's direct involvement. In using techniques already familiar to the Sanhaja and the other tribal confederations that made up the Almoravid army, the early architects of Marrakesh established a foundation (both

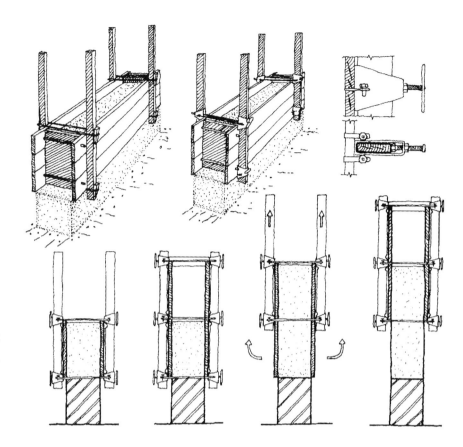

literal and figurative) that connected the new city with a longer Maghribi tradition, as has been well attested by classical and medieval authors.[31] This connection should also be extended to the other significant feature of the mosque: its qibla direction. And here is where we must retrospectively reach some conclusions about the earlier Almoravid mosque based on the evidence of its latter iteration, which has itself succumbed to the abuse of time and neglect, primarily thanks to the later Almohad interventions at Marrakesh. As Quentin Wilbaux has demonstrated, the earlier mosque was likely oriented toward the southeast, deriving an approximate qibla direction (known as *jiha* in the legal literature) that was set following precedent (*taqlīd*) rather than mathematical calculation.[32] Following the rising

FIGURE 10
Climbing formwork. After Gernot Minke, *Building with Earth: Design and Technology of a Sustainable Architecture* (Basel: Birkhäuser, 2022), 51, fig. 5.3.

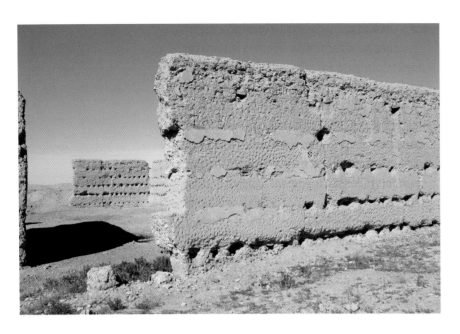

FIGURE 11
Pisé walls at Sijilmasa. Photo: author.

point of the star known as Suhayl (Canopus), this orientation was widely used in the Maghrib and al-Andalus at prominent sites in Fez, Córdoba, and Sijilmasa to facilitate ease of prayer.[33] However, upon the demolition of the Masjid al-Sawmaʿat al-Tub under Yusuf ibn Tashfin's son and successor, ʿAli ibn Yusuf (d. 1145), the qibla direction was changed to a more easterly one, as embodied by ʿAli's foundation of the Masjid al-Siqaya (Mosque of the Fountain).

So named for the elaborate marble fountain that once stood in its courtyard, the Masjid al-Siqaya appears to have been a more elaborate and expensive structure not only in terms of materiality but also in the preparations and planning that went into its construction. ʿAli ibn Yusuf's non-nomadic origins—he was raised in the city of Ceuta, his mother an Iberian Christian concubine—have opened the gates to speculation over Andalusi and Abbasid influences in the projects that bear his name. Certainly the construction of the Masjid al-Siqaya suggests this, as ʿAli begins the process not by getting

his hands dirty (à la his father at the earthen mosque) but by inviting a number of jurists and astronomers from al-Andalus to Marrakesh in order to debate the issue of the qibla. The southern orientation had already been openly criticized by contemporary Maghribi jurists such as Abu ʿAli al-Mittiji, who argued that faulty *taqlīd* had led to this misalignment, thereby voiding the use of *jiha* rather than the precise direction (or *samt*).[34] ʿAli's scholarly conference was intended to address this critique, and in 1126, they met to discuss the issue. Among these scholars was the eminent Ibn Rushd al-Jadd (d. 1126, only a few months after this meeting), grandfather to the more famous Andalusi polymath and a prominent Maliki jurist in his own right. His inclusion in this group is not surprising; it has been well established that the elder Ibn Rushd was an intimate advisor on legal as well as political matters to ʿAli ibn Yusuf, who referred to his opinions on a number of occasions.[35] In this matter, the proposed orientation of the new mosque was determined by the point of the sunrise at the winter solstice, approximately 110 degrees, which corresponded to the method and orientation of the Great Mosque at Kairouan and was in accordance with the practice of the Companions of the Prophet.[36]

Of the two Almoravid-era mosques, neither the Masjid al-Sawmaʿat al-Tub nor the Masjid al-Siqaya remains extant after the Almohad interventions at Marrakesh. The calculation for their respective qibla directions is taken from the historical sources, with the exception of two archaeological remnants that ground this analysis in the physical realm. The first and most legible of these comprises the remains of the minaret from the Masjid al-Siqaya, now folded into the complex known as the Ben Youssef Mosque. Confusingly, this mosque dates to the nineteenth century, and though it retains the

Almoravid association in name, it was in fact commissioned by the ʿAlawid sultan Moulay Slimane (r. 1792–1822). The remains of the minaret were excavated by Gaston Deverdun and Charles Allain in 1950 and published in *Hespéris-Tamuda* in 1961. In their analysis, Deverdun and Allain demonstrate that the Almoravid-era minaret was situated along the northwest side of the original mosque, likely folded within the frame of the *sahn*, or courtyard (fig. 12). Building on the standard hypostyle form with the minaret diametrically opposite the qibla wall, the Masjid al-Siqaya can reliably be said to have a distinctly eastern orientation of 110 degrees.[37]

The second piece of archaeological evidence is found in the ambiguous form of the Qubbat al-Barudiyyin, the domed structure that stands to the south of the proposed outline of the Masjid al-Siqaya described above (fig. 13). As the sole remaining edifice from Almoravid-period Marrakesh with any extensive ornamental evidence, the Qubbat al-Barudiyyin has drawn the attention of scholars largely because of its interior stucco decoration, a lavish display of floral scrollwork, muqarnas, and sharply defined arches. It is rectangular in shape, measuring 7.3 meters long by 5.5 meters wide, with four large pillars at each corner supporting the bulk of the structure. On its latitudinal sides (the wider ones), two twin pointed horseshoe arches are supported by a slender rectangular pier, while each shorter side is framed by a polylobed arch. On all four sides, the arches are framed by a simple alfiz—an architectonic rectangular panel of molding that encloses the outer edge of an arch, a common feature of western Islamic architectural ornament—which is then topped by a second story of clerestory windows, five along the longer sides and three on each of the shorter ones. These windows are alternating in style— a polylobed arched window stands at the center,

Present-day minaret
Almoravid minaret
19th-century mosque
Saʿadian madrasa
Almoravid fountain
Qubbat al-Barudiyyin

Legend
—— Archaeologically attested remnants
---- Hypothetical plan

framed either by a horseshoe arch or by a curtailed form of geometric lambrequin arch, each of which is again enclosed within an alfiz. A band of stepped merlons tops this tier and frames the dome (*qubba*), whose exterior is decorated with a ribbed chevron design. The geometrically organized exterior stands in contrast to the highly floriated scheme of the *qubba*'s interior, where the cornice bears evidence of a dedicatory inscription and above which the cupola bears the majority of surface decoration (fig. 14). Eight pendentives support the cupola, which is smaller than the exterior dome and clearly not load-bearing, while the spaces between the pendentives form highly articulated lambrequin arches. Between the four exterior corners of the structure and the pendentives themselves are four muqarnas squinches. Floral stucco work interspersed with shell motifs

FIGURE 12
Hypothetical reconstruction of ʿAli ibn Yusuf's mosque. Ashley Whitt after Gaston Deverdun and Charles Allain, "Le minaret almoravide de la mosquée Ben Youssef à Marrakech," *Hespéris-Tamuda* 2 (1961), plate 3.

FIGURE 13
Exterior view of the Almoravid Qub-
bat al-Barudiyyin. Photo: author.

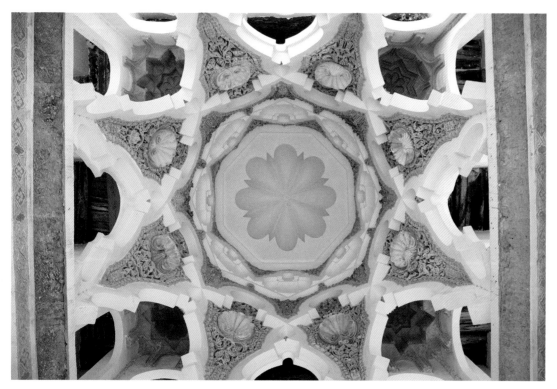

FIGURE 14
Interior view of the Qubbat al-Barudiyyin's cupola. Photo: author.

decorates the pendentives, which support a seven-petaled, rosette-shaped dome.

The *qubba*'s ornamental program not only serves as the primary example of Almoravid decoration but also indicates the lavishness of the program for a structure that seems to be missing its larger architectural framework. The Qubbat al-Barudiyyin has long been associated with a fountain or well, acting as a monumental kiosk sheltering access to water, thanks to the system of clay pipes connecting it to a cistern about ten meters toward the northeast. Whether it was a freestanding structure or one attendant to a mosque or madrasa, though, has been unclear. Because the dedicatory inscription was defaced as part of the Almohad program of anti-Almoravid demolition, it is difficult even to precisely date the *qubba*'s construction, which has significant implications for its purpose and placement. It is too far south from the remnants of the Masjid al-Siqaya—twenty-five meters south of the qibla wall—and in the wrong location to have served as that mosque's ablution fountain. The same holds true for Yusuf ibn Tashfin's mosque as well; even with the adjusted qibla direction, the *qubba* would have been squarely within the prayer hall itself rather than in the courtyard, as would have been expected. Moreover, the lavish ornamental scheme and building material—earthen brick covered in plaster rather than *pisé*—is at odds with the historical descriptions of the Masjid al-Sawma'at al-Tub. Yasser Tabbaa has suggested that the Qubbat al-Barudiyyin might have served a

commemorative function, celebrating the completion of Yusuf ibn Tashfin's hydraulic works, which brought water into the city.[38] The ambiguity of this attribution hints at the uneven nature of the Almoravid architectural program, in which the most elite spaces appear at material odds with their central role while isolated structures, such as the Qubbat al-Barudiyyin, bring an element of luxuriousness into the public domain. While it should certainly be acknowledged that there are scant remains upon which to make such a definitive statement on behalf of the dynasty's artistic and architectural styles as a whole, this apparent ambiguity is echoed in concerns over the larger network of urban associations in Almoravid Marrakesh, as will be discussed presently.

THE LEGAL AND SPATIAL PROBLEM OF ALMORAVID WALLS

What is clear from the discussion above is that early Marrakesh exhibited a haphazard plan at best, marked by governmental and religious centers but little else by way of an overarching urban morphology representative of a singular architectural vision. Rather, each Almoravid generation appears engaged with making serious adjustments to the work of the prior one, whether that be the replacement of the congregational mosque or the expansion of the city's waterworks. But one of the most significant contributions to Marrakesh was ʿAli ibn Yusuf's decision to turn Abu Bakr ibn ʿUmar's temporary fortifications into more substantial, permanent ones, and even this project is less straightforward than it first appears. As indicated above, the replacement of Yusuf ibn Tashfin's earthen mosque with his son's more elaborate and reoriented Masjid al-Siqaya not only held implications for juridical precedents regarding the direction of prayer but also significantly affected the larger plan for the city. As has been

demonstrated by Quentin Wilbaux and Mehdi Ghouirgate, the actual outline of Marrakesh's city walls reflects an unintentional haphazardness that likely originates from the timeline of the city's congregational mosque changeover. Arabic sources present conflicting information as to who was actually responsible for the city walls' construction; for example, Ibn Sammak in his *Ḥulal al-mawshiyya* (The embroidered robes) attributes this act to ʿAli ibn Yusuf at the suggestion of Ibn Rushd al-Jadd, who had recently escaped an embattled Granada and witnessed the effectiveness of monumental walls in protecting the city during siege.[39] By this point, the Almoravids were facing increasing incursions from the Atlas Mountains, as the nascent Almohad movement had begun directing its energies toward Marrakesh. However, in his history Ibn Khaldun asserts that the city walls were already well underway by this point: "Yusuf [b. Tashfin] traced the foundations of the city of Marrakesh in the year 454 (1062). There were already long-standing [established?] [areas of] tents and he constructed the wall around the mosque and a small fort designed to protect his property and his army. The fortification and the walls were then completed after him under his son in the year 524 (1130)."[40]

Rather than dispute the veracity of the medieval sources, it is perhaps more enlightening to understand them as reflective of a multistage process, simultaneously responding to different geopolitical stimuli and incorporating a shifting urban landscape. Looking at Marrakesh's system of walls in this context explains their orientation and shape not only as the result of dynastic transition between Yusuf ibn Tashfin and ʿAli ibn Yusuf but as the physical manifestation of the debates surrounding the qibla and the role of the congregational mosque in the city. In its first stage, under Yusuf ibn Tashfin's direction,

the fortifications outlining the city were in alignment with the original Almoravid mosque—the Masjid al-Sawmaʿat al-Tub—as can be determined through the placement of certain city gates (see fig. 8). The extant Bab Taghzout can be found along the northwest side of the twelfth-century walls, aligning with the proposed hypothetical axis of the earlier Almoravid foundation. Bab Fez and Bab Dukkala, however, are also found along this same northwestern wall; the somewhat awkward arrangement creates three major gates in relatively close proximity. The latter two gates likely date from the reign of ʿAli ibn Yusuf, as they stem from the axial alignment of Masjid al-Siqaya, which, as discussed above, had an adjusted qibla of 110 degrees.

The arrangement of these gates helps explain the idiosyncratic form of Marrakesh's early contours. Following Ibn Khaldun's attestation that the walls were constructed in two parts, Wilbaux proposes that it is this midway shift in qibla alignment that throws off the underlying logic of Yusuf ibn Tashfin's original plan (fig. 15).[41] The Masjid al-Sawmaʿat al-Tub and the Qasr al-Hajar formed the two major poles of the early Almoravid city, one social and spiritual, the other military and political. The remnants of Yusuf ibn Tashfin's walls indicate a quadrangular enclosure extending to either side of the Bab Taghzout along the northwest wall (though only the more easterly portion of this wall remains) and along the axis of the Bab Yntan in the southeast. Along the southwest side of the city, the linear axis of the city wall is disrupted in order to enclose the Qasr al-Hajar, while the easternmost edge of the city may have relied on the Wadi Issil for protection, rather than built fortifications. At some point, however, work on this construction was halted until the reign of ʿAli ibn Yusuf, at which point the qibla had been adjusted and we see a new morphology

taking shape. The latter version of the city plan positions city gates near the corners—the aforementioned Bab Dukkala and Bab Fez along the northwest face, and Bab Nefis and Bab Aylen along the southern façades. Each of these gates is aligned with the perpendicular axes of the proposed qibla established at the Masjid al-Siqaya after 1126. What this indicates is that the city's form was not entirely governed by concerns of population density, topography, or even defense. Rather, there is a religiopolitical ideology underwriting the very contours of the Almoravid capital, one that indicates shifting concerns about the qibla and, by extension, the role of the congregational mosque within an urban social conceptualization.

Thus, it was not until sometime after this that a wall system fully circumscribed

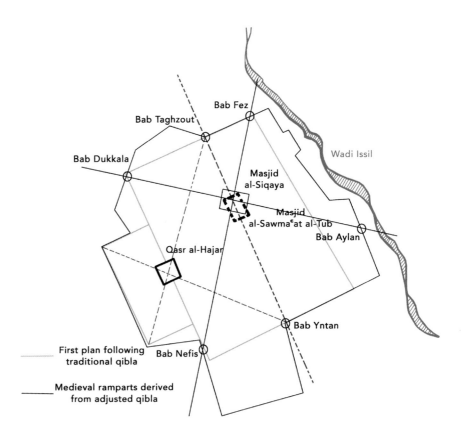

FIGURE 15
Plan of Marrakesh's city walls in two phases, following the adjusted qibla direction of the congregational mosques. After Quentin Wilbaux, *La médina de Marrakech: Formation des espaces urbains d'une ancienne capital du Maroc* (Paris: L'Harmattan, 2002), 235.

Marrakesh's boundaries, by then incorporating a number of ʿAli ibn Yusuf's other architectural and urban contributions, which included elite residences, private gardens, and a hydraulic system. The walls were constructed from the same red-hued *pisé* in what was likely a similar mode of construction to Yusuf ibn Tashfin's rammed-earth mosque. Locally available material facilitated the walls' rapid construction: they were completed within just eight months. They ran in a nine-kilometer circumference around the city and were two meters deep on average along their length, expanding out into a series of towers between eight and fourteen meters deep at regular intervals. Their height, just over six meters tall, was exaggerated by a large ditch that would have rimmed the exterior. These elements combined to give the city a sense of impregnability, a fortified citadel again reminiscent of the Atlas Mountains and pre-Saharan *qaṣr*s (fortified castles) in its trapezoidal shape and use of locally available materials. Although little of the Almoravid urban fabric remains due to the systematic program of closure or destruction that marked the Almohad transition after 1147, it is reasonable to assume that the Almoravid city was largely contained within these walls. Their construction during the rise of Ibn Tumart and his movement, and the increasingly grave threat that that movement posed to the Almoravid capital, suggests a city with little extra-urban development—and certainly none with any imperial associations.

It is curiously ironic that a hallmark of Sanhaja architecture—inasmuch as one can define it—can be tied to an external threat rather than to an effort at reconstituting elements of a familiar style in a new urban landscape. While there is little extant architectural evidence from the medieval pre-Sahara and Sahara, it is generally accepted that the rammed-earth *qaṣaba* and

*qaṣr*s that litter southern Morocco have their roots in pre-Islamic antiquity and thereby may have served as precedents for Almoravid settlement.[42] Al-Bakri (d. after 1295) also describes Saharan cities like Azuggi and Awdaghust—both in present-day Mauritania and both now in ruins—that would have been familiar to the Almoravids as towns that were large enough for several mosques and had high walls, expressing the preferences of the Zenata Berbers and Arab merchants who settled there.[43] Without wishing to make a direct comparison with any one particular site, it should be enough to emphasize here that such sites are built for fortification; the constant threat of attack, and the need to protect valuable infrastructural resources, necessitated the clear boundaries established by wall systems. That Marrakesh remained unwalled for so long, despite the Almoravids' exposure to these urban and architectural typologies, is remarkable.

The problem posed by wall systems as definitional spaces, particularly in their relation to the *masjid al-jami*ʿ, was part of a debate that dated back to the initial Islamic conquests, with the foundation and expansion of urban settlements in the eighth-century Maghrib. Fez, for example, functioned as a bifurcated city from its inception, with the eastern and western halves of the city separated by the Wadi Bou Khareb, which posed challenges to the practicalities of daily life. According to al-Jaznaʾi's fourteenth-century history of Fez, *Zahrat al-ās* (The myrtle flower), the legendary founder Idris II (d. 828) paid careful attention to the ability of each riverbank to support its inhabitants, assessing air quality, soil, prevailing winds, water conditions, and defensibility.[44] Only afterward, in 809, was the layout of the city confirmed, with each bank receiving a number of gates and walls, though notably not as a singular enclosure. Idris II then

sponsored two congregational mosques: the right bank housed the Masjid al-Ashyakh (the Mosque of the Shaykhs), while the left bank had the Masjid al-Shurafaʾ (the Mosque of the Sharifs), which was attached to the royal residence. Évariste Lévi-Provençal, however, has convincingly argued that Fez was founded in two parts: the first, Madinat Fas, was established under Idris I in 789 along the river's right bank and the second, functioning as a royal enclosure, was sponsored by Idris II along the left bank.[45] Madinat Fas was likely the site of an earlier Berber trading settlement, while Idris II's royal quarter, al-ʿAliyya, was the site of the city's administrative functions.[46] Both of the apocryphal legends surrounding Fez's foundations, as well as the scholarly explorations of the topic, suggest that the two banks of the Wadi Bou Khareb were considered separate urban entities from the very beginning, informed by their topography and the ease with which their Muslim inhabitants could attend Friday prayer. Furthermore, the city's bifurcation established a social hierarchy between the two riverbanks, embodied by their separate mosques, that formalized the relationship between the Idrisids and their subjects. This distinction, as much sociological as morphological, would prove elusive for the Almoravids at Fez as well as in their own capital of Marrakesh, thanks to urban projects that fundamentally misunderstood the role such distinctions needed to play in the dynamic of authority.

Once the Almoravids had taken control of Fez, at some time in 1074 Yusuf ibn Tashfin embarked on renovations of the city, which was to become a new provincial capital overseeing the interior of Ifriqiya. He sponsored the construction of a new wall, which encircled the entirety of both developments on either side of the Wadi Bou Khareb, as well as a bridge that linked both banks of the river, effectively creating

one *madīna*. At this point, the concurrent presence of two congregational mosques would become a divisive legal issue. Maliki jurists would permit a second *masjid al-jamiʿ* in the event of excessive difficulty for its attendants, such as in a case where the river proved difficult to cross for regular prayers, on the basis of the principle "Necessity knows no law" (*al-darūrat ṭubiḥ al-maḥzūrat*).[47] According to legend, the earlier Idrisid mosques had been replaced by ninth-century structures sponsored by Maryam al-Fihri, who built the Andalusian mosque on the right embankment, and her sister Fatima, who built the Qarawiyyin mosque on the left.[48] While it is unlikely that the two mosques were intended as *masājid al-jāmiʿ* given their foundations as feminine charitable endeavors, successive additions and expansions to both mosques sponsored a sort of rivalry between them, leading to their eventual status as congregational mosques.[49] This rivalry may have been the incentive behind Yusuf ibn Tashfin's enclosure of both banks. However, the debate was still legally questioned on a regular basis well into the sixteenth century, when the Qarawiyyin mosque's role as a university and library, as well as its historical proximity to the sultan's residence and Idris II's sepulchral mosque, granted it supremacy over its sister institution.[50]

Juridical opinions on the role of the *masjid al-jamiʿ* and its relationship to the *madīna*, both as theoretical concepts and in their practical applications, reached a relative consensus on the proscription of two or more concurrent congregational places of Friday worship within the same city. This consensus has its source in the hadith transmitted by ʿAbd Allah ibn ʿUmar (d. 693), who declared that the Prophet Muhammad never accepted more than one mosque in a city, which was then interpreted by some Maliki scholars, such as Ibn Jallab (d. 988) and

'Abd al-Wahab (d. 1030), as referring to the role of the Friday prayer (ṣalāt al-jumʿa) in bringing together the Muslim community in a cohesive group in an act of collective experience. This definition is directly related to the Hanafi notion of "the all-embracing town" (al-miṣr al-jāmiʿ), which Baber Johansen describes as "the idea—seemingly implied in the term—that a town should be a comprehensive social and political entity embracing various groups, rallying different factions into one community and uniting them under one leadership."[51] Developed between the late eighth century and the early ninth century, the notion precedes that of jāmiʿ being used in reference to the Friday mosque by nearly one hundred years, and it was likely concurrent with the urbanization of what is today Iraq.[52]

In its original application, it regulated the creation of new municipal entities and a politico-religious center in larger settlements, though as these cities grew and developed a suburban fabric in addition to a more densely populated center, the concept was refined and divided into hierarchical categories.[53] Many of the outlying suburbs or townships (arbāḍ) had their own congregational mosques prior to their larger incorporation, and the question of what role these earlier mosques were to play was directly related to the expanding quarter's political dimensions. Each weekly sermon (khuṭba) held in the Friday mosque declared the town's allegiance, both through its dedication to a specific ruler and through the associated power of the collective adult male population affirming this loyalty. The khuṭba was therefore a powerful signal, magnified through the architectural medium of the masjid al-jamiʿ, to communicate legitimacy and authority.[54] However, there was a diminishing rate of return, so to speak, with the presence of multiple masājid al-jāmiʿ produced by urban expansion (as in the aforementioned case of

Fez). In smaller, less politically significant cities, the number of Friday mosques was an irrelevant question so long as the needs of the community were being met. For example, the anonymous author of the Kitāb al-istibṣār notes that nine khuṭbas were pronounced in twelfth-century Meknes, describing it in actuality as four different cities (mudun) with a number of satellite villages (qurā) and fortresses (ḥuṣūn), all of which possessed their own attendant masjid al-jamiʿ.[55] Such a plurality suggests that the profusion of congregational mosques was acceptable in cities where urban allegiance, expressed through the khuṭba, was not a significant question for their rulers. This was not the case in Fez, and similar concerns can be found in Marrakesh.

The physical, legal, and theoretical implications of building within or beyond the city walls must be understood in dialogue with the walls' flexible ambiguity as a threshold, a space of demarcation and exclusion as well as inhabitance and enclosure. The walls' organizational importance was such that numerous legal texts were devoted to governing their construction, particularly between the tenth and twelfth centuries: Muhammad ibn ʿAbd Allah al-Zubayri's (d. 989) Kitāb al-abniya (The book of buildings), ʿIsa ibn Musa ibn Ahmad ibn al-Imam's (d. 991 or 997) Kitāb al-qiḍāʾ wa nafī al-ḍarar ʿan al-afniya wa al-ṭuruq wa al-judur wa al-mabānī wa al-saḥat wa al-shajar wa al-jāmiʿ (The book of judgment and elimination of harm regarding public spaces, streets, walls, buildings, courtyards, trees, and mosques), and even Ibn Rushd al-Jadd's Kitāb al-qaḍāʾ wa al-araḍīn wa al-dūr (The book of jurisdiction, terrain, and houses), in addition to compilations of legal rulings from various jurists.[56] These texts developed a discourse that defined the role of walls through questions of ownership, privacy, maintenance, and responsibility, revealing an awareness of the spatial dimensions

of societal order. More complex than a modern two-dimensional understanding of urban space (as reflected by conceptualizations of the city as a map of architectural sites and the space between them), the medieval city consisted of a complex interweaving of spaces bound by access, knowledge, and privilege. This city is inherently relational and multivalent in its functionalities, properties that require subtly different forms of analysis in order to understand them more fully. Somaiyeh Falahat has described this model as *hezar-tu*, literally "thousand insides," a term imported from the field of Persian literature. *Hezar-tu*, she argues, acts as "a node of, or a locus for, relationships that [generate] belonging, embracing, holding within, and including."[57] These relationships are as much spatial as they are social, characterized by a sequential experience of space and the importance of thresholds as sites of liminality. In this conception, barriers are ambiguous spaces, openly visible and present yet impenetrable and deterrent. It is with this model in mind, and in light of the prominent juridical evidence from the period, that the Marrakesh of the Almoravids should be understood.

In the late eleventh- and early twelfth-century iterations of the city, the most clearly delineated spaces are created not simply by the city walls themselves but by the gates that control access and movement through them. Highly trafficked and strategically located, the gates create the first layer of demarcation from rural to urban, the initial threshold of differentiated space. Of the twelve attested gates of the Almoravid city, eight remain extant in some form or can be located with a fair degree of certainty. As discussed above, their location appears to be largely in line with first one iteration of the qibla and then another, creating a radiating network of avenues that lead, perhaps inevitably, toward the congregational mosque at the heart of the

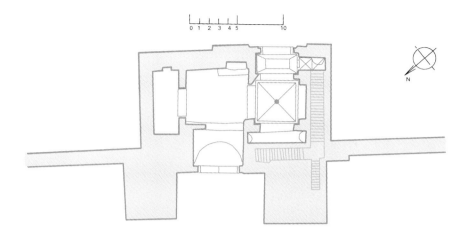

madīna. But the fact that the two-dimensional mapping of these gates and their attendant streets creates a linear and organized space does not mean that this was the phenomenological experience of the city itself in the Almoravid era. Instead, in the tradition of Islamic cosmological thought, the city (and especially cities in the Maghrib, and Marrakesh in particular) becomes a universe in miniature, with all of nature and civilization contained therein orbiting the mosque at its heart.[58] The gates, therefore, form the dialogic spaces in which one negotiates a metaphysical dichotomy—urban and rural, sacred and profane, natural chaos and civilizational order.

The principal public entrance into the Marrakesh *madīna* was known as the Bab Dukkala, so named for its northwestern location along the walls and its proximity to the region settled by the Dukkala tribe, a subsidiary of the Masmuda (figs. 16, 17).[59] The gate is set between two large bastions built out from the exterior face of the wall, which allowed for careful monitoring of the gate's daily traffic as well as a strategic positional advantage in case of siege. These bastions then form a cohesive block on the interior face of the walls, concealing a notably complex interior plan in the transition into the city. From

FIGURE 16
Plan of Bab Dukkala. Ashley Whitt after Charles Allain and Gaston Deverdun, "Les portes anciennes de Marrakech," *Hespéris-Tamuda* 44 (1957): 105, fig. 10.

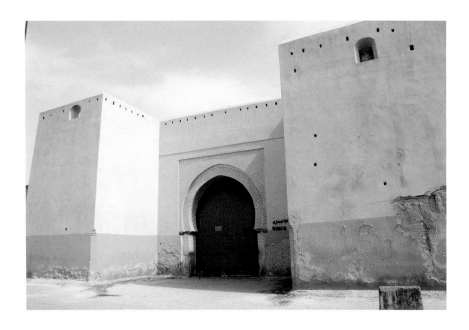

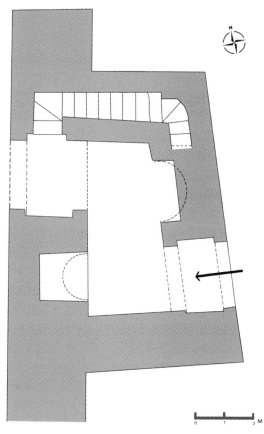

FIGURE 17 (*above left*)
Bab Dukkala, western exterior façade. AA World Travel Library / Alamy Stock Photo.

FIGURE 18 (*above right*)
Gate D from the fortress at Zagora. Ashley Whitt after Jacques Meunié and Charles Allain, "La forteresse almoravide de Zagora," *Hespéris-Tamuda* 42 (1956): 314, fig. 4.

its monumental pointed horseshoe arch on the exterior, Bab Dukkala forms a barrel vault under the ramparts to an open-roofed patio before turning a ninety-degree angle south toward the right, entering into a squared chamber covered by a groin vault. From here, the passage bends again, this time toward the left, before emerging into the city interior. This form is one of the more intricate of the Almoravid-era gates at Marrakesh and unique in its inclusion of both covered passageways and open-air patios, although we can see its likeness at the dynasty's fortress in Zagora, a strategic stop on the route across the Draa Valley to Sijilmasa (fig. 18).[60] According to Arabic sources, it was from this gate that the Almoravid army left the city to wage jihad in al-Andalus, heading north toward the Atlantic coast, though it is unclear whether the army merely gathered at this gate or processed through it.[61]

The other principal gate meriting discussion here is the Bab Makhzen, the primary gate of elite access—inasmuch as one can determine

such social stratification among the Almoravids. Located on the southwestern edge of the city, the Bab Makhzen led directly toward the Qasr al-Hajar, hence the name of the gate, which references the centralized political authority of the palace. The gate was later walled up, but its outline was still apparent along the wall's exterior façade, enough so that Allain and Deverdun were able to identify it and undertake excavations that revealed some of its interior organization (fig. 19).[62] The gate would have originally been framed by two bastions with five facets on the exterior side of the wall, of which only the northern one (to the left of the exterior side of the gate) remains extant. The arched gate then opened into a passageway with a set of stairs

leading to the upper terrace immediately to the left. Further on, the passage turned left, emerging into the *madīna* toward the north. Today, the gate has been reopened to allow auto traffic into the *madīna*, but the internal structure of the original bastions was damaged in the renovation process.

These two gates, among the oldest within the city and ones that received a great deal of traffic because of their purpose and proximity to central sites, are indicative of the majority of Almoravid-era city gates. Of the eight identifiable gates, most feature simple bent turns in their interior as a method of crowd control. Simple yet effective, these turns break the transition from interior to exterior. Traffic through the gates, which were positioned between or next to bastions, would have been under observation and scrutiny from guards posted along the walls. Of the gates that can be definitively classed as Almoravid, only two break from this pattern— the Bab Dabbag and Bab Aylan. Both appear along the eastern side of the city, Bab Dabbag to the north and Bab Aylan toward the south (on an axis through the Masjid al-Siqaya with Bab Dukkala).[63] These gates feature entrances on the side of a singular bastion and would have originally featured a single turn inward, emerging directly into the *madīna* from the walls. Both have been expanded and complicated in their interior structure since the Almoravid era. The Mu'minids expanded Bab Dabbag into a gate with no fewer than five turns before emerging from the threshold—a strategy designed as much to disorient the viewer as to control large crowds (fig. 20).[64] The exploration of the extant Almoravid gates reveals an approach to urban delineation that, though based on fortification strategies employed by the dynasty elsewhere, nevertheless takes little account of the role Marrakesh played as an urban capital.

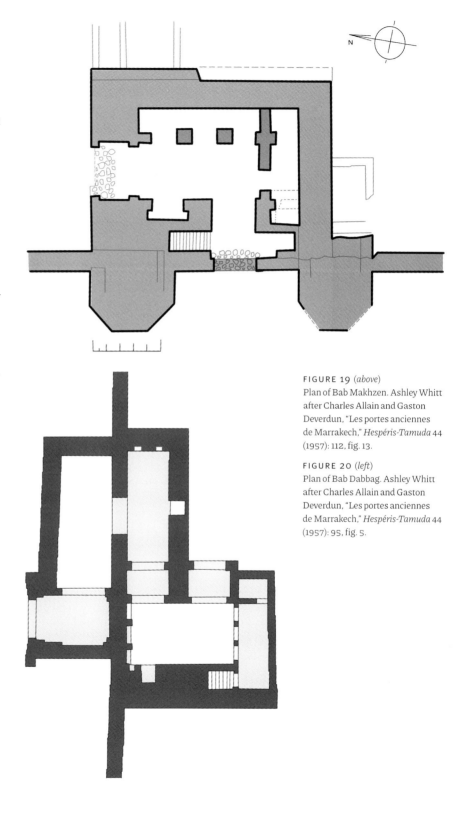

FIGURE 19 (*above*)
Plan of Bab Makhzen. Ashley Whitt after Charles Allain and Gaston Deverdun, "Les portes anciennes de Marrakech," *Hespéris-Tamuda* 44 (1957): 112, fig. 13.

FIGURE 20 (*left*)
Plan of Bab Dabbag. Ashley Whitt after Charles Allain and Gaston Deverdun, "Les portes anciennes de Marrakech," *Hespéris-Tamuda* 44 (1957): 95, fig. 5.

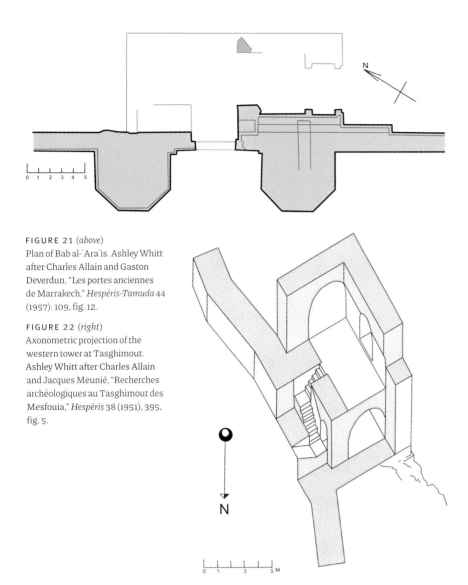

FIGURE 21 (*above*)
Plan of Bab al-ʿAraʾis. Ashley Whitt after Charles Allain and Gaston Deverdun, "Les portes anciennes de Marrakech," *Hespéris-Tamuda* 44 (1957): 109, fig. 12.

FIGURE 22 (*right*)
Axonometric projection of the western tower at Tasghimout. Ashley Whitt after Charles Allain and Jacques Meunié, "Recherches archéologiques au Tasghimout des Mesfouia," *Hespéris* 38 (1951), 395, fig. 5.

Bab Dukkala is a prime example of this, drawing upon the pre-Saharan fortifications along major trading routes in its use of the doubled bent entrance and both barrel-vaulted passages and open-air patios. Bab al-ʿAraʾis (more commonly known today as Bab Larissa, a corruption of the original "Gate of the Brides") is another gate that draws upon more rural fortification typologies, with covered stairwells to either side of the entrance leading to the upper terrace of

the bastions (fig. 21). Allain and Deverdun connect the presence of the stairwells immediately inside the entrance with a similar form found at the Almoravid fortress of Tasghimout, erected under ʿAli ibn Yusuf and therefore approximately contemporary with the construction of the walls themselves (figs. 22, 23).[65] Bab al-ʿAraʾis featured a simple bend toward the right before emerging into the *madīna*; along with the stairwell access, entry and egress through the gate appear relatively simple.

As the points of entry into Marrakesh, the city gates direct traffic through the axes determined by Wilbaux (discussed above), navigating the neighborhoods designated for various tribes to settle in as well as the Almoravid monuments that served as nodes of public space within the city walls. In Falahat's conception of *hezar-tu*, the city gates form the first layer of the urban experience, marking the transition from one mode of being and access to another. One might expect, as we see from the later Almohad renovations of the gates, that each would indicate this transition in ways that respect the levels and layers of access expected by the populations that use them. By this I mean that gates intended for public use or leading to major public sites, like markets or the congregational mosque, would be designed with this purpose in mind. Even considering the rapid construction of the walls in light of the imminent Almohad threat, the functionality of the gates must have been taken into consideration as part of the process. Certainly, the exorbitant sums spent on encircling the city within eight months would imply that considerable attention was paid to the fortifications' most vulnerable points. Ibn Sammak says that between spending 70,000 dinars on the walls in addition to the 100,000 dinars on his lavish new mosque, ʿAli ibn Yusuf ruined himself and the Almoravid treasury.[66] Though the precise figures

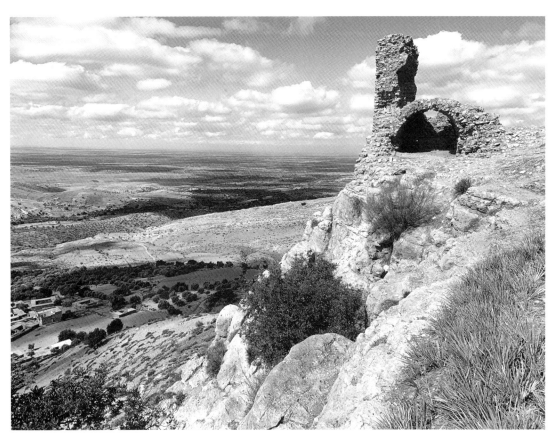

FIGURE 23
General view of Tasghimout's western fortifications. At the right,
the wall climbs to the western plateau, at the juncture of which
one can see the sole remaining tower of the fortifications. Photo:
Carlos Pérez Marín.

may have been exaggerated to a degree, other
authors confirm that the sum was enormous and
that some of it may have been levied from the
governors of other Almoravid towns.[67] Given the
financial investment in the walls, their unifor-
mity and apparent simplicity are surprising, and
those gates that do receive more lavish attention
are unexpected (especially when compared to the
later renovations of the Almohad era). Bab Duk-
kala, a public gate that was also used in a military
context, as discussed above, contains the most
complex internal structure; Bab Makhzen, which
led directly to the Qasr al-Hajar, is structurally

impossible to distinguish from a number of other
gates. One can mitigate this impression by con-
sidering the likelihood that the palace itself was
walled—for much of Marrakesh's early history,
it was the only fortified structure—but fortifica-
tion is merely one aspect of the walls' importance
to the city.

As Falahat has shown, boundaries delineate
practice and social behavior as much as they
draw physical lines in the landscape. Ornament
can underscore these practices, causing one to
stop or move more slowly to admire workman-
ship and formal qualities; it can also function

as a tool of political or religious propaganda. The disparate elements of the city gate—the bent entrances, the vaulting, a limited variety of arch typologies, the alfiz panels—help ritualize the connection between access and interiority, so that "the act of entering is ritualized by the fractioning of space, resulting in a series of elements, each of which constitutes a threshold."[68] The practice of constructing, framing, and controlling passage through city gates constitutes a vital definitional process by which the liminal space between urban and rural, sacred and profane, is smoothed. The process is vivified as much by those who move through such thresholds as it is by those who create it, a continual renewal of the transitional mode that sparks the activation of the urban experience. But within the Almoravid iteration of Marrakesh, this process is skewed so that moments of dialogic transition into the city are unevenly distributed across the city's boundaries and concentrated in unexpected areas that bear little connection to political or social hierarchies. Bab Makhzen, despite its proximity to the Qasr al-Hajar, bore few distinctive characteristics (as much as can be unearthed by archaeological and formal analysis) to indicate the kind of space one was moving toward when passing through the gate. Bab Dukkala, on the other hand, seems to strain in its functionality as a public gate and popular thoroughfare, given its double-bend structure. On the one hand, the structure does allow for greater security from a defensive standpoint, but on the other, public engagement with the city becomes constrained in ways that were antithetical to its social purpose. It is a phenomenon that would form the physical evidence for Ibn Tumart's moral and spiritual criticisms of the dynasty—and one the Mu'minids would take advantage of in their response to Almoravid urbanism.

SOCIAL DISSONANCE ON DISPLAY IN A BOUNDED CITY

The walling of Marrakesh, regardless of the practical intentions behind it, led to a series of unforeseen consequences for the Almoravid elite, not least of which were the new juridical and theoretical questions posed by the category of madīna. These questions, however, are ones that the Almoravids would have been well disposed to address, given the network of Maliki jurists within the administration who could advise, negotiate, and assist in redefining the Almoravids' responsibility to their capital city and community had they been given enough time. What I would like to suggest here is that there was another, more socially pernicious effect elicited by bounding Marrakesh, one that would form the basis of Ibn Tumart's criticisms of the dynasty and would place the Almoravids in a politically contradictory situation. The creation of a city with constricted borders put the customs and traditions of the Lamtuna and Sanhaja on public display. Their social norms undermined the Almoravids' claims to righteous and authoritative leadership over a community of equals, a position that was then exploited by their critics, Ibn Tumart chief among them. The Almoravid tradition of confirming authority through popular affirmation served as the stage upon which practices like the male face veil (lithām) and the participation of Almoravid women in public affairs were highlighted, upending the social contract upon which their leadership was based. The implications for medieval Maghribi notions of community—whether generated through aṣabiyya (tribal solidarity) or the waṭan (homeland)—were profound, calling attention to the Almoravids' moral and social responsibilities as rulers before finding them wanting.

Before delving into the specific Almoravid customs that would prove so divisive, it is

important to address the role the Almoravid ruler was expected to fill and the way in which his capital city was intended to evoke that role. The Maghrib at the turn of the twelfth century had seen a slow and uneven process of Islamization across the region, characterized by a syncretic approach that combined Islamic prophetic monotheism with a variety of indigenous Berber cultic practices. The most widely acknowledged of these is, of course, the success of Kharijism in the Islamic west, which formed the central ideological model for the Midrarid dynasty (ca. 823–976) at Sijilmasa. The Kharijites, who rejected communal arbitration in the election of a leader, instead believed that any Muslim had the right to rule the Islamic community, provided that he was morally irreproachable. The implication here is that Kharijite leadership did not need to be restricted to those with connections to the Arab heartland, which would have excluded converts to the cause like the variant tribes across the Maghrib. Instead, it provided avenues for persuasive local leadership that integrated selective Islamic values into preexisting social structures.[69] This formed the basis for the ninth-century so-called Barghawata heresy, describing a localized cult around the Tamesna plain along the Atlantic coast centered on a Berber prophet and a Berber-language Qur'an as well as a religious calendar that mapped onto pre-Islamic rhythms of fasting and feasting.[70] In the Sous Valley, south of the High Atlas, the Bajaliyya cult emerged to profess belief in the Idrisid imam, following the logic that the imamate belonged to the descendants of al-Hasan b. ʿAli b. Abu Talib (d. 670) to the exclusion of his brother al-Husayn (d. 680).[71] Meanwhile, across the Rif Mountains, the Ghumara tribe (a Masmuda subsidiary) followed their own prophet, a figure known by the two Arabic letters ḥā mīm (d. 928). Ha Mim likewise developed a Berber Qur'an and

weekly fasting days while abolishing the requirement of pilgrimage to Mecca.[72]

Each of these practices centered on the figure of a charismatic reformer who spoke in terms of the existing sociopolitical tribal structure, in which every leader, according to Ibn ʿIdhari, ruled according to his own "judgment" (ḥukm).[73] Bennison has noted that the term ḥukm implies an admixture of "custom" (ʿurf) as well as belief, reflecting the syncretic forms of Islam that emerged in the Maghrib throughout the early centuries of the conquest. Though distinct from wider patterns of Islamic political and religious norms, these syncretic forms nevertheless embedded a concept of Islamic leadership, both theocratic and socially determined, into the concept of political authority.[74] Bennison notes that "such philosophical constructs gave a paramount position to the ruler, the physician of the soul, but also imposed upon him ultimate responsibility for the welfare of those who served rather than participated in governance according to their skills and abilities."[75] The model for leadership in the Maghrib thus became indelibly linked to the cult of the charismatic individual who served as a paragon of ethical virtue, creating a hyperlocal and highly unstable equilibrium between governance (as embodied by the administrative framework) and authority (through the individual). These movements have the tendency to be inherently short-lived, struggling to extend their reach beyond the immediate tribal territory and the lifespan of the central figure. However, transcendence was possible when the charismatic figure became abstracted through the formalized hierarchy of urban space. While the aforementioned Barghawata, Bajaliyya, and Ha Mim cults remained isolated and peripheral to the larger Maghribi political sphere, the movement that coalesced around Idris b. ʿAbd Allah (d. 791) developed into a multigenerational dynasty that

navigated the complex political landscape from its seat in Fez, founded in 808 by Idris b. ʿAbd Allah's son and successor Idris II (whose foundation narrative is detailed above). Although the dynasty became a more diffuse collection of principalities after Idris II divided the kingdom among his son and brothers, leading predictably to infighting and competition, the role of Fez as the symbol of Idrisid authority persisted until the dynasty's collapse in 985.

The city's role in formalizing this phenomenon of charismatic religio-political leadership finds its theoretical expression in the writings of Abu Nasr Muhammad b. Muhammad b. Tarkhan b. Awzalagh al-Farabi (d. 950), the tenth-century philosopher of Persian extraction who later influenced Andalusi writers, like Ibn Bajja [Avempace], who are known to have served in the Almoravid court.[76] In his treatise entitled *Mabādīʾ ārāʾ ahl al-madīna al-fāḍila* (The principles of the views of the people of the virtuous city), al-Farabi describes the city as a body whose component parts contribute to the healthy functioning of the whole.[77] Al-Farabi makes a distinction between the capabilities of urban quarters as a collective entity as opposed to a village or other rural settlement. He writes: "Quarter and village exist both for the sake of the city, but the relation of the village to the city is one of service whereas the quarter is related to the city as a part of it; the street is part of the quarter, the house a part of the street. The city is a part of the territory of a nation, the nation a part of all the people of the inhabitable world."[78] In making these distinctions, al-Farabi implies that true moral perfection cannot be attained except at the urban level, where collective action holds the potential to satisfy every need, thereby preserving the life of the individual and guiding him or her along the path to righteousness. Within the corporeal analogy of the city, al-Farabi describes the ruler as its

heart, governing the attendant systems and their relationships with each other to bring order out of what could be chaos. In order to fulfill this role, the ruler must therefore be naturally predisposed toward moral and philosophical perfection, inclined not toward any one "art" but holding them all in equilibrium.[79] This conception of the relationship between ruler and ruled, the center of power and the city, would find a foothold in the Islamic west through philosophers like Ibn Bajja as well as Ibn Tufayl (d. 1185/6). The latter would go on to have a successful career at the Almohad court. Ibn Bajja took al-Farabi's conception of urban utopia further, naming any discordant elements of social organization as "weeds" that had no place in a virtuous city, especially those that represented a minority population planting the seeds of disunion.[80]

The role of the ruler is thus one predicated on a moral authority that is formalized through urban space, which translates that authority into the manifestation of the larger collective societal state of being. At least theoretically, a ruler must maintain that moral authority in order to guide society along the "correct" path—or risk becoming one of the weeds Ibn Bajja cautions against. Although Ibn Bajja's specific concerns are directed toward the position of the philosopher within an imperfect society, they may also be applicable to the negotiation of sectarian politics within the Maghrib. We know only the barest outlines of his life, but Ibn Bajja was alternately imprisoned by Almoravid officials while in al-Andalus and employed by the emir in Marrakesh, and it is difficult to resist reading his descriptions of a philosopher at odds with the society around him through this lens. As an Andalusi with a privileged place at the Almoravid court, Ibn Bajja was well placed to witness the disjuncture between Almoravid customs and the larger community of Marrakesh as a whole. Those Lamtuna

customs that marked the Almoravids as different from the rest of the general population were not ones that necessarily highlighted their authority (as would be incorporated into later Almohad practices) but ones that questioned their moral supremacy. Ibn Bajja's criticisms may not be directly addressed to the Almoravid elite, but they do hint at the larger social contract of which the Almoravids were a part—and that, by the reign of ʿAli ibn Yusuf, was in jeopardy.

The most notable of these customs (and the one seized upon by Arabic authors critical of the Almoravid dynasty) was that of the male face veil, or *lithām*. Worn across the mouth, the *lithām* was used almost exclusively by those belonging to the Lamtuna tribe, the subsidiary of the Sanhaja confederation that constituted the majority of the core Almoravid supporters and the tribe to which Yusuf ibn Tashfin and his descendants belonged. The origins of such a garment are murky; the garment goes unnoticed among the Classical authors, and it is not until the ninth century that we find its appearance in Arabic texts. Al-Yaʿqubi (d. 905) briefly mentions the custom in his description of a Sanhaja subsidiary that he names as the Anbiyya, while Ibn Hawqal (d. 978) is more forthright, ascribing the practice to a sense of shame around the mouth "since in their opinions what emanates from the mouth smells worse than what emanates from the privy parts."[81] The *Ḥulal al-mawshiyya* takes a more polemical view, incorporating the *lithām* into a proto-Islamic Lamtuna legend that posits an Arab origin for the tribe. In the legend, a Jewish rabbi prophesied the coming of the Prophet Muhammad in what is today Yemen, though none would listen to him except a group from among the Himyar, an ancient tribe from the country's southern highlands. When the faithful were overwhelmed by their sacrilegious enemies, they fled the Arabian Peninsula in the guise of

women, thereby taking the *lithām* as a mark of God's favor.[82] These chosen people became the ancestors of the Lamtuna, who maintained the custom of the *lithām*, which was then incorporated into the Almoravid justification for authority and moral superiority. It was such a distinctive part of their customary dress that the *lithām* even appeared in a fifteenth-century depiction of the Almoravid emir on the portolan chart designed by Catalan cartographer Mecia de Viladestes (fig. 24). If the *lithām* marked the elite of the Almoravid court and military as different, it was as a divine sign of their right to rule and of their support of true Maliki Islam.

This justification may have been acceptable in the abstract as a legend explaining unusual dress customs, but the implications of the *lithām* extended far beyond habits of dress into accusations of sexual immorality and gender upheaval. The custom for men to wear face veils corresponded to the tendency of Lamtuna women to go about unveiled, merely the first of many perceived moral degradations characterizing the feminine side of the Almoravid court, a fact exploited by Ibn Tumart as he began to criticize the Almoravid dynasty in his rise to power. Indeed, having cultivated a following in Fez, Ibn Tumart arrived in Marrakesh with his coterie sometime after 1120, setting himself up outside the ruins of the Masjid al-Sawmaʿat al-Tub (rather than the more lavish Masjid al-Siqaya) to preach publicly.[83] Ibn Tumart accused Almoravid women of being vain and immodest, likening their ostentatious hairstyles to camels' humps.[84] This particular assertion may have had less to do with a historically accurate coiffure than with Ibn Tumart's references to a hadith transmitted by al-Hasan al-Basri (d. 728) that compared such women to the "denizens of Hell," but as Manuela Marín has shown, unveiled women with elaborate hairstyles were in fact

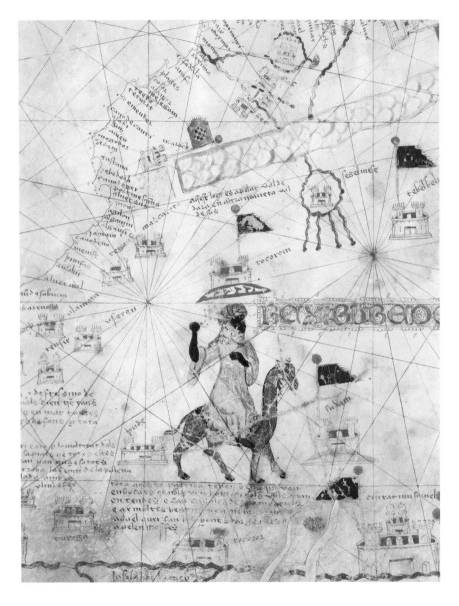

FIGURE 24
Depiction of an eleventh-century
Almoravid ruler. Detail of the
1413 portolan chart by Mecia
de Viladestes. Bibliothèque natio-
nale de France, GE AA-566.

have taken root. Things came to a head when, while trying to navigate the crowds attracted to the Mahdi's teachings, ʿAli ibn Yusuf's sister was publicly assaulted for moving about the city unveiled. Ibn Tumart himself pulled her from her horse. A similar anecdote from al-Baydhaq tells us that Ibn Tumart was then brought before ʿAli ibn Yusuf upon charges of inciting public violence. Upon being received by the Almoravid emir and told to kneel before him, Ibn Tumart asked, "Where is the emir? I see [only] veiled slave girls!"[86] This upheaval of accepted gender roles and norms was exacerbated by the prominent role of women in the court, as exemplified by the figure of Hawwaʾ bint Tashufin (d. 1126?), ʿAli ibn Yusuf's mother-in-law and cousin. Described as a "woman of letters" (*adiba*), Hawwaʾ served as the wife of the Almoravid governor of Seville before returning to Marrakesh after becoming a widow. There, she presided over the literary *majlis*, acting as a patroness of belles-lettres as well as taking part in poetic composition herself, asserting her own mode of authority and political power through the cultivation of a literary and cultural elite in the palace.[87] In adopting the role of a literary and poetic patron, Hawwaʾ (as well as a number of other Almoravid elite women, about whom the sources are briefer) represents the process of Arabization in the Almoravid court, subtly delegated between the sexes so as to allow for the simultaneous processes of maintaining Lamtuna and Sanhaja *aṣabiyya* while engaging with Arabic-Islamic courtly traditions in the vein of the Fatimids or Abbasids.[88] Endogamic practices ensured that the women performing these roles were consistently of Lamtuna heritage, further folding the prominence of women into a distinctly tribal model of authority.

By the early twelfth century, the Almoravid court had adopted a system of social references

considered one of the more obscure signs of the coming apocalypse.[85] Of course, this association played well into the eschatological nature of Ibn Tumart's reformist movement, thereby serving the Almohad cause quite nicely—but what does it tell us about Almoravid society in the 1120s?

We can surmise that if Ibn Tumart were making such accusations, enough women were both public and prominent for his comments to

designed, at least in theory, to occupy the interstitial space between a courtly sphere couched in Arabic precedent and an authoritative contract predicated upon a tribal rhetoric of Islamic reform. Among the Lamtuna, this potentially paradoxical state of affairs was reconciled through the roles prominently performed by both men and women of the court, a social behavior that very well may have had its roots in Berber custom. While women like Hawwaʾ adopted the guise of an Arabic-inflected intellectual patron, the men of the court maintained the distinctly Lamtuna custom of the *lithām*. These are, however, highly visible forms of social distinction and particularly at odds with much of the rest of the Maghribi society that populated Marrakesh. No other tribe of Berber origin had adopted the *lithām*, as its prominent notice within the historical chronicles makes clear. Moreover, we may infer that the public role of women in the Almoravid court was an anomaly, given the relative dearth of information about women later under the Almohad regime, where the lives of royal and elite women are rarely commented upon outside of their roles as mothers and wives.[89] Within the stage set by the urban space, the practices intended to aid the Almoravids in bridging two powerful strains of cultural hegemony instead undermined their legitimacy among both. The walls of Marrakesh created a microcosm of the Almoravid empire in which the discordant elements of their own tribal traditions were amplified, giving Ibn Tumart the societal "weeds" he needed to justify his own brand of radical reformism. While the medieval sources that depict such narratives as those above are frequently guilty of anti-Almoravid bias, it is significant that these become the two major threads of criticism presented as evidence of Almoravid decadence and moral laxity. They betray the social contract as theorized by scholars like Ibn

Bajja, a betrayal that can only happen in the context of the urban framework.

There is one further point to acknowledge in the discussion of the relationship between the Almoravids and their subject populace as it would have been understood in the social philosophy of the twelfth century. That is the practice of public acclamation, the ritual by which the new Almoravid emir was officially designated. Apparently unique in the Maghrib as a practice of assuming imperial authority, the various claimants to the throne would gather in the congregational mosque at Marrakesh, presumably the Masjid al-Siqaya during and after the reign of ʿAli ibn Yusuf.[90] There, the assembled elite men of the Almoravid court would hold a series of plenary sessions debating one heir or another, monitoring the crowd's reaction as they did so. The mosque itself, as we have seen from the reconstructions of Almoravid Marrakesh undertaken by scholars like Wilbaux, was centrally located and equidistant from the major gates leading into the city, even after the haphazard readjustments implicated by the change in qibla direction. This location, as Mehdi Ghouirgate has noted, encouraged the majority of Marrakesh's inhabitants (or at least those male inhabitants who patronized the mosque) to be present at the event of such public acclamation, "passively assisting in the making of decisions and contemplating the assembled Almoravid lords."[91] Shortly after the chosen heir's proclamation as the new *amīr al-muslimīn* (the preferred title of the Almoravid ruler), the imam could have ascended the minbar to issue the Friday sermon in his name, a powerful tool in the recognition of authority and the dissemination of a change in political status.[92]

The evidence for this practice comes from the acclamation of Tashfin ibn ʿAli, the son of ʿAli ibn Yusuf, who ascended to the throne in 1143. We can presume that his public acclamation

FIGURE 25
Almoravid minbar from the Kutu-
biyya Mosque. Photo: author.

likely came sometime in the year prior, which coincides with a notable episode in the artistic patronage of the Almoravid court. In 1137, ʿAli ibn Yusuf had commissioned a fine minbar from the craftsmen of Córdoba (fig. 25). Its completion required the labor of at least twelve skilled craftsmen over five years.[93] Comprising an estimated 1.3 million individual pieces of wood, the minbar incorporates a variety of different types for their variation in color, texture, malleability, and strength (fig. 26). Cedar from the Atlas Mountains makes up the entirety of the structure (except where restoration efforts have replaced it with cedar and walnut), while the marquetry along the side panels, risers, backrest, and decorative front consists of African black wood, pale yellow boxwood, and the reddish-toned jujube inlaid between tiles of bone.[94] Although time has since faded the variant shades of the wood, their original hues exhibited a bright and vibrant contrast, prompting the fourteenth-century scholar Ibn Marzuq (d. 1379)

to remark that "nowhere in the world was the equivalent ever made."[95] The variety and luxury of materials speak not only to the cost of such an object but also to the extent of the Almoravids' imperial reach, whether through conquest or trade. The minbar was then transported from Córdoba in sections before being reassembled in Marrakesh at some point between 1142 and 1145, making the acclamation of Tashfin ibn ʿAli the first occasion upon which a new emir's name was announced from this elaborate minbar.

In the context of the Masjid al-Siqaya, the minbar is the sole element of the mosque's furnishings that allows for ritual hierarchy to be enacted at the physical level.[96] As the various Almoravid elite gathered, including the candidates for emir, the imam could then proclaim the shift in political status from the vantage point of the minbar, several steps above the heads of the rest of the crowd. Certainly, this process bestows religious approval upon the newly elected heir, echoing the public's affirmation, but the new emir himself is never physically singled out in such a manner that justifies his qualification to rule beyond social election. This ritual of public acclamation, and the minbar's role within it, actually upends the social contract upon which dynastic authority in the Maghrib is based; the new ruler was not set up as an exemplary model to follow but rather symbolized the city's persona (both its moral and immoral elements) through this form of election. It is this very fallacy that Ibn Tumart would seize upon when criticizing ʿAli ibn Yusuf for being too accessible to the public, and it clearly resonated among enough of the former's followers for the Almohad movement to be as far-reaching as it was. It is unclear just how widely this practice appeared within the Almoravid set of courtly rituals, as the evidence for public acclamation comes only from the transition of power to the final Almoravid emir, but

its appearance in the twilight of the Almoravids' reign is enough to justify Ibn Tumart's claims and to hint at its role in cracking the façade of the model ruler.

There is, then, a confusion of elements hindering the Almoravids within their own capital city, at once declaring the social differences of the Almoravid elite while putting those differences on display. The role of emir, as a ruler and as the central figure within the urban microcosm, was inherently tied to the moral hierarchy of the medieval Maghribi social model. The social difference signified by the custom of the *lithām* and demonstrated outright by women's prominent presence in public arenas undercut the Almoravid emir's appeal to that moral authority, if not within the Lamtuna and Sanhaja, then among the heterogenous population of Marrakesh that represented the empire as a whole. Within the bounds of the capital city that they created, where they should have been at their most confident, we have instead the seeds of criticism that they could not avoid. The paradox here is that while the Almoravids held these differences to be the distinguishing features of the courtly elite, they simultaneously rejected hierarchies that would have justified or, at the very least, explicated those traditions. The practice of public acclamation within the mosque asked the citizens of Marrakesh to choose a leader as first among equals (at least rhetorically, if not in actual practice). But this created a potentially insurmountable challenge for the new emir, who would need to express authority while being quite literally dressed in garments that alienated him from the general populace. Public acclamation presupposed that there existed a communal sense of cohesion within the social paradigm that would warrant election as a viable pathway to power, but such cohesion was contradicted by patterns of dress and social activity at odds

with that same paradigm. Without justifying Ibn Tumart's reaction against them and keeping in mind the generation of authors that actively embarked on a pro-Almohad campaign against the Almoravids, there is nevertheless a vein of critique here that evidently became established for a Maghribi audience. The ethnosocial elements of this difference become the visible markers of Lamtuna *aṣabiyya*, creating an Almoravid elite at once restricted by its tribal relationships and striking discordant tones within the community.

In its earliest form, the morphology and monuments of Almoravid Marrakesh reveal a process of urbanization that is exploratory, inventive, and idiomatic—frequently addressing concerns as they arose rather than as the result of preconceived ideas about the nature of a city. In this chapter, I have traced the outlines of the Almoravid-era city as much as can be determined through archaeological and historical means, though there are precious few monuments remaining after the intervening centuries of successive construction. What remains, and what can be interpreted from those remains, is a city with the expected hallmarks of a medieval Islamic capital but organized in such a way that any connectivity between them, ceremonially and phenomenologically, appears incidental and informal. When Marrakesh became bounded by city walls in the 1120s, the resulting implications for the urban morphology were subtle yet profound. It was clear that while the Almoravid city manifested a clear understanding of the walls' functionality as defensive structures, their social dimensions and psychological implications went unnoticed, giving Ibn Tumart and Almoravid critics a platform from which they would launch their opprobrium. They decried Lamtuna customs that upended the traditional gender norms

of medieval Maghribi society, primarily the act of men's wearing the *lithām* while women took on public roles unveiled. Such habits were highlighted by the Almoravids' easy accessibility within the walled *madīna*.

Underscoring many of the Almoravids' choices in urban organization are the ethnic communities that made up their movement, and we continually find many of Marrakesh's identifiable urban elements expressed through ethnic rhetoric. From the beginning, Marrakesh was populated by members of the Masmuda, who not only occupied much of the surrounding territory but contributed the earliest built structures of nonimperial origin. Compared with the Sanhaja, who preferred tented habitations within the boundaries of the city, the *pisé* houses of the Masmuda were materially more in keeping with the monumental landmarks of the city, such as the city walls and the Masjid al-Sawmaʿat al-Tub, but simultaneously reflected their own tribal traditions. The Masmuda were also accorded numerous districts within the city as a result of their role within the Almoravid capital, drawing connections between the city and the territories beyond. It is much more difficult to assess the presence of the Sanhaja outside of the Almoravid court, their vernacular architecture leaving few traces for the historian to follow. But in accepting this as part of the Sanhaja traditions informing their own *aṣabiyya*, the monuments of the Almoravids become all the more striking for their distinction among their own tribe. The ethnic undercurrents of urban planning and decision-making have profound consequences for Marrakesh, although the choices themselves are neither straightforward nor easily parsed. Moreover, the ethnic identities of both the Masmuda and the Sanhaja do not correspond equally to their urban expression, and the tension between the latter and the role of the Almoravids

on the urban stage proves to be ultimately irresolvable.

This is most directly exemplified by the manner in which Marrakesh's urban morphology places the Almoravid court in a paradoxical quandary between architecture, spatiality, and social cohesion. The two central elements of the Almoravid city—the congregational mosque and the Qasr al-Hajar—have to be understood in light of the spatial relationships created between them as well as within the city as a whole. In placing the congregational mosque at the heart of the city, the Almoravids followed a well-established urban model in the Islamic world, focusing on the collective and communal space as the morphological determinant. The center of political and military power, the Qasr al-Hajar, was erected at the very fringes of early Marrakesh as a result, which placed the Almoravid court within an orbital network of tribal affiliations that revolved around the mosque. While the Qasr al-Hajar would have stood out in its materiality and apparent monumentality, spatially it set the Almoravids within a framework that equivocated over their societal authority. As the transition from the Masjid al-Sawma'at al-Tub toward the Masjid al-Siqaya further altered the early outlines of Marrakesh's *madīna*, the nodes of power established between palace and mosque were further obscured, hidden behind the ambiguous thresholds of their city gates. Without a clear hierarchy, the gates formed an urban outline that did not fully correspond to the patterns of movement and social order within them.

It is perhaps unsurprising to consider Marrakesh the urban stage upon which imperial practices were set, given the long traditions of public performance and ritual throughout the Islamic lands. And yet the Marrakesh of the Almoravid era is remarkable for the disjunctures that appear within it, from the Almoravids' architectural practices and their understanding of urban space to the way in which these spaces highlight the dynasty's social differences. In the established oeuvre of Maghribi political power, these differences undermine the Almoravids' moral authority. There is an inherent paradox in the conception of Almoravid power: the twelfth-century social contract was predicated on a model in which the leader acts as a moral exemplar, but the Sanhaja practices of the Almoravids appear to favor a more publicly engaged, informal negotiation of rule. Such informality is encoded in the physical fabric of the city, amplifying the social differences that set the Almoravids apart—not through hierarchy, which might be understood as a form of distance, but through a kind of moral failure. These are the undercurrents on which Ibn Tumart picks up in his criticisms of the dynasty, perhaps not explicitly, but in a manner indicative of a deep and structural problem in the relationship between the Almoravids and their capital city. Ibn Tumart's critique will form the basis for understanding the urban changes and renovations 'Abd al-Mu'min and his nascent dynasty undertook in forming their own version of Marrakesh.

Almohad Renovation

If the Almoravid era witnessed the foundation of Marrakesh and the establishment of its earliest community, then the Muʾminid era under the Almohads saw the formalization of the city and its establishment as a true urban metropolis. Under ʿAbd al-Muʾmin, Marrakesh's population grew exponentially, and even with a devastating plague that ravaged the city between 1175 and 1176, by the end of his son Abu Yaʿqub Yusuf's reign, the walled *madīna* housed approximately 100,000 people.[1] Having conquered the city in 1147, the Muʾminids embarked on a series of renovation projects that aimed to shape Marrakesh physically into an Almohad "city of perfection" (*madīna al-fāḍila*) in the tradition of al-Farabi's understanding of urbanism.[2] Their adopted capital's form had two functions: first, to serve as a directed response to the existing Almoravid city, separating the Almohads from the mistakes of their predecessors, and second (and more importantly), to ease the transition from the Almohad community as a religious movement of reform to the newly dynastic structure emerging from ʿAbd al-Muʾmin's reign. In pursuit of this first purpose, the early phase of Almohad renovations involved the destruction or closure of the most prominent Almoravid sites, including the Masjid al-Siqaya at the heart of the city.[3] The Almoravid palace, the Qasr al-Hajar, was temporarily left standing in order to form part of the Muʾminids' signature urban monument, the congregational

mosque now known as the Kutubiyya (named after the booksellers' market that had sprung up around it). In pursuit of this second function, the rest of Marrakesh was systematically redirected toward new urban spaces, constructed and promoted by the Muʾminids as sites of mediated elite interaction with the general public. This series of sites, along with the Kutubiyya Mosque as the tangential connection point, will be the focus of this chapter. They formed the urban expansion of Marrakesh toward the south, following a gentle topographical incline as the city rose out of the Haouz Basin and into the Atlas Mountains. This direction was not unintentional; taking advantage of the local landscape positioned the new Muʾminid quarters against the ancestral homeland of the Masmuda in the Atlas, drawing a visual link between the dynasty and its ethnoreligious heritage. Conceived under ʿAbd al-Muʾmin and amplified under Abu Yaʿqub Yusuf (d. 1184) and Abu Yusuf Yaʿqub al-Mansur (d. 1199), this expansion featured a fortified palace and royal quarter (collectively known as Tamarrakusht) as well as a large esplanade and expansive walled garden. Together, they formed a dramatic and effective staging ground for expressions of caliphal authority and spiritual legitimacy for ʿAbd al-Muʾmin's nascent dynasty.

The Kutubiyya, the hallmark monument of the Muʾminid dynasty, expressed both triumphalist and reformist attitudes toward the city's

Almoravid past while addressing Ibn Tumart's concerns about the congregational mosque's role within the faithful community and its relationship to imperial power. The Kutubiyya is also significant for the connection drawn with the dynasty's origins in the Almohad movement through an ornamental and orientational connection with the mosque of Tinmal, located in the Atlas Mountains. In both its formal ornamentation and its relationship to the landscape, Tinmal echoes the Muʾminid presence in Marrakesh and amplifies the references it makes to the power and conviction of the early Almohad movement. Its role as a pilgrimage site also extends the program of ritual and ceremony established at Marrakesh into the Atlas Mountains, thereby creating a cycle through which the Muʾminid caliphate could continually reenact the moment of its ascent to power. Couched in an explicitly ethnic rhetorical context, the Muʾminid connection to Tinmal activates the role that the Atlas Mountains play in the larger scope of Marrakesh's performative purpose. As the city grew away from the original walled enclosure, access to these districts became increasingly restricted and the rituals within them more highly formalized; carefully constructed spaces framed the Muʾminids as rulers in perfect equilibrium with the contradictory forces of their empire. A discussion of these spaces will form the second portion of this chapter, highlighting their ritualistic functions and exploring how those ceremonies were organized to recall both a general Islamic past (channeled through Spanish Umayyad precedent) and a specific and more immediate Masmuda past. The city's expansion reveals a regular engagement with its physical borders, typified by its ramparts even as the city grew beyond them, which implies how effective and visible these liminal points of contact between the Muʾminid elite and the general public must have been.

Collectively, these architectural and urban elements engage the landscape to position the Muʾminid caliphate at a specific point in the trajectory of its political, religious, and social authority. The Muʾminid urban project engages a series of liminal and tangential spaces to create a sense of "in-betweenness" that extends far beyond its physical implications. The figure of the Muʾminid caliph, as initially embodied by ʿAbd al-Muʾmin and later referenced by his descendants, acts as the steward of the transition not only between one empire and another but also from a movement built on the kind of conviction that results from a strong sense of *aṣabiyya* into the very administrative model that threatens to undermine it. If we understand that ʿAbd al-Muʾmin and the early Almohads were aware of this precarious position—and the abundance of references to the Masmuda in courtly and historical texts suggests that they were—then we can view the urban development of Marrakesh as an attempt to respond to that danger. The proclivity for using liminal spaces for displays of imperial authority couched in ethnic rhetoric, where the Atlas Mountains are the dominating feature of the landscape, can be understood as an attempt to hold their imperial identity in stasis. The suburban and periurban nature of the spaces patronized by the early Muʾminid caliphate creates a porous boundary between urban and rural—an ambiguity that takes advantage of the landscape as a primary actor in contributing to the city's function as an imperial capital.

THE KUTUBIYYA AND TINMAL MOSQUES: ARCHITECTURAL ECHOES ACTIVATING THE LANDSCAPE

As the signature monument of early Muʾminid Marrakesh, the Kutubiyya Mosque stands as both a direct rebuttal to the city's Almoravid-era

FIGURE 27
Northern exterior wall of the extant Kutubiyya (formerly the
qibla wall of the first prayer hall and part of the Almoravid palace).
Photo: author.

foundations and a declaration of the intentions of ʻAbd al-Muʼminʼs regime. Construction began almost immediately after ʻAbd al-Muʼminʼs conquest of the city, following the closure or demolition of the Masjid al-Siqaya (sources disagree as to whether the Almoravid mosque was left to fall into ruin on its own or was part of a concentrated campaign on behalf of the Almohads). Rather than building over the remains of the earlier mosque, ʻAbd al-Muʼmin instead chose the site of the Almoravid palace built by ʻAli ibn Yusuf, located toward the southwestern edge of the walled *madīna*. Indeed, the northern exterior wall of the Kutubiyyaʼs current iteration is likely reused from this prior construction, and excavations in the 1920s by Jacques Meunié

suggest that it may even have been the site of ʻAli ibn Yusufʼs funerary enclosure (fig. 27).[4] The mosque follows a Maghribi precedent, typified by the well-known congregational mosques at Kairouan, Córdoba, and Fez, for a single-storied hypostyle hall with a courtyard for ablutions positioned axially opposite the qibla wall. The typology dictates a T-shaped plan, with a larger central aisle typically positioned down the mihrab axis and another transversely crossing the qibla wall. The type had already been employed, under ʻAbd al-Muʼminʼs patronage, at the mosque in Taza, which had been founded only five years earlier to mark the Almohad movementʼs presence at a strategic crossroads in the Rif in northern Morocco.[5]

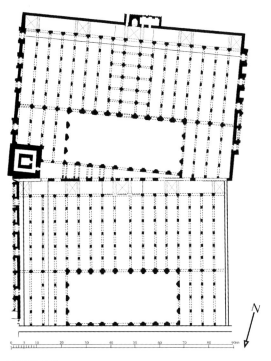

FIGURE 28
Plan of the Kutubiyya Mosque.

But the Kutubiyya Mosque is, in fact, the site of two mosques, built at an angle to each other during the latter half of the twelfth century. Though the exact dates are uncertain, the contemporary texts reveal a rough timeline of construction. ʿAli ibn Yusuf's palace was destroyed in the Almohad takeover of Marrakesh, and the first iteration of the Kutubiyya broke ground in 1147, to be completed by 1157. In the same year, it seems that construction began on a "second" Kutubiyya, adjacent to the first, with enough of the structure completed by 1158 for prayers to be performed in it—though it was not fully completed until 1161 at the earliest. The second Kutubiyya was accessed through the qibla wall of the first, reorienting the direction of prayer from 154 degrees to 159 degrees. The result was an oddly angled complex with two individual mosques separated by a thin

wedge of space, with each adjoining a corner of the minaret that stands between the two, the first at its southeast corner and the second at its northeast (fig. 28). Authors of the period merely comment on the second mosque's construction, never the underlying logic for such an unusual arrangement of buildings. In the twelfth-century text known as the *Kitāb al-istibṣār* (The book of insight), considered an updated adaptation of al-Bakri's geography, the author notes the coexistence of the two structures, at least until the end of the twelfth century: "And then the Caliph and Imam [ʿAbd al-Muʾmin] constructed there a great congregational mosque, which he then enlarged with one similar to it, toward the qibla where the palace once was, and between them was raised the most grand minaret, of which there had been none like it [before] in Islam."[6] With the later addition, the Kutubiyya complex nearly doubled in size and, while not precisely symmetrical, nevertheless retained the sense of spatial unity and focus that became so characteristic of Almohad mosques.

The most likely explanation for this odd expansion and arrangement is that it was built to accommodate an adjusted qibla direction, one that rejected the easterly orientation of Almoravid mosques and was astronomically derived following the star Suhayl (known as Canopus in the Latinate constellations). A theory that focused on qibla direction was originally proposed in 1925 by scholars Henri Terrasse and Henri Basset in a series of articles for the journal *Hespéris*; it was then promoted by their colleagues Georges Marçais and Gaston Deverdun, relying primarily on the arrangement of the two prayer halls as evidence for this shift.[7] Modern scholarship has critiqued this theory for failing to address the fact that the new arrangement directs the qibla further away from Mecca than the original, searching for answers instead

in Marrakesh's rapidly expanding population or in the physical constraints of the urban morphology.[8] Deviations from a mathematically derived qibla were not unusual in the medieval period, and this was particularly true in Egypt, Ifriqiya, and the Maghrib al-Aqsa—one the many reasons scholarship has tended to characterize the latter as an intellectual backwater. Morocco, in particular, features mosques with a wide variety of qibla orientations, with the majority of them falling between 150 and 120 degrees, though the shortest distance to Mecca (i.e., the Great Circle Route) is found at approximately 91 degrees azimuth. Yet the most consistent qibla is found among Mu'minid sites, all of which fall around 150 degrees, with the exception of the mosque at Salé, which was built upon Almoravid foundations under the reign of 'Abd al-Mu'min's grandson, Abu Yusuf Ya'qub al-Mansur.[9] This azimuth directs the qibla almost due south, which invites an alternative explanation for how the Mu'minid qibla was determined. Rather than using spherical geometry and a complex mathematical formula to calculate the direction of prayer—a practice far more favored by the Almoravids—the Mu'minids appear to have preferred the astronomical method of relying upon the rising point (*maṭlaʿ*) of Suhayl.[10] The major axis of the Ka'ba was aligned with Suhayl, which granted this method its legality as a mode of calculating the qibla in terms of general direction (*jiha*) rather than precise geographic accuracy (*samt*). This method was favored by jurists who were more concerned with local precedents and ease of practice, as correctly orienting oneself for prayer was considered an imperative for devout Muslims.[11] In keeping with the Almohad dictum promoted by Ibn Tumart to "command good and forbid evil," a valid qibla accessible to Muslims of all social strata and intellectual abilities was a crucial part of the Almohad ethos.

In the case of the Kutubiyya, the doubled prayer hall emerged in the frenzy of construction activity in the 1150s, likely while the minaret at the site was being built. Between 1154 and 1157, the minaret sprang up at the southeast corner of the "first" Kutubiyya, which was oriented at 154 degrees. It appears to have replaced a curious earlier architectural element that had served, at least temporarily, as the point from which the muezzin had issued the call to prayer. In his excavation of the first prayer hall, no longer extant after the seventeenth century, Meunié exposed evidence of a small elevated room attached to the southern wall that had been adapted from 'Ali ibn Yusuf's earlier palace.[12] But the appeal of a more monumental minaret is obvious, given the ever-growing population in Marrakesh as well as the triumphal dynastic associations of the minaret in the Islamic west. The current minaret, the one referred to in the *Kitāb al-istibṣār* as being unlike any other in all of Islamdom, can reliably be dated to the reign of 'Abd al-Mu'min thanks to Meunié's excavations, which show the minaret physically integrated into both prayer halls, as the stones of its foundation were part of a *blocage* that extended behind the southeast qibla of the first prayer hall (fig. 29).[13] According to an eighteenth-century source, establishing the foundations of the minaret alone took over a year owing to concerns about the alluvial soil forming an unstable base.[14] 'Ali ibn 'Atiyya, a former Almoravid secretary who had found a position in 'Abd al-Mu'min's court, was placed in charge of overseeing the tower's initial construction, and he hired engineers from al-Andalus with experience in building upon such temperamental soil. Once the lower half of the minaret had been formed, it was left to settle into the foundations for a full year in order to provide a more stable base for the rest of the tower.[15] It was likely at this point, with the more accurate astronomical

FIGURE 29 (*right*)
Integration of the northern arcade with the base of the minaret. Photo: author.

FIGURE 30 (*opposite top*)
Plan of the Tinmal mosque with its axial geometric schema. Ashley Whitt after Christian Ewert, *The Mosque at Tinmal (Morocco) and Some New Aspects of Islamic Architectural Typology* (London: British Academy, 1986), fig. 1.

FIGURE 31 (*opposite bottom*)
Eastern entrance to the second Kutubiyya prayer hall. Photo: author.

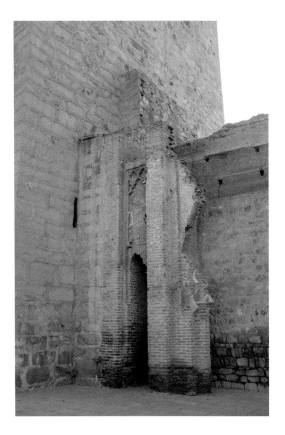

perspective afforded by the minaret base's higher vantage, that the engineers realized the misalignment of the qibla. This discovery then prompted the construction of an entirely new prayer hall adjacent to the first, rather than an awkward rearrangement or expansion of the first that would destroy the clearly delineated hierarchy of the interior.

The importance of this internal ornamental and spatial hierarchy is amplified when one compares the Kutubiyya with its Atlas counterpart, the mosque at Tinmal. Intended to serve as both a shrine to Ibn Tumart and a dynastic necropolis for ʿAbd al-Muʾmin's descendants in Tinmal, the site's location south of the imperial city is referenced obliquely through the readjusted qibla of the Kutubiyya. Though not visible from Marrakesh, the site activates

the landscape surrounding the capital city as a reminder of Almohad origins, authority, and legitimacy. Echoing the Kutubiyya in its ornamental schema, the Tinmal mosque's smaller size compresses the visual field, resulting in a more opulent and luxurious prayer hall. Its role as a pilgrimage site also works to extend the program of ritual and ceremony established within Marrakesh into the Atlas, thereby creating a cycle through which the Muʾminid caliphate could continually reenact the moment of its ascent to power. Built during the narrow margin between the construction of the first and second Kutubiyya prayer halls, the mosque at Tinmal follows the plan of the former, albeit in miniature (fig. 30). Featuring nine bays instead of the Kutubiyya's seventeen, it follows the T-shaped hypostyle form characteristic of the Maghrib, with a wider central aisle and qibla transept.

Most hypostyle halls employ columns to delineate this arrangement, and the abiding influence and imperial remnants of Roman architecture provided no shortage of columns and capitals available for reuse in the early Islamic mosques that proliferated throughout North Africa from the eighth century CE onward. Both congregational mosques at Kairouan and Córdoba employed Roman spoliated columns to great effect, and at least in the case of Kairouan, an entire industry was developed to remove and reshape columns from the Roman and Byzantine remains of Hadrumetum, Sefetula, and Djaloula.[16] And yet, because the supply of columns was not nearly as great as that in al-Andalus or the eastern Mediterranean, Maghribi mosques were faced with a different choice in building materials. Mosques in the extreme west of the Maghrib seem to have developed along a different trajectory, employing brick piers rather than spoliated columns in a manner akin to the Abbasid mosques of Samarra or the mosque of

Ibn Tulun in Cairo. This pattern appears even in the earliest extant congregational mosque in the region: the Qarawiyyin in Fez, founded under the Idrisids in 857. Archaeological work there has revealed that piers supported the structure in its first phase, though the mosque today employs pillars dating to the Almoravid era.[17] However, as Mariam Rosser-Owen has convincingly argued, this pattern (and particularly the use of brick) likely emerged as a result of convenience along the trans-Saharan trade routes rather than in an imported model from the Islamic east.[18] Both the Kutubiyya and Tinmal thus follow—and emphasize—the local tradition by extensively employing brick piers to support the hypostyle hall. Brick formed not only the columns of the prayer hall but each of the walls as well (with the exception of the Kutubiyya's north wall, adapted from the Almoravid palace), outlining each of the mosque's entrances and the mihrab (fig. 31). The brick itself was composed of *pisé* and roughly cut stone, often small pebbles or bits of rubble used to grant the *pisé* heft and stability.[19] This technique, while by no means specific to the region, incorporated building material that was locally available, plentiful, inexpensive, and easily handled. It was a popular choice for construction, surpassed only by stone in the eastern part of North Africa.[20] But whereas comparable sites, such as Kairouan, belie the locality of their construction through certain architectural references, the Almohad mosques fully embraced it. The bricks were formed using a local clay as the *pisé*, which gave them a distinctive reddish color, highly mutable in response to changes in the quality of the light.

At the Kutubiyya, these bricks were covered in plaster before being whitewashed, creating a clean, light interior (fig. 32). This stripped-back interior creates the ideal backdrop for an ornamental program with a clear and focused

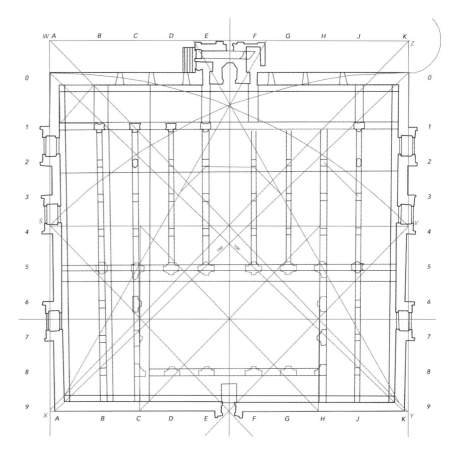

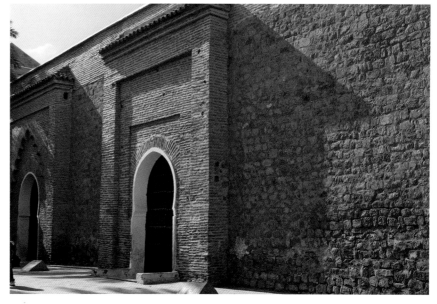

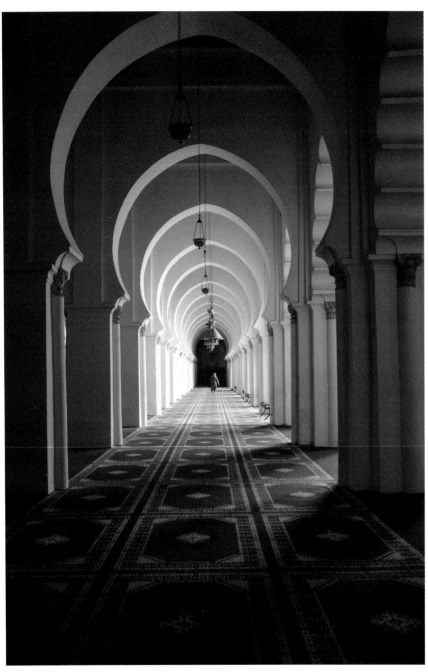

FIGURE 32
Interior of the second prayer hall,
looking west across the transept
directly in front of the courtyard.
Photo: author.

hierarchy, executed in a subtle study of texture that draws the eye toward the central aisle of the mosque to frame the mihrab niche. Beginning with the arches, most of the mosque employed simple horseshoe forms that end just above a pair of engaged columns, one each on the eastern and western sides of the piers. These columns are topped by stucco capitals featuring a variety of vegetal motifs (fig. 33). However, the closer one moves toward the qibla wall and the mihrab, the more elaborate these themes grow. The transept immediately preceding the qibla wall is highlighted by a row of polylobed arches, which, in addition to highlighting the area reserved for the caliph and his retinue, creates a sense of depth across the transept. This effect is deepened thanks to a series of small windows with *mashrabiyya* screens that line the upper reaches of the qibla wall, bringing shafts of dappled light into the space between the row of polylobed arches and the wall. The arches are elaborated into lambrequin forms along the longitudinal arches that cross the qibla transept, as is the arch that frames the mihrab in the central aisle (fig. 34). Though the materiality and color of these forms remains the same, the delicate shift from a simple horseshoe to a lambrequin arch guides the eye toward the center and southern end of the mosque, where three elaborate lambrequin arches frame the mihrab (two on either side and one to the front). The mosque's ceiling also reflects this ornamental hierarchy, saving muqarnas domes for the qibla transept and mihrab while employing flat-pitched wooden ceilings elsewhere. Five muqarnas domes fill the bays of the qibla transept: a square dome on each extreme lateral end, a rectangular dome with a doubled cap on each side, and another square dome directly before the mihrab niche (fig. 35). Each of these domes is modified to fill the space, and yet they retain a sense of symmetry and

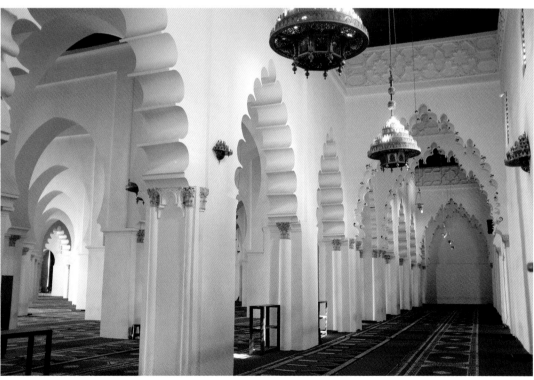

FIGURE 33 (*top*)
Engaged column with stucco capital in the second prayer hall. Photo: author.

FIGURE 34 (*bottom*)
View of the qibla transept in the second prayer hall. Photo: author.

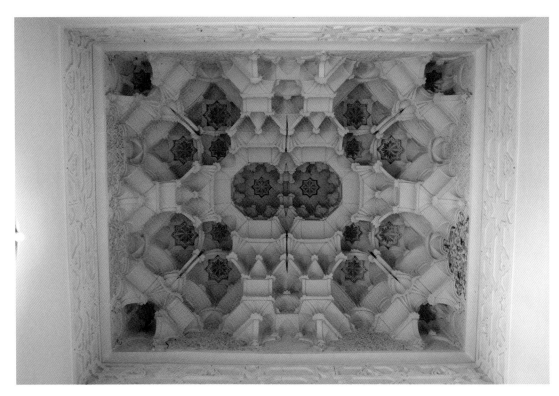

FIGURE 35
Muqarnas ceiling in the lateral qibla transept. Photo: author.

internal logic.[21] Pronounced ribs that line the individual cells emphasize this geometry, creating an aesthetic that, as described by Jessica Streit, recalls "a garment that has been stitched together with its seams showing."[22]

This program culminates in the Kutubiyya's mihrab, which is formulated as a domed chamber with a small arched entry framed by a large panel of alfiz (fig. 36). The entry features two concentric blind, scalloped arches encased within the alfiz, with two scallop-shell motifs occupying each corner. The alfiz in turn is framed by a band of geometric stucco, which is topped by a row of five polylobed arches, alternating between blind and screened in a floral *mashrabiyya,* with another row of geometric stucco above, before the muqarnas dome begins.

The mihrab itself is an octagonal room, with each wall panel framed in a blind stuccoed lambrequin arch growing out of miniature columns and a band of geometric eight-pointed stars above them. The muqarnas dome within the mihrab features the same delineated ribbing as the other domes in the mosque, culminating in a ribbed eight-pointed star that, thanks to its curvature, appears simultaneously floral and geometric (fig. 37). The mihrab is also highlighted through the only examples of nonlocal architectural material in the mosque: two sets of marble columns, presumably from an undetermined Umayyad site in al-Andalus. They are arranged so that four columns line the interior of the mihrab niche while another flanks either side of the alfiz panel that frames it. These columns

were likely spoliated from local Almoravid sites, rather than taken directly from al-Andalus—a particular theme within the Kutubiyya.[23] In addition to the cisterns and wall from ʿAli ibn Yusuf's palace (evident through the excavations of the first prayer hall), the mosque also housed the elaborately carved wooden minbar taken from the Masjid al-Siqaya, for which it had been made in Córdoba at the height of Almoravid power.[24] The Andalusi and Umayyad origin of such elements brings a note of continuity and legitimacy to the mosque as well as the triumphalist message communicated through their Almoravid associations.

Like the Kutubiyya, the mosque at Tinmal features a program of graduated ornamental intensification that creates an aesthetic impression of luxury through craftsmanship and detail rather than materiality. In the centuries following the Almohad era, Tinmal fell into obscurity as a minor village in the Atlas hinterland, overshadowed by the Hintata Berber clans who then dominated the intertribal political scene and who moved eastward into the Draa Valley.[25] This geopolitical shift has had the fortunate consequence of sheltering Tinmal from the program of "de-Almohadization" that occurred as part of the Marinid transition. Well into the Saʿadian era, local Atlas shaykhs claimed Almohad ancestry, and there were reports dating from just prior to the Protectorate period (1912–56) of ritual activity at the site, though the name of Ibn Tumart had faded from its association by that point.[26] The mosque itself appears to have suffered from its lack of patronage, as attested by the semi-ruined state Terrasse and Basset described early in their 1932 series for *Hespéris*. However, excavations in the 1970s and 1980s, led by Christian Ewert and J. P. Wisshak, uncovered much of the mosque's former glory, incorporating water management and environmental analysis into its

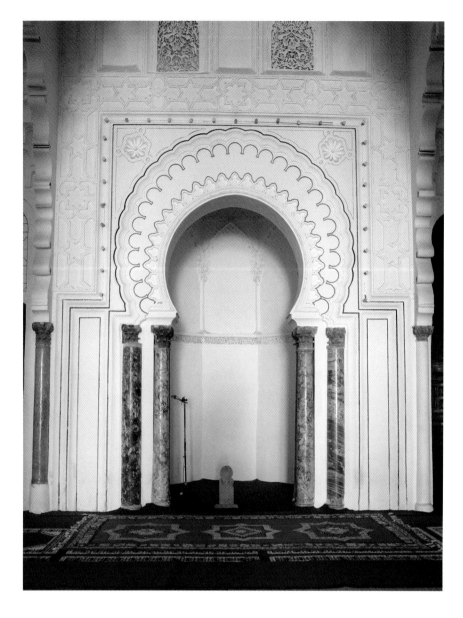

ground plan and earning the site a tentative place on the UNESCO World Heritage lists in 1995.

Responding to the ongoing architectural construction at the Kutubiyya, the Tinmal mosque followed the ornamental program of its Marrakesh sibling, albeit in miniature. Indeed, it is likely that the same craftsmen were employed at both sites, with a select elite sent to Tinmal as

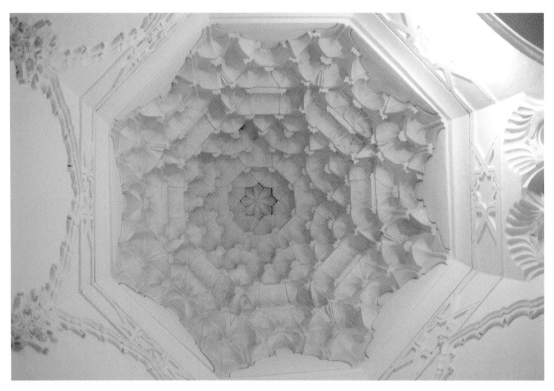

FIGURE 37
Mihrab dome at the Kutubiyya. Photo: author.

part of the pious endowment and patronage of
Ibn Tumart's tomb, further underscoring the link
between the two.[27] The Tinmal mosque employs
the same kind of reddish sandstone brick as the
Kutubiyya and would have once been covered in
a layer of plaster, though much of this has disap-
peared in the centuries since its construction
owing to neglect and decay.[28] The remaining
evidence of this plaster appliqué can be found in
the underlying spandrels of the qibla transept,
which is the only aisle to have maintained its
wooden beamed ceiling, though it has likely been
renovated and replaced on numerous occasions.
The plaster ornamentation that remains, how-
ever, is of a similar elegant quality as that of the
Kutubiyya, with lambrequin horseshoe arches
featuring spandrels with interlaced scrollwork

and a muqarnas dome directly before the mihrab
(figs. 38, 39). Ewert focuses on the spatial sche-
matics and the quadratic organization created
by the use of the iwan to demarcate the inner
"sanctum" of the mosque's most ritually charged
point.[29] This, he argues, is evidence of an indirect
"diaphanous image of a heavenly palace in Para-
dise . . . [here] intensified to monumental three-
dimensionality."[30] While this thesis is presented
as a very tentative one, it is compelling in its insis-
tence on the process of intensification, of creating
emphasis not through direct appropriation or
reference but through the compaction of space.

The ornamental similarities between the
Kutubiyya and the mosque at Tinmal are so
striking that a direct comparison appears almost
redundant; it has been well established that the

decorative program under the Mu'minids was markedly consistent across the dynasty's architectural contributions, so such a resemblance is not surprising.[31] Because of this consistency, however, subtle shifts in proportion and scale are even more apparent, which explains why a mosque like the one in such a remote location as Tinmal appears comparatively luxurious. Both the Kutubiyya and Tinmal mosques feature the same hierarchy of ornamental forms, but the Tinmal site's more intimate scale effects a more intense, opulent scheme, despite the use of similar cheap and locally available materials as those employed at the mosque in Marrakesh. Tinmal's aisles are defined by pointed horseshoe arches, while lambrequin arches frame the qibla transept as well as the bays immediately preceding the mihrab and along the lateral aisles. Though the state of the building does not leave us with much of a ceiling to analyze, the bays demarcated by lambrequin arches do feature additional ornamentation in the form of a narrow band of *sebka* lining the undersides of the archways, indicating a more elaborate ceiling (fig. 40). The densest ornamental program is predictably concentrated around the mihrab, echoing a façade like that at Kutubiyya, with a mihrab arch that features a panel of alfiz enclosing a blind ogival scalloped arch surrounding another rounded ogival arch that forms the mihrab opening. Were the two circles delineated by these arches completed, they would share a single point at their bases at the center of the opening doorframe (fig. 41).[32] The perfected geometric schema of the building is extended not only to the ornamental decoration and plan but also to the site's elevation. One of the most unusual and significant elements of the Tinmal mosque is undoubtedly its minaret, an experimental typology in which the tower encloses the area directly behind the mihrab, thereby creating

a singular mihrab/minaret block. At the current height of approximately fifteen meters, the minaret barely reaches above the roof of the mosque, and the archaeological evidence suggests that it was never much more than a meter taller at the time of its construction.[33] Its height, and its placement surrounding the mihrab, incorporates the structure into the perfected, proportional scheme of the mosque, becoming the cubic unit

FIGURE 38
Ornamental program around the Kutubiyya mihrab. Photo: author.

FIGURE 39
Ornamental program around the
Tinmal mihrab. Photo: author.

phase, directly readable by the beholder, of an all-embracing process."[35]

The unusual and apparently unique placement of the minaret, together with the geometric accuracy of the mosque's plan, speaks to a site that was consciously and conspicuously constructed for an audience of pilgrims. Certainly, both historical and archaeological sources support this theory. Its trilateral plan encouraged ritual circumambulation, with the ornamental decoration intensifying the meditative experience through its cohesive logic.[36] Ibn Tumart's tomb, marked by the form of a simple dome (*qubba*) without gilding or ornament, was located nearby. Although medieval sources do not specify where, precisely, this small necropolis was in relation to the mosque, Basset and Terrasse locate it south of the mosque in a small grove of olive trees in the open land immediately in front of the qibla wall.[37] The restricted mountainous topography makes their assumption quite likely, though the tomb was destroyed and desecrated in the Marinid period.[38] This privileged positioning established a spiritual connection between the tombs, the mosque, and the Almohad faithful who worshipped there. The intense symmetry and focus of the mosque collapse the space reserved for the performance of prayer with the *focus* of it: the body and blessings (*baraka*) of the Mahdi, Ibn Tumart. The tomb was intended to abstract the form of the Mahdi's body, mediating between the earthly plane and the divine through architectural space. In doing so, it provided a liminal space in which the Mu'minid body politic could negotiate the intersecting veins of mysticism, social critique, and legitimacy.[39]

Despite its small size and remote location within the Atlas, Tinmal was nevertheless the recipient of a great deal of patronage and ceremonial attention. The comparative lavishness of the mosque illustrates how important the site

by which the rest of the plan is measured to form an idealized proportional design.[34] The complexity of the mosque's organization is thus determined by the physical plan and elevation, while the ornamental scheme proves to be the "final

was in continually connecting and reconnecting the Muʾminid caliphs over generations to the moment of their spiritual founder's apotheosis. The main purpose of discussing it in relation to the Muʾminid era of Marrakesh is that Tinmal's symbolic and metaphorical impact extended beyond its mountainous home. Beyond the formal similarities between the Kutubiyya and Tinmal mosques, there also existed a ritual practice that can be characterized by its relationship to the landscape. Repeated processions to and from Tinmal present the Muʾminid caliph and his court as perpetually emerging from the Atlas Mountains in a reenactment of the Almohad movement's incursions against the Almoravids and into their dynastic power at the caliphal seat of Marrakesh. That the Muʾminid caliphs regularly undertook the pilgrimage to Tinmal even as their intellectual relationship to Ibn Tumart waned, as was the case with the later generations of Muʾminid rulers, is telling. The public circulation of letters detailing these pilgrimages emphasizes their importance within imperial propaganda not only for the acknowledgment of spiritual duty but in the very practical need to visit the Masmuda tribes that populated the Atlas between Marrakesh and Tinmal.[40] In addition to the profession of loyalty (*bayʿa*) ceremonies that took place within Marrakesh's large public square (*raḥba*), a more informal negotiating of alliances and hearing of grievances was necessary to ensure the tribes' continued support of the Almohad cause.[41] The continued patronage of Tinmal thus practically and symbolically renewed dynastic ties to the Masmuda clans, ties that were then promoted at home and throughout the empire to project a unified and reinvigorated sense of *aṣabiyya*. These ceremonies—processions and rituals couched in an ethnoreligious rhetoric—made Tinmal a symbolic linchpin that vivified the urban and suburban stages of Marrakesh.

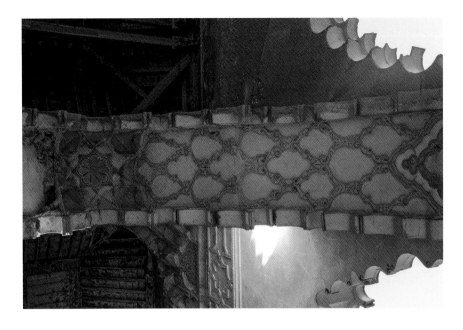

THE MUʾMINID CITY: TAMARRAKUSHT, THE *RAḤBA*, AND THE AGDAL GARDEN

Although Abu Yaʿqub Yusuf is often given credit for bringing the Almohad city to its most elaborate and sophisticated heights, historical accounts confirm that he was largely building upon the foundations established by ʿAbd al-Muʾmin. The *Ḥulal al-mawshiyya* attests that the construction of the congregational mosque known as the Kutubiyya occurred during his reign, as did the construction of a palace directly through the mosque's qibla axis, connected by a covered passageway (*sābāṭ*).[42] The congregational mosque, and all it represented, was thus physically tied to the architectural personification of the new caliphate, and though the new royal quarter lay outside the city walls, it was tangentially connected to them first and foremost through the *sābāṭ*. The palace and royal quarter were collectively known as Tamarrakusht (the feminine form of "Marrakesh"), a space that extended along the southwestern edge of the city. While little of the area remains

FIGURE 40
Sebka strapwork underneath a mihrab transept arch at Tinmal. Photo: author.

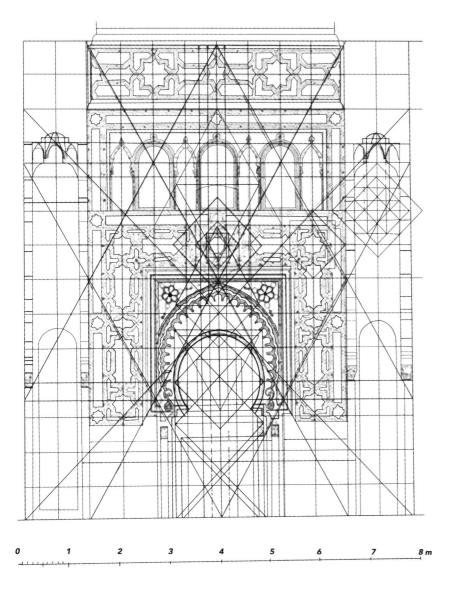

evocative titles, such as the Crystal Palace (Dar al-Ballur), the Palace of Aromatic Basil (Dar al-Rayhan), and the Water Palace (Dar al-Ma).[43] Given al-ʿUmari's secondhand information and the lack of extant material through which to understand these descriptions, it is impossible to fully reconstruct how these palaces fit into the urban space of Tamarrakusht, and their presence and lavish portrayals certainly seem to dispel the theory of a cautious Muʾminid ambivalence about sedentary luxury. But these were likely residences for members of the courtly elite, which Bennison has described as a "fortified enclave of luxurious residences and green spaces that was essentially the private domain of the Muʾminids."[44] What I am more concerned with here are those sites of public interaction that shaped the public image and reputation of the Muʾminids as they established themselves beyond their initial Almohad origins. Gates, walls, and other liminal spaces effected a transition from a more chaotic public navigation under the Almoravids into a more highly ordered and mediated space.

Marrakesh's city walls have been expanded since the mid-twelfth century to encompass the entirety of the medieval and early modern city, in the process destroying most of the architectural remnants of the Muʾminid royal quarter. It is worth noting, however, that the topography of the quarter has remained relatively unchanged, allowing us to map remnants of the Muʾminid city within their urban context. At least one of Tamarrakusht's monumental gates remains, and it may be possible to triangulate the locations of others. Bab Agnaou was built immediately after the conquest of the city in 1147, and its intricate geometric and floriated decoration, Qurʾanic inscription, and polychromic stone and brick highlight what would have been the principal public entrance into the royal

FIGURE 41
Mihrab façade at Tinmal with geometric scheme. Ashley Whitt after Christian Ewert, "El registro ornamental almohada y su relevancia," in *Los almohades: Problemas y perspectivas*, ed. Patrice Cressier, Maribel Fierro, and Luis Molina (Madrid: Consejo Superior de Investigaciones Científicas, 2005), 241.

extant from the twelfth century, historical records, place names, and archaeological evidence can help reconstruct the quarter's form. The fourteenth-century Syrian historian Ibn Fadl Allah al-ʿUmari (d. 1349), working from the accounts of historian and poet Ibn Saʿid al-Maghribi (d. 1289), described the quarter as featuring high walls and monumental gates enclosing a series of caliphal palaces featuring

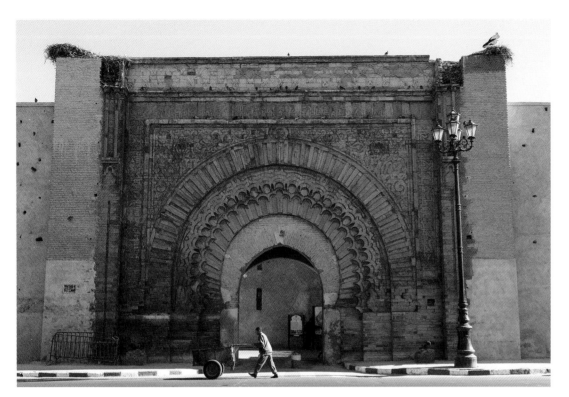

FIGURE 42
Bab Agnaou. Photo: Eduardo Blanco / Alamy Stock Photo.

quarter (fig. 42).[45] Its name comes from a later nineteenth-century corruption of *qanā* (meaning "canal" or "waterway"), referring to a basin constructed in front of the gate, likely during the Saʿadian era (1549–1659). But al-ʿUmari's account confirms that this gate was meant for the general public (*al-umma*) during Muʾminid rule of the city.[46] The elite entrance, reserved for the use of the Muʾminid court, was known as the Gate of Lords (Bab al-Sada) and led directly from the royal quarter through an extramural necropolis and into the *raḥba*, a large open esplanade of great ceremonial importance (further addressed below). Al-ʿUmari tells us that a long chain was strung along the gate, forcing entrants to dismount before entering, a practice recalling that of the Andalusi Umayyads at Madinat al-Zahraʾ

or in Idrisid-period Fez, where wooden beams blocked the streets leading to shrines "in order to force riders to dismount in the presence of the sacred."[47] Unfortunately, despite its ceremonial and political importance, the Bab al-Sada is no longer extant, and its precise location has been a topic of some debate. The historian and Arabist Maurice Gaudefroy-Demombynes, who translated al-ʿUmari's text in the 1920s, speculated that the gate could be found at or near the Gate of Pennants (Bab al-Bunud). However, he draws upon al-ʿUmari in conjunction with Saʿadian-era authors, who wrote using names and terms more consistent with the sixteenth century than the twelfth. His analysis of al-ʿUmari's description is unable to move past the Saʿadian architectural and ceremonial framework, despite disagreeing

confirms this positioning by forming the western entrance into the vicinity; the Bab al-Sada forms the southern one, concentrating the Mu'minid nexus of power in the southwestern corner of the city. This subsequently positions the *raḥba*, also known as the *mechouar* in the early modern era, further southeast along this directed alignment, extending the Mu'minid locus for public engagement through this multifunctional space that put the dynasty's intellectual, political, and military accomplishments on display (fig. 45). The former term, *raḥba*, refers to a large open courtyard or esplanade defined by its enclosure yet emphasizing the expansiveness (or perhaps emptiness) within. The *raḥba* was already well known in al-Andalus as the space in front of the city gates, set aside for temporary markets and public announcements or gatherings.[50] The latter term, *mechouar*, is more difficult to define precisely, but it likely originates in a Francophone corruption of the Arabic *mashwāra*, which refers to a consultation (or counsel) and may enlighten us as to the space's use in the Mu'minid pageant of ceremony.

with his contemporary Pierre de Cénival for similar reasons.[48] But the Bab al-Bunud is also no longer extant (or has since been renamed). Moreover, a more suggestive location may be at the modern-day Bab al-Robb, a synonymic title that also recalls a royal gate and aligns with the royal axis directly south of the Bab Agnaou (fig. 43).[49]

By locating these gates, even only theoretically, within the city's urban fabric, we can begin to outline how the Almohad expansion connected to the Marrakesh *madīna* (fig. 44). Tamarrakusht, with its enclosed palaces and restricted access, would have been positioned directly south along the qibla axis from the Kutubiyya Mosque, following from the *sābāṭ* that granted private movement between the two to the caliph and his retinue. The Bab Agnaou

Rather than receiving visitors within the lavish palace complex, ʿAbd al-Muʾmin instead engaged with both local and foreign audiences here, setting up the same red tent he carried into battle (*qubba*) near the northern palatial end of the *raḥba* near the Bab al-Sada.[51] Known as the Qubbat al-Khilafa (the Caliphal Tent), from this raised platform the Muʾminid caliph could preside over the entirety of the *raḥba* as a microcosm of the world he had created and an expression of the power he wielded.[52] The space housed a menagerie of wild animals for courtly sport and spectacle, as well as a madrasa and library sponsoring intellectual endeavors. Intellectuals were occasionally recruited into the court if they passed scholarly muster, and al-Marrakushi notes that the Muʾminid caliphs were known

for inviting speculative philosophers to come to Marrakesh and publicly debate religious matters with their own Almohad scholars. These courtly intellectuals were divided into two classes: the *ṭalabat al-ḥaḍar* ("scholars of presence") and the *ṭalabat al-muwaḥḥidīn* (literally "Almohad scholars"). The former, the *ṭalabat al-ḥaḍar*, were part of the caliphal retinue, traveling with the Muʾminid caliph as part of his peripatetic court or otherwise residing in the imperial capital. The latter, the *ṭalabat al-muwaḥḥidīn*, were recruited as part of the imperial project, stationed across the Maghrib, al-Andalus, and Ifriqiya as representatives of Almohadism in service to local governors.[53] The dynamic between the two emphasizes the tension in the relationship between the caliphate and the urban network across the empire. They also highlight a sense of guardianship over Almohadism, capable of being represented by the *ṭalabat al-muwaḥḥidīn*, who remained settled in one place but truly epitomized the concept of a caliphate in motion. While the Masmuda may not have been nomadic in the same sense as the Almoravid Sanhaja, considering their tradition of a built architecture, in their reflexive rhetoric we do not see them placing themselves on the settled or urban end of the civilizational spectrum.

The importance of the Muʾminid dynasty's heritage as transhumant members of the Masmuda is echoed throughout the ceremonial pageants and processions that were performed in the *raḥba*. It was here that ʿAbd al-Muʾmin held the annual review of the military (*jumūʿ*) stationed in Marrakesh as well as the ritual gathering of tribal representatives from the High Atlas (*ʿumūm*). The two ceremonies are described in tandem with one another—indeed, al-Marrakushi uses the term *sanfān al-muwaḥḥidīn* (literally "the two classes of the Almohads")—and it is possible to view this

rhetoric as describing the two sources of Almohad might, the legitimacy of ʿAbd al-Muʾmin's dynastic ambitions, and the dynasty's role as caretakers of the original Almohad movement.[54] The strictly organized hierarchy of Almohad society was on full display in these ceremonies, and it is notable how closely this organization mirrors that of the Berber communities upon which it drew, albeit

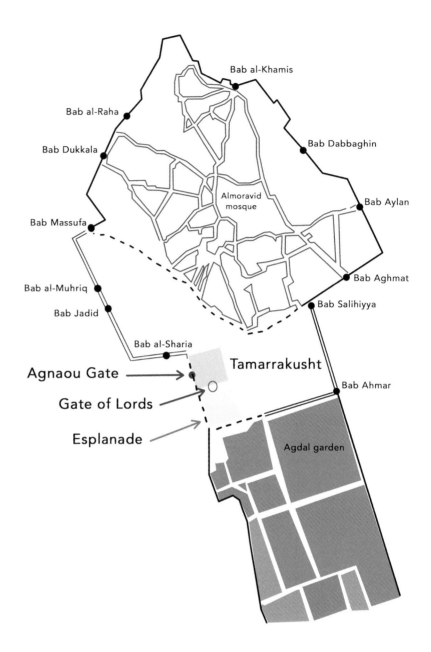

FIGURE 44
Map of Almohad-era Marrakesh. Ashley Whitt based on Maurice Gaudefroy-Demombynes's translation of al-ʿUmari's *Masālik al-abṣār fī mamālik al-amṣār: L'Afrique moins l'Egypte* (Paris: Geuthner, 1927), facing 181.

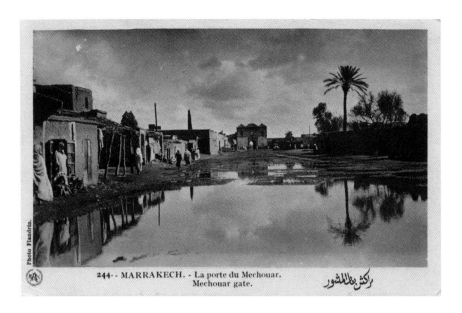

244 · MARRAKECH. - La porte du Mechouar.
Mechouar gate.

مراكش بطالمشور

FIGURE 45

Postcard of the *mechouar* (or *raḥba*) in Marrakesh, ca. early twentieth century.

with distinct and strategic differences. Though the Arabic sources are vague and often contradictory as to the precise makeup of each category, certain statements can be made as to their general composition. The basic structure appears to have roots in Almohad military organization, though by the height of ʿAbd al-Muʾmin's reign, these roles had become more multifunctional.[55] At the top of this hierarchy (after the Mahdi and the caliph) was the Council of Ten (*ahl al-jamāʿa*), which, after serving as Ibn Tumart's trusted inner circle, then became ʿAbd al-Muʾmin's de facto cabinet. Ibn al-Baydhaq and court chronicler Ibn Sahib al-Salat (d. after 1203) then name "the Fifty" (*ahl al-khamsīn*) as the next most elite group, which seems to form a representative body of the tribes loyal to the Almohad cause.[56] They included members of the Hargha, Ganfisa, Haskura, Gadmiwa, and Hintata tribes—all of which were subsidiaries of the Masmuda tribal confederation—as well as the Sanhaja and the *qabāʾil* (literally "tribes"). These last two reflect the degree to which Ibn Tumart and ʿAbd al-Muʾmin were willing to open admittance into

the movement in its formative stages. Despite their ostensible allegiance to the Almoravids, at least some members of the Sanhaja were convinced by the Mahdi's arguments and were admitted as tribal representatives to the Ahl al-Khamsin. The *qabāʾil* appears to be a more heterogenous group. Called *ghurāba* ("strangers" or "foreigners") by Ibn al-Qattan (d. 1231), they were likely not members of the Masmuda (indeed, at least three members of this category came from the Lamtuna, Zenata, and Gazula confederations).[57] While neither the Sanhaja nor the *qabāʾil* was admitted to the inner circle of the Council of Ten, both must have been politically significant enough to be incorporated into the Fifty, and they therefore had a nominal say in Almohad affairs. In the parades through the *raḥba*, these groups were then followed by the other Almohad tribes, the various branches of the military, and the *ṭalabat al-ḥadar*, whose privilege it was to provide the Muʾminid caliph with readings from the Qur'an and Ibn Tumart's *Aʿazz mā yuṭlab* in his imperial tours and military excursions.[58]

Between the Ahl al-Khamsin and the rest of the tribes was placed the family of Ibn Tumart.[59] Its position within the caliphal hierarchy is both surprising and understandable. Ibn Tumart's family, his immediate relatives and those pledged to them, is listed as first among the tribes, and in one sense this grants them pride of place among the various groups, leading the procession into the *raḥba* for the annual review. But this also demotes the Mahdi's family members from the head of the Almohad movement, placing them instead under the direct authority of ʿAbd al-Muʾmin and the later Muʾminid caliphs, which would both boost Muʾminid legitimacy and remind Ibn Tumart's family and the Marrakesh public who held power in the new Almohad state. ʿAbd al-Muʾmin's authority had already been challenged on two occasions

by the middle of the 1150s. Both of these rebellions had come from Ibn Tumart's own brothers, who objected to ʿAbd al-Muʾmin's attempt to establish a hereditary caliphate after he named his son as his successor.[60] Ibn Tumart had already chastised the Almoravid emir ʿAli ibn Yusuf for pretending to the caliphate, which Ibn Tumart decreed was "for God alone." Hence ʿAbd al-Muʾmin's pretension to the same office assuredly drew criticism from those who would have maintained Ibn Tumart's practice of awarding authority based on merit.[61] Historical sources from the period paint ʿAbd al-Muʾmin's succession as ordained by Ibn Tumart and sanctioned by the Council of Ten, Ibn Tumart's closest followers and counselors. However, as the majority of these sources were sponsored for or by the Muʾminid dynasty, their reliability on this particular matter is questionable.[62]

ʿAbd al-Muʾmin was of the Zenata confederation, based in the Rif Mountains in the north of Morocco, while the majority of Almohad support came from Ibn Tumart's tribe, the Masmuda, making the former's ascension to leadership both anomalous and contentious. Al-Baydhaq, Ibn Tumart's biographer, notes that the charismatic leader called the Almohads together in 1130 and announced that he was departing the earth but had left instructions for the next three years to be carried out under ʿAbd al-Muʾmin.[63] By comparison, Ibn Khaldun notes that the transition was much more fraught, with Ibn Tumart dying unexpectedly and the Council of Ten keeping it a secret for three years while deciding how to proceed. According to Ibn Khaldun, the support of the Masmuda could only be obtained by appealing to a prominent Masmuda shaykh, Abu Hafs ʿUmar (d. 1175).[64] ʿAbd al-Muʾmin's authority over the Almohad forces was accepted long enough for the movement to take Marrakesh and push the Almoravids into dispersal and exile, but by

1153, Ibn Tumart's brothers had rallied enough support to stage a coup. It failed largely because the muezzin had spoiled their attempt to take the Muʾminid treasury, located near the Kutubiyya Mosque. The rebels had killed the city's governor, ʿUmar ibn Tafragin, for refusing to hand over the keys to the treasury, but the muezzin watched them as he ascended to issue the call to prayer and was thus able to sound the alarm before they could escape.[65] The brothers were then exiled to al-Andalus, but they rebelled again in 1156 after ʿAbd al-Muʾmin's announcement of his succession. When their rebellion failed a second time, they were executed for their crimes.

Thus, while ʿAbd al-Muʾmin successfully fended off direct challenges from Ibn Tumart's family, this sporadic disruption illustrates how vulnerable and tenuous his hold over the various Almohad factions actually was. He would continue to be plagued by questions of legitimacy; he eventually felt it necessary to undertake a ritual confirmation of alliances known as the *tamyīz*. The process formalized alliances through the communal meal (*asmās*) and tribal council (*agrao*), but it was also used to cull those disloyal to the group and had been used to great effect by Ibn Tumart.[66] ʿAbd al-Muʾmin performed a second sort of *tamyīz* called the *iʿtirāf* ("recognition" or "acknowledgment"), in which the names of suspected dissidents were distributed among the Almohad territories. The dissidents were then systematically arrested and executed.[67] He also circulated a letter in the same year in which his son's appointment to the caliphate is cast as the informed decision of the Almohad *ṭalaba* and tribal shaykhs.[68] In a demonstration of pious deference and communal agreement, ʿAbd al-Muʾmin approached the council to inform them that a delegation from Ifriqiya had requested that his son come and serve as their regional governor. Instead, the

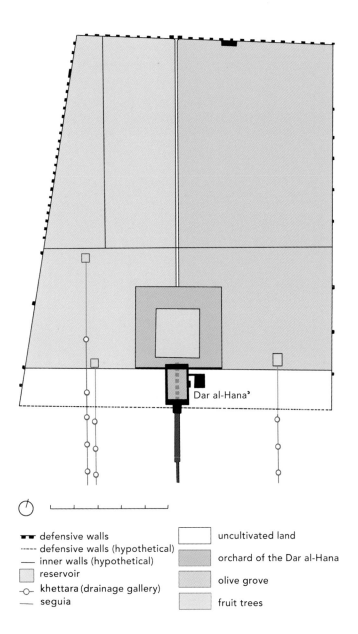

Dar al-Hanaʾ

defensive walls
defensive walls (hypothetical)
inner walls (hypothetical)
reservoir
khettara (drainage gallery)
seguia

uncultivated land

orchard of the Dar al-Hana

olive grove

fruit trees

FIGURE 46
Hypothetical map of the Agdal
estate during the Almohad period.
Ashley Whitt after Julio Navarro
Palazón, Fidel Garrido, and José M.
Torres, "The Agdāl of Marrakesh
(12th to 20th Centuries): An Agri-
cultural Space for the Benefit and
Enjoyment of the Caliphs and Sul-
tans," *Muqarnas* 35 (2018): 31.

council elected him as ʿAbd al-Muʾmin's succes-
sor, simultaneously absolving the latter from the
onus of dynasty building and solving the prob-
lem of who was to assume the caliphal mantle.[69]

These events serve to illustrate just pre-
cisely what was at stake in the early days of the
Muʾminid caliphate in Marrakesh, and we can
understand the space of the *raḥba* as directly

addressing these concerns. For ʿAbd al-Muʾmin,
who struggled not only to maintain his legiti-
macy as Ibn Tumart's heir but also to estab-
lish the dynastic interests of his own family,
the need to reinforce a social hierarchy that
could balance the Almohads' spiritual origins
and the Muʾminid dynastic project was para-
mount. Though he had politically secured his
position among the Almohad elite, remov-
ing his rivals and establishing his confirma-
tion by Ibn Tumart as well as the Council of
Ten, ʿAbd al-Muʾmin's tenure was inherently
unstable and based on the cult of his personal
charisma and success rather than hereditary
position. As he was responsible for the military
and territorial success of the empire, he was
reluctant to leave the survival of his family to
chance and watch tribal divisions destroy all that
he had accomplished.[70] The *raḥba*, as the center
of public dynastic interaction, expressed both
the anxiety and the ambition surrounding this
position, creating a space in which the Muʾminid
caliph could repeatedly play the part of a semino-
madic (or at least non-urban-dwelling) military
leader of the tribes. The *qubba* at the northern
end of the enclosure would have called atten-
tion to the performance of this identity, framing
the Muʾminid caliph as he observed the rituals
of allegiance accorded to him and in which the
social hierarchy of the Almohad movement was
reinforced. Extending directly outward from the
royal quarter of Tamarrakusht, the *raḥba* occu-
pies a liminal space between urban and subur-
ban, outside the city walls and yet tangential to
them. According to Bennison, this spatial orga-
nization was the solution to the Muʾminids' need
to "create an appropriate urban environment for
the elite that reflected their power"—perhaps
recalling the Mahdi's anger at the easy acces-
sibility of the Almoravid caliph—and the need
to communicate this power at the designated

points of interaction.[71] What emerges is a tangential, linear suburb directly connected to the city through the qibla of the new congregational mosque, the Kutubiyya. The *sābāṭ* connects the latter to the royal palace and Tamarrakusht, and Tamarrakusht in turn is connected to the *raḥba* through the Bab al-Sada, the Bab al-Bunud, and the Bab al-Robb. Here, I distinguish between the royal quarter as a network of palaces and elite residences and the *raḥba* as a site of public engagement, but the two should nevertheless be considered to work in tandem in their presentation of caliphal authority. While Tamarrakusht was a site restricted to elite access, the caliph's movement both to and from it was a highly mediated affair, and there are no accounts of casual encounters with the Mu'minid caliph (unlike with the Almoravid emir).[72]

This axis extended further with the creation and patronage of a walled garden known as the Agdal, constructed just to the south of the *raḥba*, which further enhanced the complex interplay of urban space and imperial ceremony. Established by 'Abd al-Mu'min in 1157, the large suburban garden measured a little over one thousand square meters, which was only slightly smaller than the walled *madīna* (figs. 46, 47).[73] The term *agdāl* comes not from Arabic but from a dialect of Tamazight, an Afroasiatic language particular to the Atlas region. Meaning a "meadow enclosed by a stone wall," the term is a technical one that implies a space used for seasonal herding, meant to regulate resource consumption and to preserve a plot of land for grazing in the late summer, when resources are most scarce.[74] The concept was developed among Masmuda herdsmen in the Atlas Mountains who strictly regulated access to and use of *agdāl* enclosures via intertribal councils. Since herding patterns often crossed other tribal territories, these councils may also have functioned as de facto

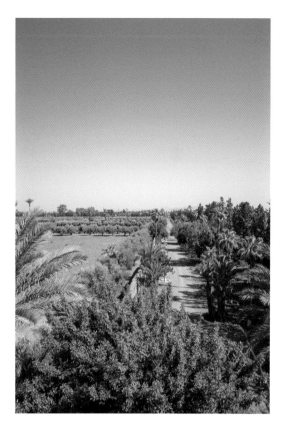

FIGURE 47
View of Agdal garden, looking north. Photo: author.

political alliances.[75] It is tempting to view this association with the monumental garden south of Marrakesh, but as has been demonstrated by Julio Navarro Palazón, Fidel Garrido, and José Torres in their survey and study of the Agdal, no medieval source actually uses the term *agdāl* to describe the garden, and its earliest reference only appears in a French 1867 plan of the site.[76] Instead, Almohad-era sources refer to it simply as *al-buḥayra* ("the lake"), referring to the large reservoir that occupied the southern end of the space.[77] Though other suburban estates belonging to members of the Almohad elite are also referenced as *baḥā'ir*, they are always accompanied by qualifying information, such as their location, their owners, or other common features in order

to identify them, whereas the imperial *buḥayra* does not require such qualifiers.[78] But the fact that the term *agdāl* eventually was applied to the garden is not insignificant, as notions of enclosure and restriction were part of the site's function from its inception. The concept of *agdāl* carries with it the idea of interdiction (*ʿurf*) in a religious and legal sense, and it is referred to as *ḥarām* ("forbidden" or "sacrosanct") by Atlas Berber populations.[79] The term *agdāl* became associated with the garden thanks to the ceremonies and rituals that enlivened it, creating a liminal space that acted in a ritual and transformative manner.

Like many of the Muʾminid constructions in and around Marrakesh, the garden would be preserved, adapted, and expanded in later centuries, most extensively during the Saʿadian era, when Marrakesh was again an imperial capital. At its greatest extent, it measured nearly 500 hectares, though increased urban development has today reduced it to approximately 340 hectares.[80] A large rectangular enclosure, the garden was divided into smaller rectangular divisions that organized plants by type, with borders of myrtles, black elderberries, and trellises of roses, sweetbriar, and jasmine demarcating the boundaries. An orange grove was located near the garden's massive reservoir in order to take best advantage of the water, and dispersed throughout the rest of the garden were other enclosures housing fig, palm, almond, and walnut trees, many of which were imported from as far away as Egypt.[81] The majority of the garden, however, was planted with groves of olives. The garden was both an ornamental and an agricultural space, and the annual revenue from the harvest was recorded as roughly 30,000 dinars, an enormous sum when considering the cheap cost of produce.

The operation was so complex that something akin to a parks and recreation department was established in order to maintain and streamline the process of the gardens' finance and upkeep, employing contractors, town planners, gardeners, and hydraulic engineers.[82] The Haouz Basin was by no means a fertile plain, and ʿAbd al-Muʾmin and his successors, as well as later dynasties, would spend a great deal of effort in collecting and managing the city's water resources. In Marrakesh's early days, the Almoravids had built a series of *khettara*s or *qanā*, channels that tapped into the subterranean water table, in order to bring water into the city to fill the extensive network of mosque and palace fountains. While sufficient for the elite and military encampments, the amount of water provided by these channels was not enough to sponsor large-scale urban growth and thus limited Marrakesh's ability to expand. Under ʿAbd al-Muʾmin, a network of canals supplemented the *khettara*s, diverting snow and rain runoff from the Atlas streams into Marrakesh. As Paul Pascon has noted, the scope of such a large-scale project would not have been possible without Almohad political control of the mountain terrain or Masmuda familiarity with the practice of consolidating water resources. Such an option was simply not available to the Almoravids, who faced incursions from the nascent Almohad movement and were separated from their ethnic power base in the Sahara and therefore could not support sustained long-distance civic projects.[83] Soon after the conquest of Marrakesh, ʿAbd al-Muʾmin undertook the expansion of the Almoravids' established collection of *khettara*s, supplemented by a number of aboveground channels that diverted water from the seasonal wadis in the Atlas foothills (fig. 48). Known as *seguias*, these channels nearly tripled the area of arable land in and around Marrakesh, expanding from 5,000 to 15,000 hectares.[84] The most significant of these was known as the Tasoultant, the "royal

channel," which diverted water from the Wadi Ourika north of Aghmat into the city along a narrow, 25-kilometer-long channel to feed the Agdal garden in addition to numerous other estates in the surrounding area.[85] Through such channels, the Muʾminid administration brought life-giving water from the Atlas into the Haouz. Their Masmuda connections to the region helped sustain the city rather than exacerbating tensions between urban and nomadic communities.

Runoff from both the *seguias* and the *khettaras* emptied into a large reservoir within the garden known as the *ṣahrīj al-manzeh* ("the park basin"), which measured 208 meters long (north to south) and 181 meters wide (east to west) and was located in the southern third of the garden (fig. 49). Capable of retaining nearly 83,000 cubic meters of water, the reservoir was an invaluable part of sustaining the city and its surrounding area during the dry season.[86] Because the garden followed a topographical incline from its urban northern end toward the south rise into the Atlas, with the basin aligned along this orthogonal axis, the reservoir was able to irrigate the surrounding grounds through gravitational channels, taking advantage of the natural slope. While the southern end of the basin was even with the ground level, its northern end reached a height of 4.2 meters above ground level, requiring the reinforcement of cuboid buttresses to counteract the thrust of the water mass.[87] Like most Almohad-era constructions in the city, the basin's retaining walls were made from a mixture of *pisé*, lime, and gravel and were roughly 5.6 meters thick, forming an upper walkway along the pool's edge. On the east and west, evidence can be seen of a lower walkway as well, with staircases providing access to the basin at the four corners and at the center of each side.[88]

In addition to providing irrigation water for the city's agricultural efforts, the Agdal

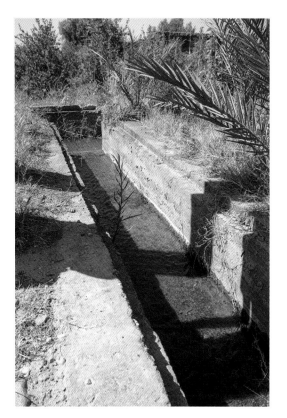

FIGURE 48
Irrigation channel feeding the *buḥayra* within the Agdal. Photo: author.

basin also supplied the city's drinking water and was used for swimming and military naval exercises.[89] In order to further utilize the space for public rituals and imperial ceremonies, the second Muʾminid caliph, Abu Yaʿqub Yusuf, constructed a large pavilion known as the Dar al-Hanaʾ (Pavilion of Well-Being, though this name is only attested as far back as the nineteenth century) from which to preside over such events. Ibn Sahib al-Salat describes one such festival to which the tribal delegations and foreign dignitaries had been invited: "On Friday, 22 Rabiʿ II [January 2, 1171], after the Friday prayers, the Commander of the Faithful left for the *buḥayra* [referring to the walled garden known as the

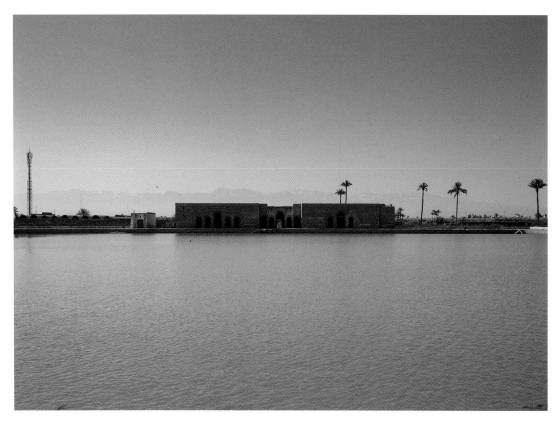

FIGURE 49
The Agdal garden *buḥayra*, looking toward the late Mu'minid
pavilion known as the Dar al-Hana'. Photo: author.

Agdal] on the outskirts of the city of Marrakesh, and he held a feast for those delegations who had arrived that lasted 15 days. Each day more than 3,000 men entered, greeted the caliph and received his blessing, and moved towards the channel that was filled with the *robb* [a sweet wine diluted with water] that was customary then."[90]

From the Dar al-Hana', located at the southern end of the reservoir and at the garden's topographical height, Abu Ya'qub Yusuf could look out not only over those gathered within the garden but over the entirety of the Mu'minid royal quarter and Marrakesh itself. This vantage point also served as the ideal location from

which to stage processions into the *raḥba* or as a gathering place before embarking on expeditions elsewhere. Even under 'Abd al-Mu'min these ceremonies were elaborately orchestrated affairs, complete with drums and the white banners of the Almohad faithful. A significant component of these parades was the dual procession of two Qur'ans preceding the caliph wherever he went, one purportedly having belonged to the third *rashidūn* ("Rightly Guided") Sunni caliph, 'Uthman, and another that had been Ibn Tumart's personal *muṣḥaf* (copy of the Qur'an). References to the use of these Qur'ans appear throughout sources describing the Almohad period, including Ibn Sahib al-Salat's *Tārīkh*

al-mann bi'l-imāma and al-Marrakushi's *Muʾjib fī talkhīṣ akhbār al-Maghrib*, as well as subsequent works like Ibn Marzuq's *Musnad*, the *Ḥulal al-mawshiyya*, and al-Maqqarī's *Nafḥ al-ṭīb*, indicating their importance in Muʾminid ceremonial. Though none specifically mentions the appearance of the Qurʾans within the Agdal, given their prominence in other ceremonial practices (as will be discussed subsequently), it is reasonable to assume that they also appeared in these ceremonies.

The grand orthogonal axis created by the gardens, *raḥba*, and Tamarrakusht encouraged processions—both military and religious, but always with a political dimension—between the three spaces and activated their potential for staging the Muʾminid self-concept as an imperial force that paradoxically retained its nonurban, sectarian identity. Surrounded by the verdant gardens filled with aromatics and groves of trees, made possible through the extensive hydraulic network and situated directly between the urban center and the Atlas Mountains, the Muʾminid caliph positioned himself as an intermediary between the imperial capital and the dynasty's spiritual and ethnic homeland. The large open spaces, enclosed by walls but definitely outside the nexus of dense urban space, provided the staging ground for exhibitions of caliphal authority in a sort of formalized ruralism that negotiated the challenge of urbanizing a community that had been resistant to large-scale settlement while maintaining that community's pastoral habits. These spaces leave much to be desired as architectural monuments—thanks either to poor preservation or to the scant use of built architecture—but as public staging grounds, they were enlivened through the religious, military, and political ceremonies that defined Muʾminid presences in the city.

Precedent and Adaptation in Muʾminid Ceremony

The pageantry of the rituals did not spring fully formed from the early days of ʿAbd al-Muʾmin's reign but rather drew on precedents from the Islamic west that connected the Muʾminid caliphate and the Almohad movement to a long history of Islamic authority. As a nascent dynasty with little experience in the traditions of imperial projection, the Muʾminids were faced with the question of how to express their connection to the Almohad movement and its origins in tribal politics on a much grander scale. The Almoravid example, which largely looked to Abbasid protocols for its architectural references, had already been dismissed as unacceptable by Ibn Tumart and was therefore not only discarded but needed to be directly rebutted. This was accomplished by ʿAbd al-Muʾmin's rejection, abandonment, and closure of Almoravid sites within Marrakesh, underscored by the considerable attention paid to developing a new quarter outside the original walls of the *madīna*. As ʿAbd al-Muʾmin focused on transitioning the eschatological religious movement of Almohadism into a sustainable and functioning empire, the architecture and urban space of this new quarter needed to concentrate the communication of power on the Muʾminid caliph as the key figure in this transition. To do so, the Muʾminids (primarily ʿAbd al-Muʾmin, but with Abu Yaʿqub Yusuf building on his example) looked to a ceremonial and ritual vernacular already well established in the Maghrib—that of the Spanish Umayyad caliphate.

The connection between the tenth-century Iberian caliphate and the twelfth-century Muʾminids has been well established by scholars such as Amira Bennison, Jessica Streit, Maribel Fierro, and Pascal Buresi, whose work is integral to the present study. As one of the most significant political and cultural touchstones in the

medieval Islamic west (the other, of course, being the Fatimid caliphate in Egypt), the Umayyads exerted an exceptional amount of influence on the art and architecture of the region, perhaps even more so in hindsight, as part of cultural memory, than in their heyday.[91] Their influence can be felt in the region's approaches to both architecture and landscape but should be understood in light of twelfth-century political and social concerns. Moreover, those components of the Mu'minid adaptations that were changed should be highlighted as conscious departures from the past, whether building on them, refocusing them for a new audience, or deliberately underscoring their differences. By communicating the new regime's power through a recognizable vernacular, the Mu'minids could be sure that they were being understood by the local populace as well as foreign dignitaries, but through subtle additions to such ceremonies or by adapting their staging, the Mu'minids further communicated the ethnosocial undercurrent of their caliphate.

Returning to the site of the *raḥba* and the caliphal *qubba*, the primary locus of interaction between the figure of the Mu'minid caliph and the public, we see an immediate reference to Umayyad practice in the use of the red tent to signal the caliph's presence. The Umayyads had been known to use similar pavilions, also featuring red tents, when gathering or reviewing their armies, establishing a martial association with the structure.[92] The Umayyads were likely drawing on the example of the Prophet Muhammad, who reportedly received a delegation from the Thaqif in a red tent as well, but under the Umayyads, the connotation of reception was shifted to one of review, from diplomacy to military action.[93] Even if the caliph himself was not present, the red tent became a stand-in for his person, reflective of his caliphal authority.

Andalusi historian and pro-Umayyad commentator Abu Marwan ibn Hayyan (d. 1076) noted that on one occasion, during the reign of al-Hakam II (d. 976), the caliph sent a red tent with his military commander Ghalib ibn ʿAbd al-Rahman on an expedition to the Maghrib as a marker of his authority, to "manifest [the Umayyad caliphate's] prestige and enrage the heart of the enemy."[94] That the Umayyad presence in the Maghrib was largely defined by their struggle against the Fatimids for regional hegemony, marked by internecine struggle among the multitudinous factions that served as religiopolitical proxies for the two larger empires, only further underscores the tent's martial associations for a Maghribi audience.[95]

But in the Umayyad oeuvre, the caliph's role as a military leader was only one aspect of his rulership and not even necessarily the primary one. The Mu'minid program made the caliph's role as the head of the Almohad forces paramount, reflecting the peripatetic habits of the Mu'minid court, its origins in a religious movement based on jihad, and an ambivalence toward the built environment. Sources hint at the fact that the Mu'minid *qubba*, in Marrakesh as well as in other imperial capitals like Seville and Rabat, was likely the temporary structure of the red tent; Ibn Abi Zarʿ notes that such a red tent was where ʿAbd al-Mu'min received the *bayʿa* of the Berber tribes, and Ibn Sahib al-Salat describes Abu Yaʿqub Yusuf's first campaign to al-Andalus as featuring a large red pavilion in the field.[96] The tent's appearance in the *raḥba* and its role in the ceremonies that took place there further emphasize the military nature of the Mu'minid caliphate and, as Bennison notes, the "dedication of their military power to religious ends was constantly reiterated by the performance of prayer and Qur'an recitation."[97] In the context of Marrakesh's urban history and the Mu'minid

response to the Almoravid approach to urbanism, the use of temporary structures as a symbol for caliphal authority must furthermore be understood as a direct rebuttal of the Almoravids' descent into sedentary habits. By using a symbol of movement and martial prowess in such a public location, where ceremonies visibly staged the hierarchy of Almohad society in microcosm, the Mu'minid caliph preserved the moment of transition into urban decadence so feared in Ibn Khaldun's narrative model of power. Having reached the peak of its righteous authority and *aṣabiyya*, the Almohad movement (as encapsulated in the figure of the Mu'minid caliph) had not yet descended into the tranquil seduction of sedentary life. Repeated not only at the outset of military excursions but annually, too, as part of the necessary sociopolitical negotiations that maintained the Almohads' tribal confederation, these ceremonies reinforced the position of tension in stasis occupied by the Mu'minid caliph.

Yet another element from the Umayyad ceremonial program appears in the very structure of the parades through the Mu'minid city, that of processing behind two Qur'an codices as an expression of caliphal piety and authority. As mentioned above, the Mu'minid caliph was preceded by the *muṣāḥif* of both 'Uthman and Ibn Tumart in a direct appropriation and adaptation of Umayyad practice. For the Umayyads, the use of the Qur'an in an imperial context signaled their entry into the contest for regional hegemony in the Islamic west, for which their primary opponents were the Shi'i Fatimids. The use of the Qur'an of 'Uthman in public ceremony was part of a dialectical program of propaganda, one that emphasized the Umayyads' staunch support of Sunni orthodoxy and the Maliki tradition as well as recalling their Levantine heritage and the prerogative of the Banu Umayya to lead the Islamic faithful before all others.[98] Part of

this role was the public reading from the codex, which was housed in the *maqṣūra* constructed as part of al-Hakam II's expansion of the Great Mosque in Córdoba.[99] By the second half of the twelfth century, however, it had made its way into the Almohad treasury, though the sources differ on whether it came into their possession under 'Abd al-Mu'min or Abu Ya'qub Yusuf.[100] It then became a regular feature in the reports of Mu'minid processions, and al-Marrakushi describes these parades as follows: "And this volume [of the Qur'an] we have mentioned was from the copies of 'Uthman—may God be satisfied with him—which came to [the Almohads] from the treasure stores of the Banu Umayya. They carried it in front of them wherever they went upon a red she-camel [adorned] with precious trappings and a splendid brocade of great cost. . . . Behind the camel came a mule similarly adorned carrying another copy [of the Qur'an] said to be written by Ibn Tumart, smaller than the Qur'an of 'Uthman and ornamented with silver."[101] Bennison has extensively discussed the significance of 'Uthman's codex in Mu'minid ceremonial as a symbol of caliphal legitimacy, drawing connections between 'Abd al-Mu'min's dynasty and the Spanish Umayyads. She argues that the codex was part of a concerted effort on behalf of the Mu'minid dynasty to accord it the kind of religious legitimacy enjoyed by the Umayyads at the height of their power.[102] However, it is important to consider the significance of Ibn Tumart's *muṣḥaf* in these processions as well, which often coincided with military victories.

Upon initial inspection, it would appear that Ibn Tumart's *muṣḥaf* is accorded a secondary place, following after 'Uthman's, and their decorative materials would corroborate this claim. 'Uthman's codex is enclosed in a gold and silver case and famously adorned with a number of jewels, including a large ruby in the shape of

a horse's hoof.[103] In contrast, Ibn Tumart's is much simpler, covered only by gold-plated silver. Even their modes of transport seem to suggest this imbalance; ʿUthman is accorded a red she-camel, while Ibn Tumart is placed on a mule. However, I would suggest that this arrangement could also be symbolic of Almohad religious claims, particularly Ibn Tumart's status as the *mahdī*. As a reformist movement, Almohadism revolved around the character of the *mahdī*, particularly his asceticism and his doctrinal focus on knowledge over interpretation.[104] The two Qurʾanic codices were very visual reminders of Ibn Tumart's criticisms of the Maliki school and their Almoravid patrons, who he believed had strayed too far from the sources of true knowledge, and of the source of his and his chosen successor's roles as redemptive spiritual guides. That his *muṣḥaf* follows that of ʿUthman is in accordance with his role as a reformer and the *mahdī*, literally the second coming of communal salvation. One could even compare the order with that of the *ʿumūm* ceremony, in which the Muʾminid caliphs are "announced" by the family of ʿUmar al-Sanhaji; similarly, though the ʿUthmanic codex is the Qurʾanic standard, it is superseded by that of Ibn Tumart.

Constructed Genealogies and the Duality of the Muʾminid Identity

The precedent set by the Umayyads clearly loomed large in the cultural memory of the Maghrib as the chief example of what it meant to establish an empire based on religious authority. Indeed, in their most expressive modes of communicating authority and stability, the Umayyads were largely playing to a Maghribi audience in an attempt to dissuade them from supporting the Fatimid cause.[105] In a belated sort of reciprocity, ʿAbd al-Muʾmin's early dynastic efforts were largely concentrated on

communicating a similar, if updated, form of authority to the Andalusi and Arab factions that populated the wider Maghrib and the Iberian Peninsula. This required a delicate negotiation between the Almohads' Berber background and a more widely understood imperial vernacular, perhaps most expediently expressed through the construction of an Arab genealogy. Al-Baydhaq records two lineages for ʿAbd al-Muʾmin that tie him to the Islamic heartland and to the significant figures of early Islam (at least, in the Maghribi conception of such a history).[106] Of the two, the more widely circulated one connected him on his father's side to Qays b. ʿAylan b. Mudar b. Nizar b. Maʿadd b. ʿAdnan, the progenitor of the Banu Qays who governed northern Syria and formed a major political bloc under the first Umayyad caliphate (661–740) and from whom the Spanish Umayyads traced their own lineage. Promoted in later sources such as the *Ḥulal al-mawshiyya* and al-Marrakushi's *Muʿjib*, this ancestry granted ʿAbd al-Muʾmin a legitimate claim to the caliphate, which required an agnatic connection to the Prophet Muhammad, according to the commonly accepted doctrine in the Islamic west. As outlined by Ibn Hazm, the caliphate was the sole province of the "descendants of Fihr ibn Malik [a direct ancestor of the Prophet and progenitor of the Banu Quraysh] . . . and for this we rely on the word of the Messenger of God, who said that the imams or chiefs will be of the tribe of Quraysh."[107] While ʿAbd al-Muʾmin's ancestry is indirectly connected to the Prophet Muhammad, the Banu Qays and the Banu Quraysh did share a common ancestor in Muʿadd b. ʿAdnan, thus providing ʿAbd al-Muʾmin with a legitimate yet innovative channel through which to push his caliphal claims. As a propagandistic tactic, the promotion of this lineage appears to have been successful, having won over the Banu Hilal and Banu Sulaym, two

prominent Arab tribes that had settled in Ifriqiya and would go on to form an important branch of the Almohad military.[108]

Al-Baydhaq also provides ʿAbd al-Muʾmin with a Qurayshi ancestry by tracing his mother's relation to the figure of Gannuna, the daughter of Idris II, who professed direct descent from the Prophet Muhammad through his daughter Fatima.[109] However, as has been noted by both Fierro and Bennison, cognatic or matrilineal chains of ancestry in pursuit of sharifian claims were considered weak or suspect, with the exception of connections through Fatima.[110] Why then does al-Baydhaq include this second genealogy, which is left unacknowledged in later accounts of ʿAbd al-Muʾmin's ancestry? It is likely because Ibn Tumart also claimed sharifian authority through the same figure, which bolstered his position as the *mahdī* through genealogical connections as well as spiritual ones.[111] By connecting himself to the Idrisids—who were credited with converting the Maghrib to Islam in the late eighth century—and through them to the Prophet Muhammad, Ibn Tumart was demonstrating one of the characteristics by which the *mahdī* should be recognized. Though he never claims the title for himself, in his discourse on the principles of Almohadism, *Aʿazz mā yuṭlab*, Ibn Tumart describes the nature of the *mahdī*'s nobility as twofold: he must exhibit both an acquired nobility (*ḥasab*) and an inherited nobility, or, in other words, genealogy (*nasab*).[112] Conveniently, Ibn Tumart appears to have fulfilled both of those requirements, the former through his establishment of the Almohad movement, and the latter through his connection to Fatima.[113] For ʿAbd al-Muʾmin, then, this claim to a common ancestor has less to do with claiming a connection to the Prophet Muhammad and creating an Arab ancestry—which had been accomplished through his patrilineal line, albeit on a less grand

scale—than with bolstering his position in relation to Ibn Tumart and the Masmuda.

Much like the ceremonies that took place in the *raḥba* and Agdal, this secondary genealogy of ʿAbd al-Muʾmin's was designed to confirm and strengthen his claim not only to the caliphate but also to rulership over a potentially fractious confederation of Berber tribes, a confederation largely formed from a tribe different from his own. ʿAbd al-Muʾmin's ties to the Zenata threatened to undermine his authority among the Masmuda and, as we have already seen, nearly succeeded in doing so in the early days of his leadership. Ibn Tumart's doctrinal emphasis focused on a pan-tribal form of *aṣabiyya* that superseded internecine conflicts through subscription to the Almohad ideology, but after his death, it was put under great stress as the result of ʿAbd al-Muʾmin's transition to leadership. In order to maintain the momentum the Almohads had achieved, ʿAbd al-Muʾmin needed to justify his authority not only to the larger social groups of Ifriqiya and the Maghrib—as represented by his ancestral connections along the maternal line—but also back to Ibn Tumart and the Masmuda. Rather than taking his constructed lineage at face value, we must understand it in this particular context as part of maintaining that connection to the *mahdī*. ʿAbd al-Muʾmin had formally rejected his Zenata ties to become the adoptive son of Ibn Tumart through his marriage to Safiyya b. Abu Imran, the daughter of one of Ibn Tumart's earliest companions from Tinmal.[114] As Streit has argued, these dual lineages allowed ʿAbd al-Muʾmin to "present himself as the heir to whoever was politically expedient, regardless of contradictions," thereby maintaining the delicate balance by which he had come to power in the first place.[115] But rather than viewing one genealogy as superseding the other after his

ascent to the caliphate, as has been suggested elsewhere, the promotion of ʿAbd al-Muʾmin's Qaysi ancestry is more likely reflective of a later program of "de-Almohadization" by later authors and copyists, who viewed Ibn Tumart as "an eccentric character to be avoided at all costs."[116]

Moreover, as Maya Shatzmiller has observed, the practice of Berber groups' creating Arab genealogies for themselves was fairly common by the twelfth century. In both al-Andalus and the Maghrib, dating as far back as the days of the eighth-century Islamic expansion, various Berber vassals to both the Umayyads and the Fatimids constructed an Arab lineage as part of an expanded or heightened political role at court.[117] Moreover, with the emergence of the Idrisid dynasty, which claimed a sharifian ancestry of its own and would vacillate between Umayyad and Fatimid allegiance in the course of its tumultuous hold over the region, the role of an Arab / Prophetic genealogy became simply another trope in the royal expression of legitimacy. The Almoravids had claimed a Himyaritic lineage (i.e., from southern Arabia or Yemen) not only for Yusuf ibn Tashfin and his family but also for the entire Sanhaja confederation as part of their assumption of power, though this particular legend was already widespread in the Sous Valley by the time of the early Almoravid state. While the Muʾminids' lineages are not quite so exaggerated, this underscores the widespread use of such genealogies in the discourse of power.[118] It also calls into question just how emphatic these lineages were meant to be if their use was to be expected and, coincidentally, calls attention to variations within the norm, such as ʿAbd al-Muʾmin's dual genealogies that connected him not only to the Umayyads but also back to Ibn Tumart. That this latter lineage disappears in late manuscript recensions reflects

more upon the manuscripts' post-Almohad authors than on the early Muʾminid purpose in composing them in the first place.

Taken in conjunction with the ceremonial practices that were also adapted under ʿAbd al-Muʾmin, a subtle yet effective program of caliphal propaganda begins to emerge, one that "deployed all the material, ideological and symbolic resources at his disposal, regardless of mutual contradictions."[119] At least in the short term, under his reign as well as those of his son and grandson, such a program should be considered effective, as all three figures were successfully able to contribute to the expansion and enrichment of the empire, particularly with respect to Marrakesh.[120] They constructed a new lockable royal market adjacent to Tamarrakusht, encouraging the burgeoning trading economy that filtered through the city, and a hospital within the *madīna* dedicated as a charitable foundation, where Abu Yusuf Yaʿqub al-Mansur "ordered perfumed and fruit-bearing trees to be planted within and installed flowing water to all the rooms in addition to four pools in the center, of which one was made out of white marble."[121] These endeavors highlighted the Muʾminids' commitment to their capital city, while their formal public engagements maintained an authoritative distance from the public and densest part of the city, thereby avoiding the pitfalls so vividly demonstrated by the Almoravid example. By doing so, they could maintain the prestige and authority expected of the caliphal title, qualities that were confirmed through the mediated visibility of the caliphal personage and confirmed through the urban fabric of the Muʾminid royal quarter.

The concept of religious and political authority requiring such mediation, particularly within the confines of urban life, taps into a much wider pattern of rulership evidenced throughout the

Islamic world, in which the transition from a ruling Islamic minority to a larger Muslim majority necessitated new paradigms for expressing exclusivity.[122] This problem has been discussed in the context of the Abbasid move to Samarra, the Fatimid development of al-Qahira, and the Umayyad construction of Madinat al-Zahraʾ.[123] While a direct reference to the Abbasids would have been rejected owing to their connection with the Almoravids, the early Muʾminid court could look to both the Fatimids and the Umayyads for precedents in manipulating urban space to frame the figure of the caliph in ways that projected his authoritative difference into the landscape. For the Umayyads, this meant a remove from Córdoba to the caliphal city of Madinat al-Zahraʾ, where the suburban complex could create controlled axial vistas through topographical manipulation, "bypassing the established power base and long-standing associations of the older city, which . . . already had an existence independent of whichever king inhabited it."[124] Likewise, the Fatimids also sought to turn seclusion to their advantage with an urban *tabula rasa*, establishing al-Qahira as the physical manifestation of Ismaʾili cosmology, which contrasted with the majority Sunni population of commercial Fustat.[125] However, both Madinat al-Zahraʾ and al-Qahira functioned as codependent spheres with the older, more established cities from which they had ostensibly broken away. Neither city was completely self-sufficient. Rather, they grew out of preexisting relationships with Córdoba and Fustat, respectively, creating a sense of continuity and an "integrated relationship between the ruler and the ruled" that would persist in the Islamic west.[126]

The Muʾminid expansion of Marrakesh adapts this paradigm, retaining the elements of ceremony and ritual that drew attention to the caliph and defined the Almohad version of the caliphate. But rather than using this program as a bridge between the public—as embodied by the existing urban fabric—and the caliph encapsulated in a new imperial city, the Muʾminid approach relocated those ceremonies to an adjacent (albeit new) city quarter, developing a constructed site to serve as the stage. This in turn shifts the caliphal locus elsewhere, for as has been discussed above, the Muʾminid royal quarter functioned more as a site for mediated public interaction with the caliph rather than the caliph's exclusion from the public. Given the north-south axis that governed the space, accentuated by the topographical incline and the continually reenacted processions along this axis, we must consider the visual potential that this directed focus encourages. Set against the backdrop of the Atlas, Muʾminid ceremonies continually depicted the caliph as bringing salvation and religious knowledge down from the mountains, resonating with the local populace as reinforcing the dynasty's Berber origins. This is the key to understanding the southwestern expansion of Marrakesh, particularly as it was conceived under the first three Muʾminid rulers. Rather than engaging directly with the city, carving space out of the urban density of the *madīna* for palaces, fortresses, and other built structures, ʿAbd al-Muʾmin's urban vision was more about creating these staging grounds that mediated public contact with the Almohad elite. In some ways, this is yet another reaction to Ibn Tumart's criticism of the Almoravids; the informality with which the Almoravids had treated their exposure to the public reflected, at least to Ibn Tumart, the degree to which they were susceptible to corruption and decadence. The Muʾminid program is, by comparison, much more highly mediated, putting the Almohad elite at a remove except in those arenas in which everything around them confirms the narrative of their origin and rise

to power. This is, of course, the ideal for any imperial dynasty seeking to project its authority visually, but the real innovation of the Muʾminid project was to use recognizable ritual programs and signifiers—such as those adapted from Umayyad al-Andalus—in a setting that simultaneously recalled their own identity as Masmuda Berbers and their connection to Ibn Tumart.

The Muʾminid program of urban expansion, in self-conscious contrast to the haphazard nature of Marrakesh's Almoravid era, deliberately crafted staged areas of public interaction with the caliph that framed the Muʾminid dynasty in the moment of transition from religious movement to dynastic empire. ʿAbd al-Muʾmin and his descendants, especially the first two generations of Muʾminid caliphs after him, were likely aware of Ibn Tumart's criticisms of the Almoravid emir for his easy accessibility, which undermined the powerful cult of personality that characterized so many Maghribi movements couched in sociopolitical and ethnoreligious terms. The urban structure of Marrakesh under their reign responded to this concern in its use of the topography and enclosure to place Muʾminid authority within a liminal space. This liminality is certainly spatial and possibly even temporal to the degree that the ceremonies and rituals performed within those spaces recalled moments that became increasingly remote as the dynasty matured. By performing the ceremonies within these locales, the Muʾminid caliph could renew his connection to Ibn Tumart, the Almohad movement, and the Berber origins that underwrote his right to rule.

The Kutubiyya, Tamarrakusht, the *raḥba*, and the Agdal garden each spoke to this heritage, albeit in highly specific ways particular to their larger function inside the city. The Kutubiyya, while symbolizing a return to form in the larger context of Maghribi qiblas, confirms a societal habit of the Almohad community on an urban and imperial scale. Meanwhile, Tamarrakusht reflects an overall ambivalence and caution toward this very urban space, placed at the edge of the *madīna* and clearly demarcating a transition from the city into an altogether different category of space. Using the feminine form of Marrakesh places the district at a tangential relationship to the rest of the city, an ambivalent urbanism that helped the Muʾminids walk the line between urban and rural, settled and nomadic. The Khaldunian model of empire, in which urbanism leads to an entropic decadence, is thereby placed in stasis here. The use of the *raḥba* and the Agdal confirms Muʾminid ambivalence toward urban space and further cements the role of such an ambivalence in maintaining the Muʾminids' connection to their past, both spiritual and sectarian. By staging public audiences and tribal rituals within the *raḥba*, the caliph was able to perform those elements of political negotiation particular to the Berber tribes, like the *jumūʿ* and *ʿumūm* ceremonies, in a highly public manner that made them an indelible part of the Muʾminid ethos. The Agdal, too—although its ceremonies are reminiscent of Umayyad practice—was nevertheless imbued with references to the Almohad past with the incorporation of Ibn Tumart's Qurʾan as an integral element of the processional relics. Even the structure of the Agdal, recalling the agricultural practices of the Atlas Masmuda in negotiating seasonal herding grounds and political territories, further inflects the space with a sectarian identity. The topography takes advantage of this, lifting the Muʾminid constructions along their north-south axis into the hills out of the Haouz Basin, framing these ceremonies within a context that continually reenacts their emergence from the Atlas as the harbingers of reform.

Each one of these spaces also places the figure of the Mu'minid caliph at a remove from the general public, which had a dual effect within the corpus of imperial identity creation. First, restricting the public's interaction with the caliph to those sites and ceremonies that confirmed his heritage (either real or constructed) as a Berber, and a Masmuda in particular, heightened the effects of the ceremonies in re-creating that identity. Second, divorcing the strict cult of personality from the social contract's understanding of power preserved the authority of the caliph within the momentum of the Almohad movement. At least within the early generations of the Mu'minid caliphate (by which I refer to the reigns of ʿAbd al-Muʾmin, Abu Yaʿqub Yusuf, and Yaʿqub al-Mansur), the transition of power was negotiated in such a manner that after the death of the ruler, the new caliph was imbued with the widely acknowledged attributes that connected authority to the force of the Almohad movement. The *qubba*, the ceremonies of the *raḥba*, and even the processions into and out of the Agdal: all were symbols of social and spiritual authority that were easily carried across generations. The highly mediated nature of the Mu'minid caliph's public appearances stands in direct contrast to the practices of the Almoravids, whom Ibn Tumart criticized for being too accessible, which weakened their claims to moral leadership. The figure of the Mu'minid ruler, by continually associating himself with the Mahdi as the source of divinely ordained authority wherever large public gatherings occurred on a regular basis, could become an abstracted emblem of the Almohad movement's *ʿaqīda*. The very structure of Marrakesh's urban form, as it shifted from the common space of the *madīna* to walled districts of increasingly restricted access, confirmed and shaped that authority in a powerful play upon the public's perception.

It must not go unremarked that the foundational element within this program of urban ceremony and the deliberate staging of space is the landscape and topography of the Haouz Basin. The Mu'minid expansion of the city toward the southeast takes advantage of the gentle rise into the Atlas foothills, granting the *raḥba* a slight perspectival advantage over the *madīna* (and the Agdal garden an even greater one). From the heart of the city, the Kutubiyya Mosque's realigned qibla echoes this directionality, redirecting the urban focus away from the enceinte and toward the periurban spaces associated with the Mu'minid dynasty. Although reasonably justified by the return to the use of Suhayl in its calculation, a method with sound precedent among scholars, this realignment nevertheless carried a host of secondary implications, drawing the eye and metaphysical attention toward the new urban districts. The *raḥba* and Agdal, following out from this axis, were then crafted to display the Mu'minid court in a context that echoed their Masmuda heritage. Both of these spaces, separated from the *madīna* and from each other by high walls and ornamental gates, were topped by the rim of the Atlas Mountains, ever-present in their deceptive nearness. The ancestral home of the Masmuda, the tribe of Ibn Tumart as well as the majority of the Almohad faithful, watches over Marrakesh, imbuing the Mu'minid expansion of the city with a subtle yet powerful societal resonance. Its presence is more than a mere backdrop, however; it is, in fact, the crucial element that makes the Mu'minid program of imperial and religious performance work. With Tinmal serving as an architectural expression of the links between the dynasty—as embodied by the Kutubiyya in Marrakesh—and its spiritual heritage, the Atlas Mountains activated the liminal space between them. It is against this backdrop that the processions up and down the Agdal

and within the *raḥba*, which draw upon the dynasty's Almohad origins as expressed through their affiliation with both Ibn Tumart and the Masmuda tribe, become fully realized within both geographic and temporal space. By staging these performances as such, the Muʾminids continually reenact the Almohads' emergence from the Atlas at the moment of their spiritual and military apotheosis. It was also at this moment, when the movement conquered Marrakesh from the Almoravids, that the expression of *aṣabiyya* among the Almohads was at its highest, blurring the lines between tribal affiliation and religious subscription. As the transition from religious movement to political dynasty unfolded throughout the reign of ʿAbd al-Muʾmin and under his successors, maintaining this cohesion and the authority that stemmed from it became paramount. These performances, and the spaces in which they occurred, were vital in the attempt to hold Almoʿhad spiritual righteousness and Muʾminid political power in equilibrium.

I have argued here that while these practices and spaces were maintained, such a strategy of expressing the interwoven strands of religious, political, and sectarian authority was relatively successful. It was only later, as the Muʾminid caliphs moved away from Ibn Tumart as a source of imperial legitimacy, that the delicate social balance realized through the unitarian doctrine of the Almohads began to fracture beyond repair. Particularly at Marrakesh, with its role as a dynastic capital making implicit references to a more spiritual and ethnicized one, these ceremonies and spaces retained their power to shape the identity of the Muʾminid caliph. The city drew upon allusions to both an immediate past as well as a longer tradition in the Islamic west to create a *genius loci* that placed the Muʾminid caliphate within a multivalent conceptual model of authority. In observing the early urban patterns of Marrakesh and the criticisms Ibn Tumart heaped upon the Almoravids, it is clear that the Muʾminid model sought to stave off dynastic entropy through a sophisticated network of highly mediated and hierarchical spaces. But as shall be discussed in the following chapter, this model was inherently tied to its own place, its sense of the landscape, and what that landscape meant to a primarily Masmuda population. In the other cities of major imperial patronage— Seville and Rabat—these strategies lost their symbolic power.

Almohad Urbanism Elsewhere

SEVILLE AND RABAT

The subtlety and sophistication of the urban model established at Marrakesh cannot be fully understood without an exploration of its implications elsewhere—namely, in Seville and Rabat, the two other cities that served as urban centers of the Muʾminid empire. Seville, or Ishbiliya in the Arabic sources, had been conquered under ʿAbd al-Muʾmin's forces in the late 1140s, not long after he cemented his authority over Marrakesh and effectively ended Almoravid control in the Maghrib. Already a wealthy agricultural and administrative center by the time of the Almohads' arrival, Seville became a regional capital from which to establish an Almohad presence in al-Andalus, incorporated into the route established by ʿAbd al-Muʾmin's itinerant court.[1] If Seville then became one pole of the empire, with Marrakesh at the southern end, then Rabat became the halfway point along this route. Located along the Atlantic coast, Rabat was the ideal location for amassing forces for Andalusi campaigns, as ʿAbd al-Muʾmin determined in 1151. This city, too, became a regular stop in the constant military campaigns, not only for ʿAbd al-Muʾmin but for his son and grandson as well. Both cities received significant rounds of architectural and infrastructural attention under the first three Muʾminid caliphs—congregational mosques, fortifications, aqueducts, and waterways—that reflected their strategic importance and the societal ambitions attached to their

urban development. And yet, both cities retain little of their Almohad-era constructions and were casualties of imperial decline in the later generations of Muʾminid rule.

Seville and Rabat mark generational shifts in the oeuvre of Almohad urbanism, and each city's development in the period can be loosely mapped onto the reigns of the second and third Muʾminid caliphs. Abu Yaʿqub Yusuf (r. 1163–84) spent a significant period of his young life as the Almohad governor of Seville, and shortly after his ascension to the caliphate, he returned to the city and embarked upon an extensive program of renovations, expansion, and new construction. Abu Yusuf Yaʿqub al-Mansur (r. 1184–99) had a more antagonistic relationship to al-Andalus, which began with his father's death in Portugal and continued through successive offensives, including the Battle of Alarcos in 1195, a monumental victory that earned him his epithet of al-Mansur ("the Victorious"). Instead, the third Muʾminid caliph set his sights on Rabat, with the apparent ambition to transform the military outpost into a far grander metropolis on the scale of Marrakesh and Seville. Both Abu Yaʿqub Yusuf and Abu Yusuf Yaʿqub al-Mansur took their cues from the established plan at Marrakesh, founding congregational mosques that elaborated on the hierarchical forms of the Kutubiyya and crafting each city's outer limits—their monumental gates, walls, and other fortifications—in a manner that

framed the city as an urban stage for expressing dynastic authority. The impact of ʿAbd al-Muʾmin's urban approach can be keenly felt in his successors' respective efforts, and indeed, each city also bears some of his direct interventions, as both came under Almohad dominion during his reign. But whereas Marrakesh was designed to speak to a specific audience with whom the Muʾminids were intimately familiar, at Seville and Rabat, that message appears dissonant, at odds with their surrounding environments, both natural and man-made.

In uncovering the twelfth-century urban morphology, there are also historiographical concerns to take into account, many of which have made analyzing Almohad contributions to Seville and Rabat difficult. At Seville, the Almohad period is an interlude in a long history of urban development; centuries of occupation prior to the Almohads' arrival meant that any new constructions had to contend with the preexisting urban fabric, which obscured some of the subtlety crafted through hierarchical boundaries in the Muʾminid plan. Moreover, Almohad sites in Seville were subject to extensive destruction or renovation in the centuries after the city fell into Castilian hands as part of the Reconquista in 1248. The congregational mosque sponsored by Abu Yaʿqub Yusuf was converted into a cathedral that same year, its orientation redirected toward the east and internal dividers set up to create chapel spaces. But in 1401, the entire structure of the prayer hall was demolished to make way for a new Gothic-style cathedral, leaving only a few remnants of the original Almohad space in the courtyard and minaret-turned-bell tower. The rest of the Muʾminid monuments suffered similar fates, frequently converted or renovated beyond immediate recognition. Archaeological excavation has done much to rehabilitate these spaces, but it is of limited effectiveness in a city

that was continuously inhabited. At Rabat, similar concerns are instead rooted in the opposite problem; after the city was conquered in the 1248 by the rival Marinid dynasty, it was effectively abandoned. The early ambitions for this new foundation were never realized. It was left to crumble and fade into relative obscurity as an enclave for Iberian refugees after the 1492 expulsion of Muslims from sovereign Spanish territory. Imperial neglect meant that Muʾminid monuments were mined for building materials over the intervening centuries, and shock waves from the Lisbon earthquake of 1755 caused extensive damage, which was left unaddressed until the foundation of the French Protectorate of Morocco in 1912.

Thus, there are significant challenges in comparing Seville and Rabat with their southern counterpart at Marrakesh, but as I have argued in the preceding chapters, this does not necessarily imply an absent avenue of research. Rather, as at Marrakesh, a more oblique understanding of the Almohad period in these cities is necessary, examining the monuments not only in isolation but in their relationship to one another as well as the surrounding landscape. Doing so highlights their affinities with one another, drawing from the urban program established at Marrakesh under ʿAbd al-Muʾmin to create a hierarchy of space and an ambivalent relationship with their suburban surroundings. But this approach also underscores the uniqueness of Marrakesh in both its effective subtlety and expression of imperial identity. Absent the imposing presence of the Atlas Mountains, both Seville and Rabat struggled to enunciate the crucial connection between dynasty, tribe, and homeland.

ALMOHAD ISHBILIYA

Unlike Marrakesh, Seville had a long history of occupation well before the Almohad conquest

of the city. Its earliest remains date to the eighth century BCE, when it was an island on the Guadalquivir River, which was navigable from the Atlantic Ocean inland as far as the island and whose unpredictable flooding patterns made settlement around the river difficult.[2] According to Isidore of Seville, the city's inhabitants built their houses on stilts to safeguard against the river's moods, which led the Phoenicians to name the city Hispalis, or "island on stilts."[3] As the river's tributaries shifted and dried over the centuries, successive waves of inhabitants began to build new settlements in the appearing landscape. In the seventh century, the Phoenicians settled just south of Hispalis on the higher ground along the banks of the Tagarete, one of the Guadalquivir's tributaries, which formed the older city's southern boundary; in 206 BCE, the Romans established a veteran outpost to the northwest of Hispalis known as Italica, which also took advantage of higher ground for both infrastructural and military purposes. The region continued to prosper economically as a hub in the commercial exchange of the western Mediterranean, exporting precious metals as well as flax and wool to the rest of the Roman Empire. In 45 BCE the city was surrounded by its first network of walls (no longer extant), which enclosed an axis created by two perpendicular streets: the Decumana Mayor, running east from what is today the Plaza de Alfalfa to the Puerta de Carmona, and another from the Church of Santa Catalina through the Alfalfa to the area of the cathedral today (fig. 50). An aqueduct, public baths, and a functional sewage system served the city's increasingly sophisticated elite, and although successive invasions of the Vandals and the Visigoths upended the stability and wealth of the city, its infrastructure remained, ensuring continued settlement at a key point along the Guadalquivir River.

But the most profound changes to the city were to arrive with the expansion of Islam into the Iberian Peninsula in 756 CE, when Hispalis was conquered and its name adapted into Arabic as Ishbiliya. Although the capital of the Andalusi Umayyads would be moved to Córdoba, Seville (as the city shall be referred to from here on out) remained an important economic and geopolitical center and a significant recipient of caliphal patronage. Indeed, the Islamization of the city represents one of its more profound morphological shifts, establishing a fundamental urban framework that would persist until the eighteenth century. Unsurprisingly, the first documented structure established was a congregational mosque that became known as the Mosque of Ibn ʿAdabbas, located to the west of the Plaza de Alfalfa and founded in 829 under the reign of ʿAbd al-Rahman II (d. 852). Adjacent to the mosque was the gubernatorial palace, built between 889 and 890, though its existence can only be attested textually, as no archaeological

FIGURE 50
Plan of Roman Seville. Ashley Whitt, after F. Collantes de Terán Delorme, *Contribución al estudio de la topografía sevillana en la Antigüedad y en la Edad Media* (Seville: Escuela Gráfica Salesiana de Sevilla, 1977), 74.

Bab Qurtuba
(Cordoba Gate)

Bab Qarmuna
(Carmona Gate)

0 500 m

Huerta del Rey

Buhayra al-Kubra

Alcázar

Bab Maqrina
(Macarena Gate)

Old mosque of 829

Almohad mosque
of 1182

Bab Sharish
(Jerez Gate)

Dar al-Sina'a
(naval arsenal)

Torre del Oro

Torre
de la Plata

Bab Jawhar
(Royal Gate)

evidence remains to give us any more particular details. The conflation of the mosque and representative seat of government into a singular locus was quite common to many of the urban efforts undertaken after the conquest, with similar arrangements attested from Iraq to the Maghrib throughout the eighth and ninth centuries, part of what has been called the "urbanizing intention" of the expansion.[4]

But with the crumbling and collapse of caliphal authority after the civil war (*fitna*) that ended in 1031, Seville became one of the many city-states, or *mulūk al-ṭawāʾif*, ruled more or less independently by their former public servants—in this case, the family of the city's magistrate and judge (*qāḍī*) Abu al-Qasim Muhammad Ibn ʿAbbad (d. 1042). The ʿAbbadids, as they became known, were responsible for laying the foundations of a palace whose successive iterations and expansions would firmly place the political locus of the city on the eastern edges of the walled *madīna*. Known today as the Real Alcázar

of Seville ("alcázar" being a corruption of the Arabic *al-qaṣr*, or "castle"), the ʿAbbadid palace abutted the city walls, while a large garden surrounded it on the exterior, a complex known as the Buhayra al-Kubra (fig. 51). Taking its name from the drained lake that supplied the fertile soil of its orchards and formal pavilions, the garden was a productive working landscape as well as an aesthetic respite from city life, conveniently located through the city gates.[5] Other suburban villas sprang up around the Buhayra al-Kubra, and although little remains after centuries of rebuilding programs, their poetic descriptions detail aromatic gardens interwoven with pools and studded with domed structures.

My purpose in lingering over this description of Seville's history is to emphasize the layered and dense urban fabric that met the Almohad forces upon their conquest of the city in 1147. Unlike Marrakesh (or even Rabat, as we shall see later in this chapter), Seville had a thriving, developed urban core that any Muʾminid plans for expansion or renovation would need to contend with. The city was already walled and had both a congregational mosque and a series of palace structures. Gardens provided both pleasurable and productive spaces for the city's inhabitants. Only a few decades prior, in 1126, the Almoravids had renovated the city walls under the order of ʿAli Ibn Yusuf, enclosing those parts of the city that had expanded beyond their Roman borders.[6] The subtlety and clarity of the Muʾminid urban plan, as conceived of at Marrakesh, required space to develop the series of hierarchical spaces that framed the ruling elite so distinctly. Seville seemed ill-equipped to provide such a stage.

But the city's strategic importance, in addition to its established reputation as a commercial and political powerhouse during the *ṭāʾifa* period, made Seville indispensable to the Almohads' Andalusi ambitions. Its geography

in particular—112 kilometers from the Atlantic coast in the twelfth century—allowed the Almohads direct access to the heart of al-Andalus without having to fight their way across frequently hostile territory. Navigable by ship up to the point of Seville, the Guadalquivir River was the primary route to the city, and as such it shaped the city's urban morphology and settlement patterns. It held extraordinary irrigative capacities, creating a rich fluvial plain that supported Andalusi agriculture, including the largest center of rice production (a water-heavy crop) in Spain.[7] But the river could also be highly unpredictable, flooding its banks with exceeding irregularity as its course shifted westward from the Roman era through the medieval period (its course has remained relatively stable since the twelfth century).[8] While the majority of these floods happened in the winter, their intensity and reach were hard to predict in the area around Seville, and fear of flood damage was a constant for Seville's inhabitants throughout the Islamic period, up to and including Almohad occupation.[9] Adding to these concerns was the presence of the Tagarete along the city's eastern fringes; this tributary of the Guadalquivir further enclosed the city's morphology and proved a further source of flooding anxiety. Water, a scarce and precious resource in the environs of Marrakesh, was an abundant menace in Seville. While the Muʾminids would sponsor extensive renovations and new constructions over the course of their tenure within the city, their most profound contributions would take the form of infrastructural projects to manage Seville's waterways.

These efforts would inflect almost every aspect of Muʾminid construction, much of it begun under Abu Yaʿqub Yusuf, who had spent the majority of his young adult life as the governor of Seville while his father, ʿAbd al-Muʾmin, maintained his itinerant court. The exception

to this was the construction of a *qaṣba* in 1150 in response to complaints from citizens that Almohad troops had spilled out into the cemetery known as al-Jabbana, located just south from the *ṭāʾifa*-era palace outside the city walls. ʿAbd al-Muʾmin sent his first governor of Seville, Yusuf ibn Sulayman, to arrange housing for the Almohad forces. His solution was to effectively dismantle the palace of Ibn ʿAdabbas, which had been next to the congregational mosque, and use its stones as raw material for a new garrison (*qaṣba*) next to the *ṭāʾifa*-era palace inside the city walls. This required the forced eviction of numerous Sevillians from their homes, and although they were supposedly compensated with new homes elsewhere in the city, it fostered further discontent among the Almohads' subjects.[10] According to Ibn ʿIdhari, writing in the fourteenth century, the distress was "harder for people than being killed and it greatly increased their cares and woes. . . . The people did not stop complaining about this exchange through the reigns of the first, second, and third caliphs."[11] Tensions between the Sevillians and the Almohad troops garrisoned in the city were still high in 1157, when an Andalusi delegation to Marrakesh requested that ʿAbd al-Muʾmin send one of his sons to govern Seville instead.

Abu Yaʿqub Yusuf thus arrived in Seville with the explicit mission to stabilize Almohad authority in the region, a project that would continue throughout his governorship and well into his tenure as caliph. Politically, Abu Yaʿqub Yusuf took strategic steps to assure Andalusi alliances, marrying (and later divorcing) the daughter of Ibn Mardanish (d. 1172), a *ṭāʾifa* king of Murcia who had allied with the Christian Castilians in rebellion against Almohad dominion.[12] He also appointed governors from Maghribi tribes loyal to the Almohad cause in the Andalusi provinces, and he brought Andalusi elites into positions of

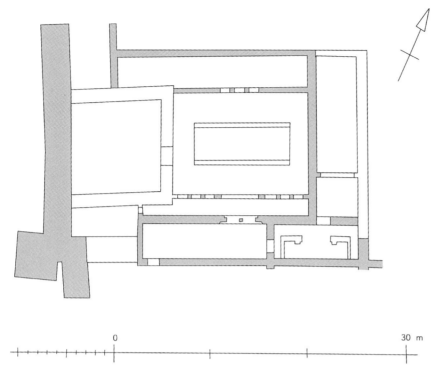

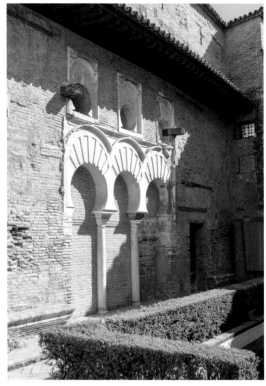

moderate authority in his gubernatorial court at Seville. Architecturally speaking, Abu Yaʿqub Yusuf's contributions to the city largely took place after his elevation to caliph, which is noteworthy in that this required extensive periods of Andalusi residence (away from the Masmuda homeland in and around Marrakesh). Drawing from certain precedents already established at Marrakesh by his father, he attempted to craft an Almohad legacy at Seville that relied on the symbiotic relationship between city and landscape, sponsoring constructions both urban and suburban. After his appointment to caliph in 1163, Abu Yaʿqub Yusuf spent a stint of five straight years, from 1171 to 1176, in Seville, during which the majority of these urban projects were undertaken at his direct behest. It would appear that another significant stay was also planned in 1184, when he would initiate work for a monumental new

minaret for the city's congregational mosque, but his sudden death after an ill-advised siege of Santarém in Portugal cut short any further ambitions.

Continuing the 1150s renovations near the palatial complex at the southeastern edge of the city, Abu Yaʿqub Yusuf oversaw further expansions of the Alcázar. Given the site's history of continual occupation and expansion from the tenth century onward as well as its current status as a residence for the Spanish royal family, most of the direct exploration of the Alcázar's Almohad elements has focused on textual and archaeological sources. Altogether, there were at least six renovated enclosures within the original ʿAbbadid palace and another nine in ʿAbd al-Muʾmin's expansion.[13] Two of the most visible, well-preserved examples are the Patio del Yeso (Courtyard of Stucco) and the Palacio del

Crucero (Palace of the Crossing), both named for their post-Almohad descriptions and purposes rather than for their medieval function.

The Patio del Yeso is a small courtyard located near the southwest corner of the ʿAbbadid fortress, an approximately square space featuring a rectangular pool in the center, running along the patio's east-west axis (fig. 52). The southern façade of the patio (on its northern wall) dates from approximately 1150, likely part of ʿAbd al-Muʾmin's efforts at the site, and features a central arcade of three blind horseshoe archways, surrounded by radiating voussoirs that recall those of earlier Umayyad palaces at Córdoba (fig. 53).[14] On the opposite side, toward the south, Abu Yaʿqub Yusuf sponsored the construction of a new hall in 1172, of which only the entrance façade and portico are now preserved, looking out onto the Patio del Yeso (fig. 54). The portico features a large central lambrequin arch supported by two brick piers, flanked on either side by three smaller polylobed arches standing upon two columns each. The lateral façades are topped with pierced stucco in an open latticework of interlocked arches, while the central arch features a blind alfiz panel carved with similar interlocking arches. Through the central arch, the entrance to Abu Yaʿqub Yusuf's new hall emerges, a singular column dividing two horseshoe arches, surrounded by a panel of alfiz with minimal ornamental decoration and two small windows to allow light into the space. The column dividing the hall's entrance perceptually bisects the main archway of the portico, a symmetrical patterning between portico and entryway that creates a sense of rhythm and depth, amplified by the reflection of the pool in the courtyard's center. Some scholars have noted parallels between the ornamental hierarchy of the Patio del Yeso's façades and the program found at the monumental Almohad minaret

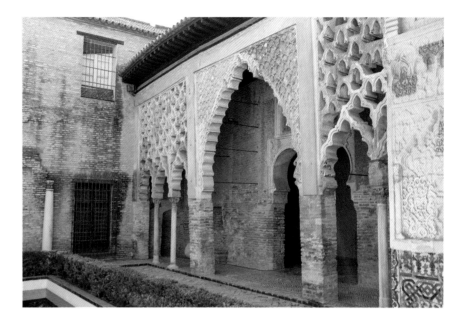

constructed nearly a decade later, an exaggerated version of the hierarchy established at the Alcázar.[15] What is more, we can see these ornamental hierarchies—developed in Marrakesh under ʿAbd al-Muʾmin—becoming more refined and heightened in Abu Yaʿqub Yusuf's Andalusi experiments.

The Palacio del Crucero, which was constructed upon the occasion of Abu Yaʿqub Yusuf's ascension to caliph in 1163, was the largest of the enclosed palaces built within the Alcázar, with a central courtyard measuring sixty-eight meters long and forty-five meters wide. Much of the structure was subsequently changed after the Reconquista came to Seville in the thirteenth century, but a significant portion of the palace's courtyard has been excavated, enough to establish a plan and hypothetical reconstruction of the space. The courtyard was oriented along an approximate northwest-southeast axis, the palace surrounding it a two-storied structure with two broad reception halls at the northern and southern ends. Its most remarkable feature,

however, was the sunken garden that occupied the center of the courtyard. A walkway circumscribed the perimeter of the garden, while two others crossed at right angles at the garden's midpoint, both walkways elevated so that its patrons could walk level with the tops of the trees planted below. The walkways that crossed the center of the patio were suspended above a water basin that would have irrigated the garden and provided a reflective surface for the dappled light coming through the trees. While sunken gardens and bridged water basins were not entirely new concepts in al-Andalus, their combination in the Palacio del Crucero was innovative and would have created a paradisiacal space that played with light and transparency in equal measure.

Other enclosures and palaces from the Almohad era remain in some form—among them the Patio de la Contratación and the Patio de la Montería—but subsequent interventions have raised doubts about their precise chronology. It is sufficient here to note that while Abu Yaʿqub Yusuf did expand the Alcázar significantly, those particular contributions were of a private nature, designed almost exclusively for an elite experience. What is perhaps more notable in its comparison with Marrakesh is that Almohad Seville saw a number of public and suburban projects come to fruition as well, again largely under the direction of the second Muʾminid caliph. In addition to the Alcázar, Abu Yaʿqub Yusuf commissioned a series of suburban palaces in the Buhayra al-Kubra, funded by the state treasury and housing a large variety of fruit trees from all over the Iberian Peninsula. Pear, plum, apple, and olive trees were planted throughout the estates, and Abu Yaʿqub Yusuf tasked the *qāḍī* Abu al-Qasim Ahmad ibn Muhammad and the imam Abu Bakr Muhammad ibn Yahya with overseeing these new orchards. They are named explicitly in the sources for "their knowledge of surveying, soil preparation, and cultivation to design for him [Abu Yaʿqub Yusuf] everything concerning his palace constructions and the barren land surrounding them."[16] As architectural historian D. Fairchild Ruggles has pointed out, this was one of the earliest Hispano-Islamic references to what we might call a garden designer (as opposed to an agronomist, who would be more concerned with production yields and crop efficiency).[17] Modern urban sprawl and continuous habitation since the twelfth century have left few physical remnants of the Buhayra al-Kubra, but place denominations as well as early modern archival documentation have helped scholars outline the garden's dimensions and paint a distant picture of the Almohad-era space.[18]

The Buhayra and its estates immediately recall the Agdal at Marrakesh, and indeed Abu Yaʿqub Yusuf had a hand in developing those Maghribi estates as well. Both gardens technically lay outside the city walls, but their location adjacent to each city's royal quarters gave them a tangential relationship to the walled *madīna*. Measuring approximately seventy-eight hectares, the garden was originally surrounded by a *pisé* wall. Although no remnants have yet been excavated, making it difficult to draw a precise outline of the garden's dimensions, the general hypothesis posits a quadrangular enclosure extending eastward. Like the Agdal, the Buhayra al-Kubra also featured a large pool as its principal element, measuring forty-three meters square and located in the garden's western end. A palatial pavilion has been excavated to the east of the pool, mirroring the polar organization between inner-city palace and suburban palace that had already been constructed at Marrakesh. Where the two differ, however, is in their relationship to the surrounding landscape. The Maghribi capital, with the Atlas Mountains forming a dramatic backdrop to the ceremonies

and processions organized within the Agdal, utilized the garden as an interstitial space in which the Muʾminids could perform their identity as Masmuda Berbers. Absent that landscape at Seville, and in an environment decidedly less legible in terms of its ideological associations, the Buhayra al-Kubra reads more ambiguously. In order to establish a clear program of dynastic authority and identity, Abu Yaʿqub Yusuf needed a clear, unequivocal architectural message.

The most dramatic of these was, undoubtedly, a new congregational mosque. The new mosque of Seville formed the new religious heart of the city, relocated from the Umayyad-era Mosque of Ibn al-ʿAdabbas. This shifted one of the primary loci of public engagement from the heart of the *madīna* southward toward the fringes, in keeping with the Muʾminid preference outlined at Marrakesh for a tangential elite expansion away from the more densely built center. According to Ibn Sahib al-Salat, the older Umayyad mosque no longer fit the city's population of Muslims for Friday prayer, and the faithful were spilling out to pray "in the patios and porticos and the shops along the contiguous streets."[19] In the medieval Maghrib, the decision to found a new congregational mosque on the grounds of space restrictions was common; this justification frequently had as much to do with distinct ideological shifts as it did with population growth, and in the case of Seville, the choice was likely some combination of both.[20] Seville's long history prior to its status as an Almohad capital certainly implies a more developed urban core, and careful archaeological analysis has traced the city's rapid expansion into the neighborhoods south and west of the royal quarter as the city became a cultural center in the *ṭāʾifa* period under the ʿAbbadids (r. 1023–95). And while the Almohads certainly looked to the Umayyads for architectural and urban

precedents, as has been discussed in previous chapters, the radical departure of early Almohadism from the Maliki tradition of the Islamic west called for distinct architectural spaces to signal this new chapter of Islamic practice.

The new congregational mosque was begun during the month of Ramadan in 1172, that year in May, under the supervision of Ahmad Ibn Baso, an architect and engineer (*muhandis*) who had already assisted the Almohad forces in constructing a garrison at Gibraltar. He oversaw a team of architects gathered from around al-Andalus and the Maghrib, including both Seville and Marrakesh, to outline the foundations for the new mosque and level the ground, which featured a three-meter variance between the qibla wall and the courtyard as the ground sloped down to the Tagarete. To address this imbalance, builders constructed a wedge-shaped platform of mortar to create an even, horizontal plane for the prayer hall's foundations and diverted the subterranean sewers that ran underneath to prevent any future shifting in the foundations due to erosion.[21] Abu Yaʿqub Yusuf was apparently so invested in the project that he visited the site nearly every day, accompanied by his brother or members of the court.[22] The process of laying the foundation alone took nearly four years, which speaks to the complexity of the endeavor.

By 1176, the majority of the mosque had been constructed, although the first sermon (*khuṭba*) was not given there until 1182. The mosque followed a rectangular plan, measuring approximately 100 meters by 150 meters, with a large prayer hall toward the southeast and a courtyard directly opposite the qibla wall (fig. 55). The courtyard, known today as the Patio de los Naranjos, represents the primary portion of the mosque that remains extant following the site's conversion into a cathedral. The prayer hall took the typically Almohad T-shaped hypostyle form,

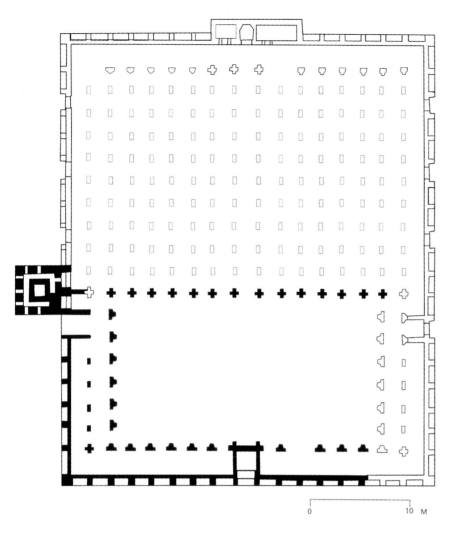

FIGURE 55
Plan of the congregational mosque
at Seville. Ashley Whitt.

as well as a dome of carved stucco within the mihrab.[23] Excavations undertaken in the late 1990s revealed the remnants of the mosque's qibla, located within the present-day Patio de los Limoneros that belongs to the Alcázar. Although all that remains is the lime and ashlar masonry, remnants of a *sābāṭ* leading toward the palace could be identified, confirming Ibn Sahib al-Salat's account of the passageway.[24]

The same excavation also revealed remnants of carved stucco decorated with polychromy on the exterior of the qibla, hinting at a much more elaborate ornamental scheme than that of the Kutubiyya in Marrakesh (fig. 56). They reveal fragments of interlacing *sebka* with vegetation filling the interstitial space, acting almost like a trellis for the climbing vines, which, Jessica Streit has argued, encouraged the viewer toward a more mimetic reading of the architectonic and organic forms. This reading draws upon the writings of contemporaneous Andalusi philosophers and members of the courtly intelligentsia (specifically the *ṭalabat al-ḥadar*; see chapter 2) Ibn Tufayl (d. 1185) and Ibn Rushd (d. 1198, better known in Europe as Averroes). Both espoused an intrinsically rationalist worldview that complicated Ibn Tumart's exoteric teachings, in which observation of the natural world served as proof of God's existence, perhaps a more palatable reading of Almohad principles for an Andalusi audience. The ornamental program suggested by the stucco fragments of the Seville mosque may thus have served as a visual meditation practice within the mosque, emphasizing the philosophical outlook of two of the region's most prominent and respected scholars.[25] While the placement of the stucco fragments remains debatable—their excavated provenance on the exterior of the qibla raises questions as to whether they belonged to the mosque's ornamental program or were instead part of the

measuring seventeen aisles east to west and thirteen transepts north to south, each of which ended in a door onto the courtyard. Brick piers, likely plastered and whitewashed, supported horseshoe arches between the aisles, which would have been exaggerated into polylobed and lambrequin forms along the qibla aisle and transept. Ibn Sahib al-Salat notes that particular attention was paid to the mihrab of the mosque, which featured three cupolas in the transept space directly before the niche that utilized small skylights to allow light to penetrate the interior,

sābāṭ—the increased naturalism of their vegetal scrollwork suggests that the Andalusi iteration of Almohad ornamental hierarchies was a conscious attempt to respond to its audience. For Sevillian Muslims, more wary of Almohadism and its Maghribi proponents, this modification of the ornamental program may have been more recognizable and walked the delicate line between subscription to Almohad beliefs and more traditional Maliki thought.

If the mosque's interior decorative scheme showed evidence of adapting the tenets of Almohad faith to the Andalusi, the towering minaret that abuts the prayer hall is a characteristic example of the dynasty's ordered architecture. Known today by its Spanish name, La Giralda, the minaret was built in the second phase of construction activity at the mosque, begun at the behest of Abu Yaʿqub Yusuf in 1184 and completed under his son's tenure as caliph by 1198 (fig. 57). The minaret is located on the eastern side of the mosque at the division between the prayer hall and the courtyard, a large cuboid structure measuring 13.6 meters by 50.5 meters, with a second tier measuring 14.4 meters by 6.8 meters, conforming to the proportional 1:5 schema of the Almohad type. Like the minaret at Marrakesh, which had been raised nearly thirty years prior, the Giralda was organized around a series of seven superimposed chambers with a ramp winding its way upward between them and the exterior wall. The second tier would have originally been topped with a tiled dome and a finial of four superimposed gold-plated spheres known as a *yamur*, but these elements have since been removed as the Giralda was converted into a bell tower following the fourteenth-century adaptation efforts at the site. Ibn Sahib al-Salat describes the ceremony marking the completion of the minaret as replete with drama, with a large cloth covering the finial whipped off in a flourish

to reveal "the most astonishing thing that had ever been seen or heard of."[26] Its ornamental program is more ordered and consistent than that of the Kutubiyya minaret, with each of its four faces exhibiting two parallel panels of interlaced *sebka* springing from two blind arches, topped by a second register of the same. Between each of the panels is a central unit of two registers featuring two recessed windows framed by a tall alfiz, which is filled with carved stucco surrounding a polylobed or lambrequin arch. The ornamental program on each face of the minaret mirrors the rise of the interior ramp, so the *sebka* panel begins at a staggered height, starting with the north face and then, sequentially, the west, south, and east. It is this hierarchy that has drawn comparisons to the Patio del Yeso, though such comparisons are hard to expand upon in light of both spaces' subsequent post-Almohad alterations.

FIGURE 56
Stucco fragments from the Seville mihrab. Ashley Whitt after Jessica Streit, "Well-Ordered Growth: Meanings and Aesthetics of the Almohad Mosque of Seville," in *"His Pen and Ink Are a Powerful Mirror": Andalusi, Judaeo-Arabic, and Other Near Eastern Studies in Honor of Ross Brann*, edited by Adam Bursi, S. J. Pearce, and Hamza Zafer (Leiden: Brill, 2020), 313, fig. 14.7.

FIGURE 57
The Giralda. Photo: author.

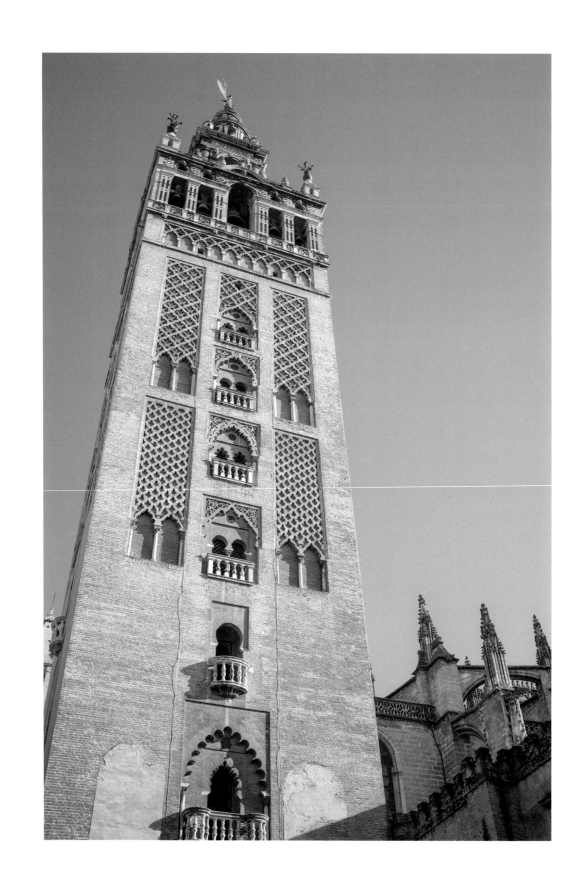

But while monuments such as the new congregational mosque and the expansion of the Alcázar were certainly impressive, beautiful examples of innovative and monumental architectural expression, the most integral of Abu Yaʿqub Yusuf's contributions were undoubtedly the public infrastructural works that formed the foundation for Seville's thirteenth-century prosperity. Under his reign, the city walls (initially begun under Almoravid rule) were completed along the western boundary, at least two major marketplaces were expanded, and a number of public bathhouses (*hammām*, pl. *hammāmāt*) were established near the congregational mosque as well as in residential quarters.[27] Both the textual and archaeological records attest to the exponential growth in the city's wealth during this period; pottery caches from what is today known as the Plaza Nueva indicate a thriving period of occupation and consumption from the Almohad era.[28] A key element underpinning Seville's Almohad-era renaissance was not any particular architectural structure, however, but rather the dynasty's approach to managing its water resources and hydraulic technologies. As at Marrakesh, the role of water management was one emphasized in court chronicles, and Ibn Sahib al-Salat devotes significant attention to chronicling these efforts. There are few explicitly named architects recorded by these historical sources, though Ibn Sahib al-Salat does make special note of those figures who were responsible for engineering the city's running water. But while Marrakesh's struggle was in bringing enough water into the Haouz Basin to allow for urban fountains, baths, suburban pools, and agricultural irrigation, Seville faced the opposite challenge—that of too much water, and water that behaved in erratic and frequently destructive ways. It is no wonder, then, that its mastery was such a vital component of the Muʾminids' urban policy.

Part of this policy involved renovating the Roman aqueduct that had fallen into disrepair, leaving much of the surrounding agricultural estates dependent on seasonal rainfall for their crops. Work began in 1171, after a survey of Seville's suburbs revealed the remains of an aqueduct on the road toward Carmona. According to Ibn Sahib al-Salat, "After inspecting these remains, the engineer al-Hajj Yaʿish discovered that they belonged to an aqueduct through which the water used to be brought to Seville, a work of the first Roman kings . . . Yaʿish continued to excavate without ceasing, with the help of miners and laborers and hundreds of men, until they discovered the ancient spring by the name of ʿAyn Gabar."[29] Altogether, the excavation uncovered 17 km of aqueduct, and under al-Hajj Yaʿish's supervision, the system was renovated to better distribute the water throughout Seville's environs. Originating around Alcalá de Guadaíra just south of the city, 10 kilometers of the canal ran through a subterranean system of *khettara*s, winding through the suburban estates east of the city (including the Buhayra al-Kubra) until reaching the district of what is today known as Torreblanca de los Caños. From there, approximately 5.3 kilometers flowed into an open-air canal in a grand curve diverted around the walls, finally utilizing the Roman system of arches of graduated heights to turn inward toward the city near the Puerta de Carmona for the final 1.7 kilometers. Once inside the city walls, the aqueduct branched off into two directions: toward the Alcázar and congregational mosque and toward the urban interior.[30] The aqueduct was a vital part of Seville's revivification under Abu Yaʿqub Yusuf, turning the surrounding landscape into a productive and—perhaps more importantly—stable agricultural region. Feeding urban cisterns, fountains, and pools, the aqueduct also guaranteed Seville a

1852.[31] The use of the ship hulls as the platform's support allowed the bridge a degree of flexibility to negotiate the Guadalquivir's fluctuations, thereby protecting the bridge and flow of traffic from seasonal surges and flooding. Abu Yaʿqub Yusuf also sponsored a number of other bridges around the city, smaller works that provided passage across the Tagarete, which wound around the eastern and southern borders of the city (fig. 58). These bridges, of which at least ten can be historically attested, took advantage of the hydraulic infrastructure already established under the caliph's reign; as the aforementioned aqueduct wound its way around the city, arches connecting it to urban sewage channels simultaneously supported pathways in and out of the city gates.[32] By the time of Abu Yaʿqub Yusuf's death in 1184, Seville had been thoroughly and physically linked to its surrounding landscape through its series of bridges, the antithesis of its Roman past as an isolated island city. Many of these bridges remained in use until well into the nineteenth century, underscoring their profound importance to Seville's social and economic livelihood.

Supporting this economic development of Seville during the twelfth century, in 1184 Abu Yaʿqub Yusuf also ordered the construction of quays on either side of the Guadalquivir, equipped with ramps to facilitate loading zones for merchant and military vessels (fig. 59). He also sponsored shipyards and ship sheds just outside the southern borders of the city, then located between the Bab al-Qataʾiʿ (Gate of Ships, known after 1248 as the Puerta de Triana) and the Bab al-Kuhl (Gate of Alcohol, whose contemporary identification is less clear).[33] The remains of these shipyards were discovered in a 2001 excavation of a former prison known as the Atarazana de los Caballeros (Shipyard of the Knights), revealing seven ship sheds measuring

supply of fresh water that was not dependent on the Guadalquivir's unpredictable temperament.

This challenge was also addressed through the foundation of a number of bridges that facilitated access across the Guadalquivir as well as the Tagarete, mediating communication between the city and its surroundings. The grandest of these was the bridge now known as the Puente de Barcas, oriented along the route leading from Seville toward Badajoz, which depended on the former's provisions in its defense against the Castilians. A series of thirteen ship hulls, placed one after the other, were strung together by an iron chain across the Guadalquivir, anchored on each riverside by brick piers. Across the top, a ten-meter-wide platform of wooden planks created an even surface over which dense traffic could cross. Although the bridge took a mere thirty-six days to build, the innovation of the bridge's pontoon construction made it one of the Almohad era's most lasting contributions to the city, maintained until it was replaced with the Puente de Isabel II in

approximately seven meters by forty-five meters. Ships could enter the yard through two gates located in its western wall; the gates opened into the Guadalquivir and are still preserved today (fig. 60).[34]

Protecting the port—and its valuable cargo— were two towers, the northern one known as the Torre de la Plata (Tower of Silver) and the southern one as the Torre del Oro (Tower of Gold), which are the most recognizable remains of the medieval port despite the Guadalquivir's shift westward. The Torre de la Plata is the older of the two, constructed as part of the port in 1184 as a watchtower to guard the quays as well as the Puente de Barcas and the primary entry into the city (fig. 61). An octagonal tower, the Torre de la Plata was constructed out of brick with ashlar masonry reinforcing the corners. Two narrow arched windows occupy the upper third of each face, with a single slim arrow slit on the story just below and merloned battlements encircling the top of the tower. It was incorporated into the city walls and later into the Casa de la Moneda under the reign of Alfonso X (r. 1252–84), dur- ing which the tower's original entrance was lost. A companion tower was built nearly forty years later, in 1220, at the behest of Abu al-ʿAla Idris al-Maʾmun (d. 1232), a son of Abu Yusuf Yaʿqub al-Mansur, who was then governor of Seville but would later jockey for control of the caliphate after the death of his brother. The river had continued its shift westward, and this new tower was intended to extend the city's maritime defenses. Known as the Torre del Oro, it was a grander iteration of the Torre de la Plata, using the same techniques of brick-and-ashlar con- struction to create a dodecagonal tower of three superimposed chambers (fig. 62). Its exterior decoration is also moderately more elaborate, with a hierarchical series of arched windows: the lowest tier features a single arched window on

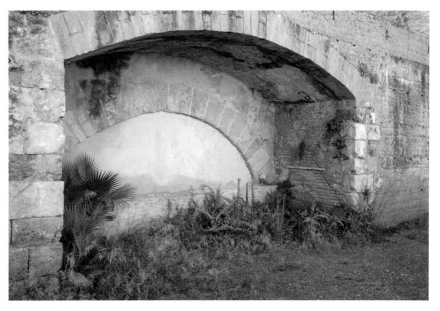

FIGURE 59 (*top*)
Reconstruction of the Almohad shipyard and its seven ship sheds, ca. 1221, with the extension of the southern wall and the con- struction of the Torre del Oro. Ashley Whitt after Carlos Cabrera Tejedor, *From Hispalis to Ishbiliyya: The Ancient Port of Seville, from the Roman Empire to the End of the Islamic Period (45 BC– AD 1248)* (Oxford: Archaeopress, 2019), 182.

FIGURE 60 (*bottom*)
Remnant of the Almohad-era shipyard gate. Photo: author.

FIGURE 61
Torre de la Plata. Photo: author.

every other face of the tower, with the upper tier featuring a smaller arched window on each of the tower's ten sides. Its uppermost tier, which also includes an additional story and lantern, was added after the Christian conquest of Seville in 1248. An iron chain was strung between the two towers, which could be raised to close the shipyard in case of siege.[35]

The initiative to revitalize Seville under its Mu'minid stewardship was both profound and long-lasting. The city's port became more active, encouraging greater trade and communication between al-Andalus and the Maghrib. Its bridges knit Seville into the heart of a rich and productive agricultural landscape, blurring the human boundaries between urban and rural, a feature

that even medieval writers noticed. In the words of Ibn Sahib al-Salat, the Puente de Barcas was founded "for the passage of the people of the city and the people of the countryside toward the city for their crops and occupations and businesses."[36] By the time of Seville's conquest, the city's population had grown exponentially. It housed as many as 95,000 people by some estimates, making Seville the second-largest city in the Iberian Peninsula and one of the largest in all of Europe.[37] The Mu'minid investment in urban infrastructure, and particularly in hydraulic infrastructure, laid the foundations for sustained growth and greater prosperity in the region, independent of the political instability generated by regular conflicts with the Castilians.

There are noticeable parallels with the Mu'minid program at Marrakesh, and it is clear that Abu Ya'qub Yusuf was building on the model established at the Almohad capital. The structural and ornamental similarities of their respective congregational mosques are most immediately apparent, with the Sevillian mosque employing the same plan for its prayer hall and structural form for its minaret, albeit both as slightly larger iterations of their Maghribi precedents. The creation of a large suburban garden complex recalls the foundation of the Agdal as well. But there are more subtle connections that reflect a deep engagement with the urban plan and the role the figure of the caliph would play within it. By shifting the location of the congregational mosque to the southern fringes of the city and adjacent to the palace complex of the Alcázar, Abu Ya'qub Yusuf created a distinct quarter that combined the spaces of both religious and political authority, just as his father had at Marrakesh. This tangential engagement with urban space, on the fringes of the walled *madīna*, had already worked effective stagecraft

at Marrakesh, where the Mu'minids could position themselves as continually engaging with their righteous religious past and certain norms of their ethnic heritage.

But the subtlety of that particular urban plan, in the context of a city with a much longer history of occupation than Marrakesh, becomes lost in the maze of renovations, restorations, and general urban sprawl. At their Maghribi capital, the Mu'minid quarter was clearly defined and entirely new; at Seville, although the Mu'minid contributions were generally clustered together, the city's well-established morphology failed to highlight the significance of that area. As a symbol of political power, the Alcázar was a compilation of sites, of different eras and rulers, and the subtle differences between them would likely have mattered little to the city's inhabitants until the Reconquista. What is more, the significance of the Mu'minids' tangential relationship to the city, its establishment of a social hierarchy and its recollection of a nonurban past, was disconnected from the experience of Seville's largely Arab-Andalusi population, which had a long history of equating power with urban centers—such as the Umayyads at Córdoba.

Despite Abu Ya'qub Yusuf's extensive sponsorship of the city, Seville would never completely accept Mu'minid authority. The tensions that had erupted during his father's commission for a new garrison never fully faded, and even during the second caliph's reign, numerous rebellions and internecine conflicts hampered the subtle ideological program established through the Mu'minid urban plan. After the third generation of direct Mu'minid rule, Seville would become the domain of the caliphate's rival contender for power, Abu al-ʿAla Idris al-Maʾmun, who would eventually abandon the Almohad doctrine and its official support of Ibn Tumart as the Mahdi.[38] He effectively abandoned the city

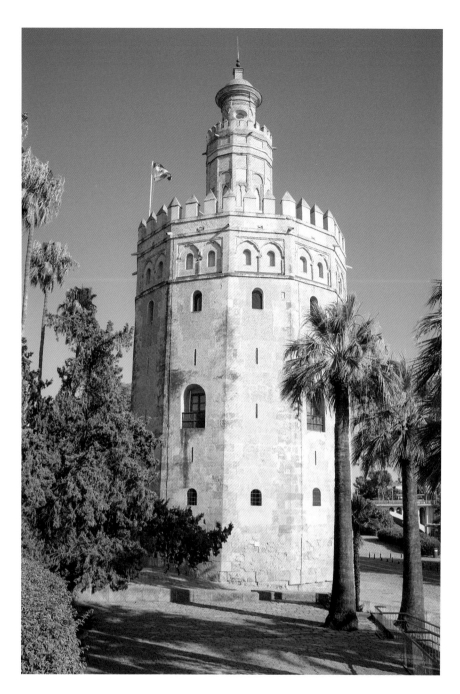

FIGURE 62
Torre del Oro. Photo: author.

by 1228, when he departed for the Maghrib in order to consolidate his authority there, leaving Seville at the mercy of the Castilians as city after city fell to Christian forces. For all of their dynastic efforts to support and enrich the city, the

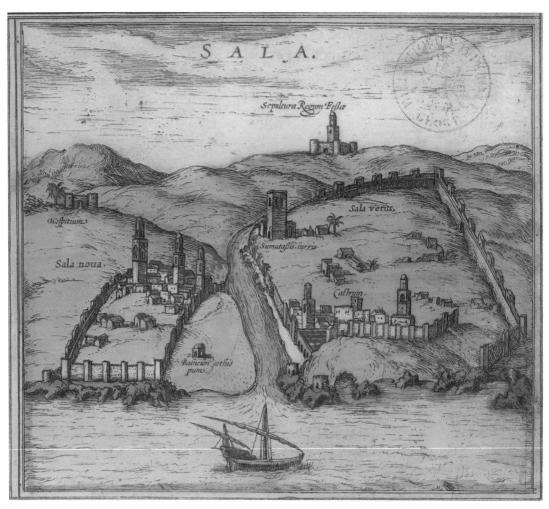

SALA.

FIGURE 63

Hans Hogenburg, engraving of the Moroccan coast with Salé on
the left and Rabat on the right. From Georg Braun, *Théâtre des
cités du monde* (Cologne, 1645). Bibliothèque nationale de France,
GE DD-1605.

Muʾminids remained outsiders in Seville, a tactic
that at Marrakesh enhanced their authority but
in Seville ultimately undermined it.

RIBAT AL-FATH

Along the banks of the Bou Regreg River, where
the estuary feeds into the Atlantic Ocean, stands
a rocky outcrop. At this juncture, considered
for much of its history to be the very edge of the

world, grew two settlements in an intercon-
nected (if, at times, competitive) relationship:
Sala (better known today by its French name,
Salé) on the right bank of the Bou Regreg, and
Ribat al-Fath (more commonly referred to as
Rabat) on the left (fig. 63). For the purposes
of examining Muʾminid urbanism, Rabat is
undoubtedly the primary focus of the two, but it
is impossible to discuss one without the other.

Indeed, the two banks of the Bou Regreg have even been considered a single entity on occasion. Yet the distinctions between Salé and Rabat are significant—namely, in their respective landscapes, urban organization, and social character—and affected their development in the Almohad era. Assessing that development, too, is complex, as the intervening centuries established new threads of connectivity between the cities. So while this chapter will focus primarily on the shape and fate of Rabat, reference to Salé will be necessary.

The earliest urban remains in the region date from the period of Roman occupation in North Africa as part of the province of Mauritania Tingitana. Though the province itself was annexed after the death of Ptolemy of Mauritania (d. 40 CE), who had served as Rome's proxy governor in the region, descriptions from Pliny the Elder date to 39 CE. He rather disparagingly dismisses the region as "near now to the wilderness, and much infested with Herds of Elephants."[39] Perhaps even more damningly, he notes that outnumbering the elephants were a tribe known as the Autololes, a particularly dangerous group constantly pillaging the countryside. (The Autololes are most commonly understood as a subsidiary of a local tribe that populated the region between the plains and the Atlas Mountains.) Here, along the Bou Regreg and barely five miles from the outermost *lime* (limit) of the Roman Empire, stood Sala Colonia, an outpost on the southern bank of the Bou Regreg, just outside of the southeastern wall of what would eventually become the Almohad-era urban limits of Rabat. The settlement was clearly intended for defensive purposes, with a large fortress known as the Oppidum Sala dominating the majority of the site, a civilizational buffer between the Roman Empire and the wilderness populated with the Atlas tribes so clearly feared by Pliny. But there

is evidence of a more permanent settlement as well: a large forum, paved roads, a senate meeting hall, and a triumphal arch have been identified through archaeological excavation.[40] These elements appear to have been more functional than luxurious. They certainly cannot compare to those further inland at Volubilis, the only other significant site of Roman settlement in the realm of the Maghrib, but they do indicate a settled and urbanized population outside of a strictly military and frontier role.

But Sala Colonia's position on the western fringes of the empire exposed it to external threats, and as the empire's influence and resources waned in the fourth and fifth centuries CE, the city was left to fend for itself. The sources are silent on the precise nature of Sala Colonia's decline, but Arab authors from the early Islamic period attribute it to the Vandal invasion of 476, when the tribe swept through the region from the Iberian Peninsula.[41] What is clear is that by the arrival of Muslim forces in 683, led by Arab general ʿUqba ibn Nafiʿ, the shores of the Bou Regreg were home to little more than ruins of the former Roman settlement and a small village on the opposite bank populated by Ghumara Christians, a subsidiary tribe of the Masmuda.[42] This settlement, too, faded quickly from the historical landscape, for Ibn Hawqal (d. 978) merely notes the existence of "Old Sala" in reference to the ruins of the Roman fortress. As Janet Abu-Lughod has pointed out, the absence of a tenth-century settlement along the Bou Regreg, an important entry point to the Gharb plain along the northeast and a buffer zone between al-Andalus and Ifriqiya, is notable in light of the geopolitical tension between the reestablished Umayyad caliphate and the Fatimids. She posits that this may reflect the Bou Regreg's role as a natural boundary between the territory belonging to the Barghawata, the Masmuda tribe that

had moved into the region south of the river by that period, and the confederation of Zenata tribes that controlled the area to the north.[43] This is confirmed in Ibn Hawqal's account, where he notes the existence of a fortified *ribāṭ*, an enclave for militarized mystics that could serve as tribal representatives, at the intersection of the Bou Regreg and the Atlantic:

> Beyond the Sebou River in the direction of the lands of the Barghawata, approximately one day's journey, is the Wadi Sala. There is the last place occupied by the Muslims, a monastery citadel [*ribāṭ*] in which the Muslims gather. The ruined city called Old Sala has been destroyed but people still live there, attaching themselves to a ribat by it. There are 100,000 holy soldiers [*murābiṭūn*] gathered in this place who attack at will. Their ribat is aimed against the Barghawata, a Berber tribe which has spread in this area along the Atlantic Ocean which limits the soil of Islam.[44]

Ibn Hawqal's description implies that while there was no major permanent settlement around the Roman ruins, there was a structure capable of accommodating quite a significant number of inhabitants that dates prior to the waxing of the region's fortunes by the turn of the eleventh century.

The fortress took on a new importance with the development of Salé on the right bank of the Bou Regreg, a town with semimythologized origins and a keenly felt role as the steward of religious well-being in the area. Most accounts agree that the region was settled by 1030 by an Andalusi Arab family known as the Banu ʿAshara, who descended, according to legend, from ten children who had been born simulta-neously and whose parents were granted the

land from the Umayyad caliph in recognition of such a remarkable feat.[45] Upon the arrival of the Almoravids merely twenty years later, a town with three distinct quarters had sprung up along the right bank. Representatives from both the Barghawata and the Zenata resided in their own respective quarters, and a third was reserved for the descendants of the Banu ʿAshara and a congregational mosque, known as the al-ʿAshara Mosque.[46] Enclosed by a wall system that abutted the old Roman road on its southern boundaries, the town of Salé was thus doubly insulated against the chaotic geopoliti-cal and religious landscape that surrounded it. Under the Almoravids, the *ribāṭ* across the river was alternately known as Qasr Bani Targha and as the Qasbat Amir al-Tashfin, the former title a reference to the clan that served as the Almoravids' representatives in the region, and the latter, an affectionate allusion to their service to the Almoravid emir. Though the *ribāṭ* certainly existed prior to the Almoravids' arrival, it took on a new significance as tension rose between the Almoravids and the Barghawata, who appear to have resisted their regional authority.[47]

By the time ʿAbd al-Muʾmin and the Almohad forces arrived in the region in 1146, Almoravid authority had been reduced to the *murābiṭūn* sequestered within the *ribāṭ* itself. Though the fortress held out against ʿAbd al-Muʾmin, Salé was unresisting, possibly due to its connection with the Barghawata, who were subsidiaries of the same Masmuda tribe as the bulk of the Almohad forces. Notably, the only stipulation from the Almohad forces was that Salé demol-ish its existing ramparts, as had been the case at Fez and Ceuta, as proof of the city's submission to Almohad authority.[48] After a relatively quick capitulation, ʿAbd al-Muʾmin then turned back to Marrakesh for the final assault on the remnants of the Almoravids, but he returned to the region

soon after being declared caliph in 1150. It was from here, at the *ribāṭ* across from Salé, that he gathered his forces together in order to launch new campaigns toward al-Andalus, whose provinces were proving rather contentious for the new caliph and his nascent empire. It is likely at this time, too, that ʿAbd al-Muʾmin realized the potential of the site as a secondary residence or capital at the intersection of the Maghrib and al-Andalus, both for military campaigns and for diplomatic and political meetings. It was a deliberate choice to erect an entirely new city across the river from Salé, a rejection of the region's historical associations with al-Andalus and a deliberate statement of the new regime's ambition and urban approach.

He almost immediately set about renovating the *ribāṭ*, turning it into a more permanent dwelling as a fortified palace, and commissioning a new congregational mosque and reservoirs designed to bring water in from the ʿAyn Ghabula springs nearly ten miles away.[49] In the midst of all this construction, ʿAbd al-Muʾmin invited the intellectual, literary, and political elites from al-Andalus who had recently pledged their allegiance to the Almohad cause to Salé. Referred to by the sources as rebels (*thuwwār*), it is clear that there was a certain tension between ʿAbd al-Muʾmin and his Andalusi allies, perhaps reflecting Andalusi anxieties about Almohad religious fervor and retribution.[50] Here they formally pledged the submission of their lands and titles to ʿAbd al-Muʾmin, and he in turn granted them clemency and incorporated them into the wider network of the Almohad elite, reconfirming their positions in Andalusi society as he did so. In a theatrical bit of staging, ʿAbd al-Muʾmin met with these notables in the courtyard of the former residence of the Banu ʿAshara (recall, an originally Andalusi clan) after having housed them in the countryside outside Salé's walls,

in full view of a massive construction site on the opposite bank.[51]

It is important at this juncture to highlight a distinction in the names that appear in the historical sources in reference to the cities on either side of the Bou Regreg and to note how those terms shift over the course of the Muʾminids' reign. The medieval sources tend to use two names for the city on the left bank, modern-day Rabat, apparently interchangeably: "Ribāṭ al-Fatḥ" and "al-Mahdiyya." However, Janet Abu-Lughod has convincingly argued that these two names were, in fact, distinct references to two different places. She notes that the original name given to ʿAbd al-Muʾmin's new urban project was "al-Mahdiyya," a name intended to honor Ibn Tumart, but that in the publication of a series of Almohad letters by Lévi-Provençal in 1955, three of the earliest letters, under ʿAbd al-Muʾmin's reign, are dated from "Ribāṭ al-Fatḥ." And yet the accepted histories of the Almohad era—sources like Ibn Sahib al-Salat—clearly indicate that "Ribāṭ al-Fatḥ" is used in reference to the "new" city built under Abu Yusuf Yaʿqub al-Mansur after his victory at Alarcos. To reconcile these contradictory designations, Abu-Lughod hypothesizes that "Ribāṭ al-Fatḥ" originally referred to the *qaṣr-ribāṭ* compound, while "al-Mahdiyya" referred to the small settlement outside the compound walls under ʿAbd al-Muʾmin's reign. She further suggests that the latter term never gained widespread acceptance and was abandoned after ʿAbd al-Muʾmin's death.[52] This hypothesis is in line with the gradual distancing of the Muʾminid court from Ibn Tumart's radical doctrine and with the city's revitalization under Abu Yusuf Yaʿqub al-Mansur, and I will therefore follow Abu-Lughod's designations from here.

Very few architectural remains from ʿAbd al-Muʾmin's reign have survived, thanks to post-Almohad periods of abandonment followed by

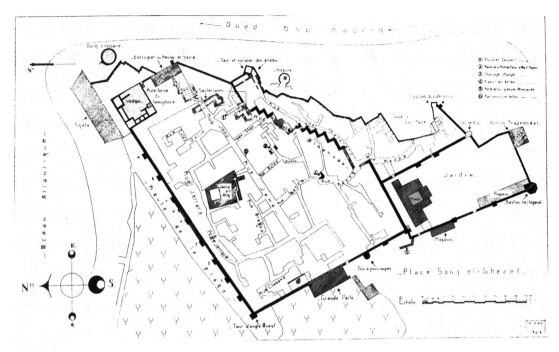

FIGURE 64

Plan of the Qasba des Oudayas. Ashley Whitt after Jacques Caillé, *La ville de Rabat jusqu'au protectorat français* (Paris: Vanoest, 1945).

waves of population increases in the seventeenth and nineteenth centuries. But what does remain tells a similar tale to that of Marrakesh—one in which the local landscape is manipulated to create a highly mediated urban space that confirms impressions of military strength (and, by extension, religious fortitude). The area that served as the site for ʿAbd al-Muʾmin's new construction is today known as the Qasba of the Oudayas, situated at the corner of the medieval city atop a steep outcrop. It is an extreme and striking landscape, not to mention a dangerous one. The *Kitāb al-istibṣār* notes that it was common knowledge among twelfth-century sailors and traders that the conflict between the ocean tides and the estuary made for a dangerous port, which probably explains Salé's preeminence until the Almohad era.[53] Yet it was precisely

this mutable nature that made the site such an attractive locale for a new settlement, particularly one intended to function as a *ribāṭ*, with all its military and jihadist connotations. The coast and riverbank formed natural defenses for Ribat al-Fath, protecting ʿAbd al-Muʾmin's assembled forces as they prepared to launch their attack on al-Andalus.

At the juncture of these bodies of water, ʿAbd al-Muʾmin had erected the walls of the *qaṣba*, which form an irregular pentagon stretching from the northeast to the southwest (fig. 64). Not all of what remains can be reliably dated to the twelfth century, but many of the extant restorations are evidently built upon twelfth-century foundations. This is particularly true for the northwest face of the wall that runs along the coastal side of the *qaṣba*; built directly

on top of the rock face, it would have received substantially more weathering from ocean winds and tidal erosion. The other portion of the *qaṣba* that postdates the Almohad era is the quarter that now encloses the Andalusi Garden and the Museum of the Oudayas, which appears to have been an extension of the medieval walls under Sidi Muhammad b. ʿAbd Allah in the middle of the eighteenth century. What can be reliably measured from the twelfth-century enclosure is an area measuring roughly 166 meters on the coastal side and 140 meters on the southwest inland side, with a wall measuring 162 meters running diagonally from the northeast toward the southwest, interrupted by the garden at one end and an eighteenth-century platform known as the Semaphore at the other. Because of these later interventions, it is difficult to precisely gauge ʿAbd al-Muʾmin's *ribāṭ*, but we can estimate that the mid-twelfth-century Ribat al-Fath enclosed roughly 2.5 acres of rocky terrain.

As mentioned above, of the urban construction belonging to the reign of ʿAbd al-Muʾmin, little remains in terms of complete architectural sites. According to Jacques Caillé, who wrote a definitive architectural survey of Rabat in 1945, only two of the pillars from an early palace can be reliably dated prior to ʿAbd al-Muʾmin's death in 1163.[54] The palace is no longer extant and was only located by Caillé through these two pillars, making a reliable map of the Almohad-era *qaṣba* virtually impossible. The other early-era monument within the *qaṣba*'s confines was, inevitably, a congregational mosque. Now known as the Jamiʿ al-Atiq, it has also received substantial renovations and additions since ʿAbd al-Muʾmin's day (most notably during Rabat's renaissance in the eighteenth century), to the point that nothing remains from the twelfth century. However, Caillé notes in his survey that the placement and elevation within the *qaṣba* are likely the same as

that of ʿAbd al-Muʾmin's mosque, and although this means little for the purpose of architectural analysis, it does afford us the opportunity to examine the plan of Ribat al-Fath and contemplate how the Muʾminid court moved through it.

Both the mosque and ʿAbd al-Muʾmin's palace were positioned at the heart of the *qaṣba* on opposite sides of what would have been the main thoroughfare, which ran northwest from the grand entrance to the *qaṣba*, parallel to the exterior walls, with the mosque on the northwest side and ʿAbd al-Muʾmin's palace on the southeast side. The original mosque was likely intended to serve an itinerant and highly fluctuating population, part of the Almohad military during stays in Rabat, rather than a permanent and steady group of inhabitants. Likewise, the *qaṣba* was intended for the more practical purposes of fortification within the *ribāṭ*, housing not only the caliphal retinue but Andalusi and Ifriqiyan hostages as well, brought back to solidly Almohad territory after campaigns abroad.[55] Public ceremonies and performances, like those widely attested for Marrakesh, are less frequently mentioned, but when they are they appear to have taken place outside the *qaṣba*. Ibn Khaldun notes one occasion upon which ʿAbd al-Muʾmin left the *qaṣba* on horseback in white robes, followed by a servant bearing the white caliphal banner and numerous other flags signifying all of the various tribes. Accompanied by members of his family, tribal representatives, and Almohad scholars, ʿAbd al-Muʾmin went on a progress around the gates of the *qaṣba*, stopping at each in turn to make an invocation and allow for a reading from the Qurʾan or the writings of Ibn Tumart before proceeding.[56] Similar accounts suggest that this was part of ʿAbd al-Muʾmin's pageantry of arriving or departing from a major city, and they hint at a ritual preparation or cleansing of urban space.[57] As at

Marrakesh, the *qaṣba* was set into a dramatic landscape to frame Almohad authority, in this case on the promontory overlooking the Atlantic Ocean (and the edge of the known world). Processions like those described would have left an intense and imposing impression upon the viewer, the bright white of the caliphal banner striking against the blue of the ocean and the ruddy ochre of the *qaṣba*. The more eschatological connotations of the Almohad message are brought to mind, echoed by the stark landscape and the triumphant yet military architecture within it.

While the *qaṣba* occupied the highest point of Rabat at the very edge of the ocean and the river, approximately two kilometers inland toward the southeast stand the remains of a monumental congregational mosque, known as early as the fourteenth century (in the *Rawḍ al-qirṭās*) as the Masjid al-Hassan. The name is ambiguous in origin, and Caillé, whose survey of Rabat remains the most comprehensive analysis of the city's formation, posits two potential sources for the name.[58] The first is a derivation from the Beni Hassan, a tribe of purported Arab origin that settled between the Tadla and Moulouya Rivers in north-central Morocco in the Almohad period. But at some point, the Beni Hassan were recalled by the Almohad governor of the Sous Valley in the south of Morocco for aid in putting down a rebellion, making this attribution specious at best. The other most commonly noted attribution is to the architect who oversaw the site, although Caillé gives little evidence to support this claim.

Credit for the mosque's patronage is most commonly given to ʿAbd al-Muʾmin's grandson, Abu Yusuf Yaʿqub al-Mansur. The details surrounding the commission and foundation of the mosque are unclear; Ibn Abi Zarʿ cites the celebration of key military victories in

Spain—including the pivotal Battle of Alarcos in June 1195, which effectively checked Castilian power for years afterward—as the motivation for the new mosque. But Caillé notes that this proposed dating makes for an implausibly short period for construction, between Ibn Abi Zarʿ's given dates of November 24, 1196, and November 13, 1197.[59] Al-Marrakushi notes that the construction of the mosque, like the city of Rabat itself, was continued under Yaʿqub al-Mansur, suggesting a much earlier date of commission, possibly extending back to his father's reign if Caillé's thesis is to be believed.[60] This suggests that a new congregational mosque, distinct from the military and imperial functions of the *qaṣba*, was part of a larger plan for Rabat's expansion and development throughout the earliest generations of Muʾminid authority. The plan of the mosque reveals the enormity of these ambitions. Measuring 183.12 meters by 139.32 meters, the mosque was erected atop an enormous platform on a promontory overlooking the Bou Regreg River. The platform was accessed by several sets of staircases leading up from the city below. Four can be found on the northern end of the platform, two on either side of the minaret, which would have led to the neighborhood below, serving as the most direct public access point. Four other staircases are to be found along the platform's western elevation and three more on its eastern elevation, while the southern side was made level with the surrounding topography. The footprint of the mosque and courtyard indicated dimensions that would have made it the second-largest in the world at the time, surpassed only by the Abbasid mosque at Samarra.

Like other Almohad mosques, including the Kutubiyya, the mosque took the form of a large hypostyle hall oriented at approximately 155 degrees, but the formal similarities largely end there.[61] In both plan and architectural style,

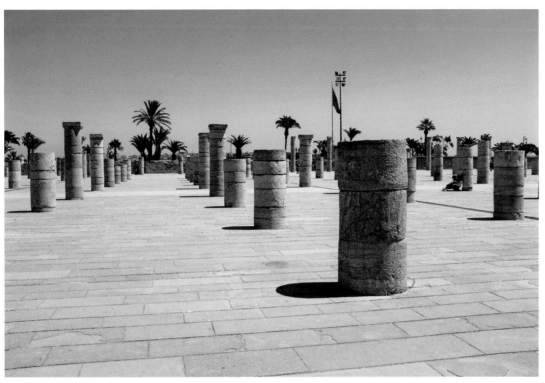

FIGURE 65

Drummed columns at the congregational mosque attributed to Yaʿqub al-Mansur in Rabat. Note that many of the columns have been replaced with concrete after much of the extant mosque was destroyed in the 1755 Lisbon earthquake. Photo: author.

Yaʿqub al-Mansur's mosque represents a significant expansion and aggrandizement of the Almohad form. Its hypostyle hall is articulated not with brick piers but with massive columns constructed out of limestone drums of varying heights, between 0.12 and 1.37 meters, and approximately 0.801 meters in diameter (fig. 65). They were likely topped by brick arches, although the arches themselves are no longer extant. The prayer hall's twenty-one aisles form the T-shaped plan standard among Almohad mosques with a wider central aisle, but the qibla transept is defined by three transverse aisles rather than one, set apart from the rest of the prayer hall by piers of dressed limestone. A large *sahn* measuring 139.32 meters by 43.13 meters (eleven bays by four bays) occupies the northern end of the mosque, surrounding a cistern formed out of four concrete walls, measuring 68.98 meters by 28.15 meters and 5.10 meters deep. There is evidence of ten subterranean concrete walls extending toward the north, forming an additional eleven cisterns perpendicular to the primary one in the *sahn*, all fed by water runoff from the roofs as well as aqueducts bringing water from outside the city.[62] Two additional *sahn*s were located within the prayer hall itself, organized perpendicularly to the northern primary *sahn* and measuring 49.85 meters by 17.89 meters (three bays by eight bays). The

courtyards were enclosed by a series of stone piers, some with engaged columns and some without, marking the distinction between the interior and courtyard spaces. This exceedingly unusual arrangement allowed for additional light and air circulation within the cavernous prayer hall, while shallow canals running the length of the *sahn*s added an auditory element of running water that would have echoed through the halls.

Opposite the qibla wall on the northern side of the principal courtyard stood the defining feature of the mosque today: a monumental minaret whose dimensions dwarfed those of its Almohad predecessors in both Marrakesh and Seville (fig. 66). Each face measured 16 meters wide and, utilizing the remarkably consistent proportional schematics of the Almohad oeuvre in which the minaret's height was approximately five times its width, we can estimate that its intended height would have been 80 meters tall, which would have made it the tallest minaret in the world in its day. The impression of its monumentality was further emphasized by the topography, which sloped steeply downward from the northern side of the site directly in front of the minaret's urban-facing façade. Constructed out of ashlar sandstone, the minaret's material exhibits the same varying rosy tint as the minaret of Marrakesh, glowing red with the dawn and fading to soft pink in the sunset. The exception to this is along the minaret's northern face, where humidity from the river has eroded some of the façade's color, turning it a soft grey. Each façade bears upper registers of blind, interlaced polylobed arches creating a latticework pattern, while the lower registers feature alfiz panels framing varying polylobed arches that gradually recess into the surface to surround small window openings, allowing light into the interior. Six superimposed chambers would have constituted

the interior space, accessed by a concrete ramp that ran around to the summit of the structure. An entry into the minaret on the southern face is framed by an alfiz panel and enters into a small vestibule with a cedar ceiling, which extends through the 2.5-meter depth of the exterior walls.

The layout of the mosque and the inconsistent application of certain ornamental elements, such as the engaged columns mentioned above, are at odds with the strictly organized hierarchy of Almohad-era mosques, but in this case, such inconsistencies are likely rooted in the building's half-finished state. In 1199, at the relatively young age of forty-eight, Yaʿqub al-Mansur died following a prolonged illness in Marrakesh, where he was briefly interred before being buried at the dynastic necropolis in Tinmal. With his death, the construction on Rabat's new congregational mosque ground to a halt, leaving the structure in a partially finished state and the minaret half as tall as was originally planned. Internecine struggles pulled attention and resources away from the monumental mosque, and by the time of Abu al-Hassan al-Said's (d. 1248) reign, the mosque's wooden ceiling was being stripped for parts to support the caliph's naval ambitions.[63] The 1755 Lisbon earthquake further damaged the site, knocking down many of its column drums and exposing what remained of the mosque roof to the elements. By the nineteenth century, Christian travelers to the Rabat-Salé region neglected to mention it in their travelogues, and by the twentieth century the site was covered in wild foliage.[64]

The relationship between the Hassan Mosque and the *ribāt-qaṣba* of ʿAbd al-Muʾmin takes advantage of the landscape around the Bou Regreg River and the coastal plains of the Atlantic, creating two distinct polities along the highest points of the riverbed. The view from

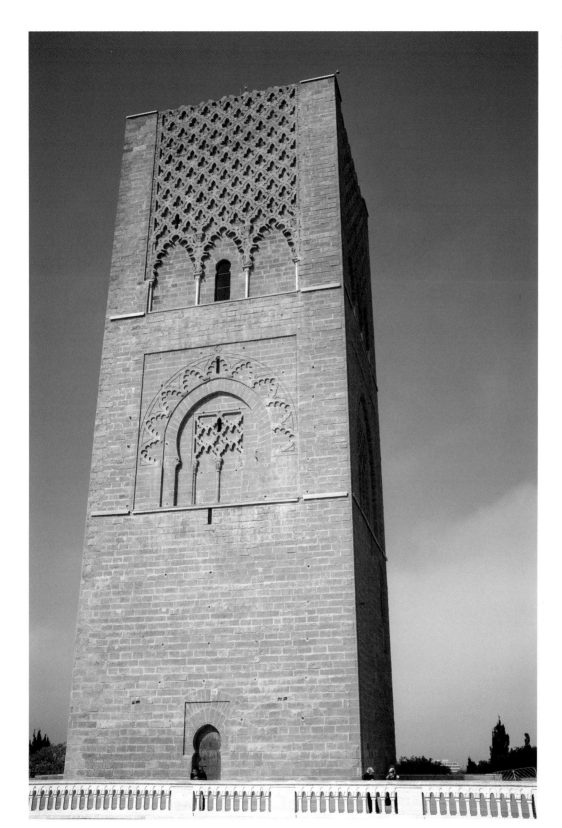

FIGURE 66
Remnants of the Rabat mosque's
monumental minaret. Photo: author.

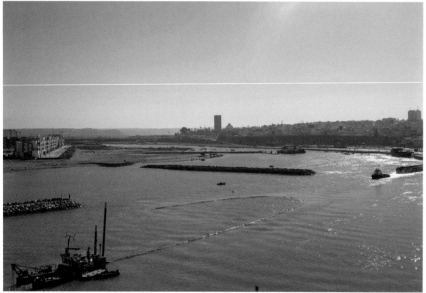

one site frames the perspective onto the other,
the surrounding ground rising up to the peak
of either the fortified walls of the *qaṣba* or the
monumental minaret of the mosque, creating
a visual reflection of Almohad authority (figs.
67, 68). Between the two promontories spreads
the *madīna* of Rabat itself, also largely devel-
oped and outlined during the reign of Yaʿqub
al-Mansur. Five gates trace the outlines of the
late twelfth-century city, four along the western
side and a singular gate along the south, delin-
eating the remnants of the walls that were also
erected during this period; the Atlantic coastline
and the Bou Regreg formed natural borders
along the northeast and northwest (fig. 69). The
western gates form the contemporary boundary
between the "old" city of Rabat and the "new"
city established under the French Protectorate.
From northwest to southeast, the identifiable
gates from the Almohad-era city are Bab al-Alou
(or Bab Lalou, as it is commonly transliterated),
Bab al-Had, and Bab al-Rouah. There was also a
fourth gate, along the same axis, that was demol-
ished to make way for the ʿAlawid sultan Sidi
Muhammad ben Abdallah's eighteenth-century
palace, situated just outside the Almohad-era
city walls. A fifth gate, Bab al-Zaer, marks the
southern limits of the *madīna*, the walls curving
back up toward the northeast and around the
promontory that supported the Hassan Mosque,
effectively delineating the Almohad city from
the remains of the Roman settlement. Each of
the gates features multiple bent entrances, and
some even include small open-air vestibules,
their complexity recalling the major gates of
Muʾminid construction at Marrakesh (fig. 70).
The ultimate extent of the city in this period,
probably achieved around 1197, was a trapezoi-
dal enceinte encompassing approximately 418
hectares.[65] This was only marginally smaller
than Marrakesh's 500 hectares, not inclusive of
any extra-urban foundations or utilities, which
were necessary for the city's functioning.

Key to Rabat's development was the man-
agement of potable water resources, an aspect
of the city that was not neglected even in its

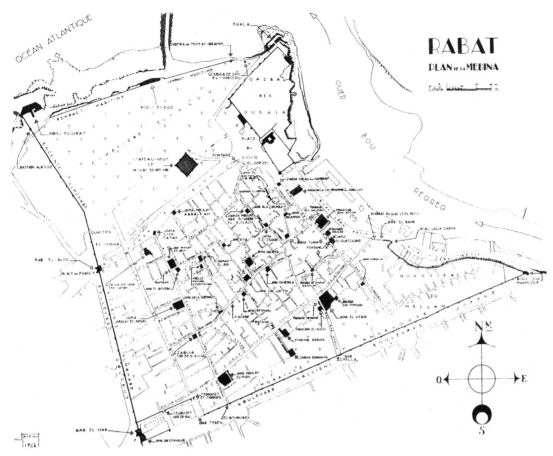

FIGURE 69
Plan of Rabat. Ashley Whitt after Jacques Caillé, *La ville de Rabat jusqu'au protectorat français* (Paris: Vanoest, 1945).

earliest stages. ʿAbd al-Muʾmin was responsible for commissioning the construction of a series of aqueducts that brought potable fresh water from the springs of ʿAyn Ghabula, nineteen kilometers to the southwest of present-day Rabat. The twelfth-century canal is no longer extant, having been replaced in the eighteenth century as part of the renovations and construction of the ʿAlawid royal residence. However, certain inferences about ʿAbd al-Muʾmin's canal can be made, based on the archaeological, geographic, and historical evidence. First, the canal followed the northeast slope from ʿAyn Ghabula and

turned northwest to enter the city along what is now the Avenue Chellah.[66] This journey was both shorter and not as steep as the series of *khettara*s that brought water into Marrakesh; only two-thirds as long as its more southern cousin, the ʿAyn Ghabula system descended only about sixty meters from its source to its output. The Arabic sources—namely, the *Rawḍ al-qirṭās* and al-Nasiri's nineteenth-century *Kitāb al-istiqṣāʾ*—only mention that ʿAbd al-Muʾmin was responsible for bringing water from ʿAyn Ghabula into the city, neglecting to provide any details as to the system's construction or

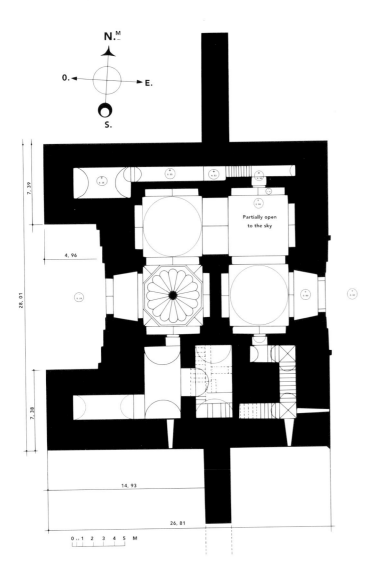

N.^M

O. ← → E.

S.

Partially open
to the sky

7, 39

4, 96

28, 01

7, 38

14, 93

26, 81

0 .. 1 2 3 4 5 M

manner of shifting water. Meanwhile, more modern sources simply refer to the 'Ayn Ghabula system as aqueducts, conflating them with the Roman-era systems of water management, none of which appear in Moroccan archaeological contexts. It is more accurate to say (and more probable) that the system was similar to that of the *seguias*, the aboveground channels that more typically diverted rain runoff. Based on the comparable evidence at Marrakesh, we know that the channels were used over distances at least

as long as the nineteen kilometers between 'Ayn Ghabula and Rabat.

Aboveground water channels like the *seguias* require proper stewardship and management of the surrounding territory. At Marrakesh, this was accomplished through the Mu'minid court's itinerant schedule through the Atlas and the reliable network of Masmuda clans. In the plains around Rabat, protection came in the form of fortifications. According to a 1933 survey by Raymond Thouvenout, a village seventeen kilometers southwest of Rabat (and colloquially known in the twentieth century as Dchira) housed the ruins of a fortress that overlooked the water channels coming from 'Ayn Ghabula. Located on the northern fringes of the village on top of a hillock, the remains of the fortress command the view over the rolling countryside outside Rabat. To the east, inland, views look out over a eucalyptus grove that housed a local market, while to the west, one has a clear view to the Atlantic. The southern side of the fortress is protected by a sharp rise in the topography toward the springs, while the northern view toward Rabat is somewhat obscured by the hillside. Though it is not mentioned in any of the historical texts (to this author's knowledge), Thouvenout convincingly dates the structure to the Almohad era based on the site's construction materials and methods. The telltale reddish limestone and mortar are present, as are the large quantities of rubble that serve as infill, and Thouvenout goes even further, noting that the absence of concrete in the exterior walls is typical of Almohad constructions from 'Abd al-Mu'min's reign.[67]

The fortress is utilitarian in plan, with only two entrances in the outer wall, one on the east side and another on the western side. Both gates appear to have been guarded; the western gate possessed the foundations of a tower over the entrance, while the eastern gate's lateral

FIGURE 71
Eastern gate of the Dchira fortress. Ashley Whitt after Raymond
Thouvenout, "Une forteresse almohade près de Rabat, Dchira,"
Hespéris 17, no. 3 (1933): 66, fig. 5.

walls featured a tower to either side (fig. 71). The exterior walls themselves formed a roughly rectangular enclosure, measuring 286.5 meters by 143 meters. The walls were reinforced with a series of sixteen solid tower blocks: four on both of the longer sides, two on each shorter side, and one tower at each corner. Within the fortress, isolated series of buildings form one- or two-room structures, and though few remains can guide us to their purpose, Thouvenout suggests that they were meant as housing for soldiers or small shops. There is also evidence of grain silos and potters' ovens, creating the impression of a relatively self-sufficient settlement. Further emphasizing this impression is the presence of a small mosque along the interior of the fortress's northern wall. It is clearly a provincial mosque, measuring only 10.35 meters by 6.15 meters

along the exterior faces, and it held a singular prayer hall with a small south-facing mihrab axially positioned across from the entrance. A small tower platform served as the mosque's minaret, positioned at the northeast corner, while along the southern face of the mosque, at the eastern corner, stood a rectangular enclosure that seems to have served as a sort of cistern or fountain.

The presence of such a fortress in the Rabat-Salé region tells us a number of things about Mu'minid control over the area. Chiefly, it implies the *need* for protection of the nearby water source as a guarantee that much-needed fresh water would actually reach Rabat. At Marrakesh, the Mu'minids' connection to their Masmuda brethren and their Atlas homeland was immediately present in the landscape. The mountains dominated the Marrakesh horizon, and the annual

progress through the Atlas to Tinmal ensured that the political and social ties necessary for extra-urban civic projects remained strong. The Muʾminid attitude toward Rabat, by contrast, reveals an anxiety and decidedly more defensive approach to water management. A military outpost that appears strategically placed to protect the *seguias* reflects the Muʾminids' more tenuous relationship with the region, where the inter- and intratribal politics were less reliable. Despite the local Barghawata's subscription to the Masmuda clan, their Kharijite history and beliefs put them at odds with the unitarian doctrine of the Almohad faith, a requirement for subscription into the Muʾminid elite in the empire's early stages. The tribe was listed as one of the supporters of Muhammad ibn ʿAbd Allah al-Massi (d. 1148), a man from Salé who had styled himself as a spiritual alternative to Ibn Tumart, going by the honorific *al-hādī*, "the guide," a title with similar connotations and sharing etymological roots with the term *mahdī*. Although the Barghawata were eventually routed, they remained enough of a threat that the city needed to be fortified against attacks from the Maghribi interior as well as against naval attacks from al-Andalus, an ever-present concern.

Despite Rabat's relative newness at the time of its foundation, we do not see nearly the same kind of suburban development in the surrounding territory that we have come to expect from Almohad capitals. It is neither attested in the medieval sources nor evident in archaeological excavation. Descriptions of the internal urban morphology are frequently vague or else generic in their praise: wide avenues, a covered market, "numerous houses of all sorts," and "plenty of other buildings for the decoration or government of the town."[68] There is no mention of a ceremonial space akin to Marrakesh's *raḥba*, merely spaces intended to house the military and allow

for their passage through the city—and no mention of any accompanying rituals as they did so. While the *seguias* channeled water to the walled *madīna*, there is little to no evidence of developed suburban estates such as those around the Agdal garden at Marrakesh or the Buhayra al-Kubra at Seville. There are a number of possible explanations for this. Rabat's role as a port for military excursions elsewhere may have made extramural construction an expensive risk, and permanent residences for such a newly founded city may not have been practical in the first generations of Muʾminid rule.

Moulay Driss Sedra has argued that the extensive urban projects undertaken during Yaʿqub al-Mansur's reign are indicative of a larger plan to move the capital from Marrakesh to Rabat.[69] Certainly the sizable dimensions of the city suggest the potential for a large urban population as well as major monuments that would match or surpass earlier iterations. Rabat had the potential to be a truly "Almohad" city, absent of any prior settlements or foundations (discounting the Roman ruins at the outskirts) that would obscure the clarity of Muʾminid manipulation of the local topography. Yet most sources agree that Rabat's architectural ambitions were grossly overestimated and that the city never flourished much beyond the temporary influxes of soldiers and cavalry in preparation for the crossing to al-Andalus.[70] That is not to reject Sedra's hypothesis outright, as indeed the grandeur of the Hassan Mosque indicates bold ambitions on Yaʿqub al-Mansur's part, but rather to highlight the inherent instability of Rabat's function within the empire. It was almost exclusively used for military purposes, for assembling the Almohad forces in the back-and-forth across the Strait of Gibraltar, resulting in a decided lack of permanence in the patterns of settlement. This is only further underscored by Rabat's almost

complete abandonment in the decades after the Almohads' fall from power.

After the death of Yaʿqub al-Mansur, Rabat retained its status as a military outpost, but internecine struggles for power among the Almohad elites meant that there was little time or money available to complete the third caliph's vision for a new capital on the Atlantic coast. The next caliphal generation, spearheaded by Muhammad al-Nasir (d. 1213) and Yusuf al-Mustansir (d. 1224), was preoccupied with near-constant military campaigns in al-Andalus and Ifriqiya. Thus, while Rabat saw significant occupation during this period, its role was more utilitarian than political or ideological. Lacking a settled permanent population, Rabat's existence relied on two aspects of Muʾminid patronage: its itinerancy and its military nature. When the death of al-Mustansir in 1224 set off a series of minority regencies and squabbles for control (eight caliphs in forty-four years, almost all killed in internal battles or assassinated), both of these began to fracture. As different Muʾminid lineages sought support among tribal factions, the grand military expeditions of the past were no longer possible, and contenders for the caliphate sought to consolidate increasingly smaller territories rather than spread their resources too thinly. When the Banu Marin, a tribe that derived its initial legitimacy from Idris al-Maʾmun's abandonment of Ibn Tumart as the *mahdī*, conquered Rabat in 1248, most of the city had already been abandoned for the more stable and established Salé across the river.

The urban approaches taken at Seville and Rabat reflected their importance within an empire that spanned a broad geography, from the fringes of the Sahara to the Iberian Peninsula. The itinerant nature of the Muʾminid court necessitated strong outposts that could communicate

authority even when the caliph was not present—and express that authority unambiguously when he was. For both cities, this was most directly expressed through the establishment of a new congregational mosque that employed the monumental minaret, hypostyle hall, and hierarchical ornament originally developed at the Kutubiyya. But Seville's and Rabat's mosques attempted to refine these principles, experimenting with color and scale in their expression rather than reductively copying the mosque at Marrakesh. The mosques reveal both Abu Yaʿqub Yusuf's and Yaʿqub al-Mansur's willingness to experiment and adapt the forms established by their predecessors in a manner responsive to the environment. Seville's mosque created a new urban center that better connected to the Muʾminid expansion of the city toward the shifted Guadalquivir, while its ornamental scheme folded local Andalusi beliefs into a more clearly Almohad framework. Rabat's mosque, with its grand dimensions and prominent position within the topography, can be seen as an expression of a revitalized cultural and religious spirit under Yaʿqub al-Mansur. Simultaneously imposing and inspiring, its monumental minaret signaled the potential for a fresh start at Rabat, a truly Almohad city with none of the historical and ideological baggage of its sister cities.

Less immediately clear—but perhaps more fundamental to the daily lives and experiences of its inhabitants—is the reworking of the urban plan under the Muʾminids through the establishment of gates, gardens, and fortifications that outlined the social and political hierarchies of the dynasty's presence. The Buhayra al-Kubra and the expansion of the Alcázar in Seville mirrored the creation of Tamarrakusht and the Agdal as liminal spaces within the city. In them, the figure of the caliph was both part of and yet removed from the general public. Meanwhile,

Rabat's elaborate city gates and fortified *qaṣba* created a distinct sense of separateness from the surrounding territory, employing the threshold as a site of transition and transformation. Projects in both cities also required intimate knowledge and awareness of the landscape and its idiosyncrasies, whether the capricious flooding of the Guadalquivir or the dangerous estuary where the Bou Regreg met the Atlantic. Repairs of aqueducts, the construction of bridges and ports, and the creation of canal channels physically trace the development of that awareness. We can infer from the success of such endeavors that the landscape was a key element in the development of their urban plans.

If both Seville and Rabat were ultimately failed experiments in the dynasty's tenure, it is due not to their relationship to the landscape but rather to the disconnect in what that landscape meant in terms of the complex web of politics and identity that made up the empire's social fabric. Seville lacked any tribal resonance within its local landscape, turning it into something that had to be managed rather than a contributing factor in the imperial impression of authority. Rabat did carry those resonances, but they were more antagonistic toward the Almohad agenda, leading to a city whose fortifications appeared defensive rather than giving an impression of strength. Both of these shortcomings only highlight the effectiveness of the plan at Marrakesh, where the Atlas Mountains crafted the perfect stage for the performance and confirmation of Mu'minid authority.

Epilogue

THE *GENIUS LOCI* OF MARRAKESH

Marrakesh proved to be the last bastion of the Mu'minid dynasty, despite decades of infighting and challenges to succession. It remained the capital of the Almohad empire until its dissolution at the hands of the Marinids in 1269. Once the city fell to Marinid rule, it was stripped of its status as an imperial capital in favor of Fez, a city whose origins in the ninth century and connections to Idrisid lore made it attractive to the Marinid interest in a more orthodox agenda. Other former capitals with connections to political movements couched in ethnosocial terms, such as Sijilmasa or the Qalat Beni Hammad, were abandoned following the collapse of their governing bodies, as the surrounding countryside offered a safer refuge for newly subjugated populations. But despite its inferior status, Marrakesh was never abandoned on the same scale, remaining instead a distinct metropolis even as its fortunes waxed and waned. It would be difficult to dismiss the role played by the landscape in Marrakesh's persistent prominence throughout both the Almoravid and Almohad dynasties as well as in the city's afterlife. The subtle awareness of topographical changes, the politics of water management, and the cultivation of intramural spaces created an urban center that recognized the landscape— both physical and social—in which it operated. That these qualities endured long after the medieval empires that constructed them speaks to both their innovative potential and their particularity in their own context.

After the fall of the city to the Marinids, Marrakesh's loss of its capital status also meant a corresponding loss in financial and institutional support, exacerbated by political tensions between the Marinid sovereigns and their Marrakeshi subjects. Apart from a governorship based out of the Almohad *qaṣba*, there was little imperial involvement with the city except in times of political crisis. Marrakesh was the epicenter of numerous rebellions against the Marinid cause, often instigated in the name of the very Marinid governors sent to subdue a restless population.[1] By the second half of the fourteenth century, Marrakesh was a de facto independent city-state under the leadership of the Hintata tribe, a sedentary subsidiary of the Masmuda that was local to the High Atlas. They were noted supporters of the Almohad cause. One of the Hintati shaykhs, known as ʿAmir (d. 1370), went so far as to marry one of the Marinid sultans' widows and ruled in outright defiance of Fez. Even after he was besieged in the Atlas Mountains and eventually executed in 1370, his family and their clients remained in control as the "kings of Marrakesh," according to a long-standing custom that punished the individual but not the family. As the Marinids' authority waned under pressure from their Wattasid viziers in the early half of the fifteenth century,

Marrakesh was left to its own devices until the threat of Portuguese conquest in 1514. Although the Hintata never controlled much beyond the city and its immediate environs, it was enough to sustain the city through more than two hundred years of instability, neglect, and occasionally outright derision.

The political tension between Marrakesh and Fez was mirrored in the religious positions espoused by their respective leaders as well as in the dichotomy between institutionalized and popular religious practices that sprang up around them. In countering what they understood as the dangerous heterodoxy of the Almohads, the Marinids (and their Wattasid viziers) adopted a more orthodox Sunni position, although they were less zealous in their imperial promotion of their beliefs. Instead of establishing their authority upon a religious righteousness, the Marinids chose to court Sunnism as an institutional ally, relying on a community of jurists and scholars who would vouch for their rule. This led to a spate of madrasa construction in Fez and elsewhere, an act that simultaneously ingratiated the dynasty with the religious elite it relied upon for support and established spaces for a reliably pro-Marinid intellectual community drawn from the dynasty's Zenata supporters.[2] Most of these madrasas were constructed in and around Fez, revealing the Marinids' focus on their own capital city and reflecting Fez's historical associations with Sunni scholarship and religious learning, but at least one was attested at Marrakesh as well. Ibn Marzuq wrote that the Marinid sultan Abu al-Hassan (d. 1351) included Marrakesh among a number of other cities to receive "identical monuments" of "stately construction, marvelous decorations, [and] numerous masterly compositions of elegance."[3] Yet all further evidence of this madrasa has been lost, and the later historical sources disagree about

where the madrasa was situated within the city, with attributions placing it within the *qaṣba*, attached to the Kutubiyya, and even on the site of the later Saʿadian madrasa north of the Almohad extension of the *madīna*.[4]

The Marinids may have rejected Marrakesh as an imperial capital, but that is not to say that they ignored the lessons to be gleaned from it, particularly in its more subtle manipulations. As part of their renovations intended to return Fez to its former glory as an imperial capital, the Marinids adopted the Muʾminid model of establishing a new imperial enclosure adjacent to the older walled city. Built along the eastern border, this new imperial foundation was called Madinat al-Bayda', the White City, and it took advantage of a topographical incline in that direction to establish visual dominance over the urban plane. This approach to their new capital city is immediately reminiscent of the Muʾminid royal extension of Marrakesh, first with Tamarrakusht and then with the Agdal garden. Although the Marinids set themselves apart as much for defense as for ideological purposes, it is clear that they understood the urban potential for authority, framing dynastic power into a physical hierarchy. Recalling that Fez had previously been a bifurcated city before its enclosure as a single city under Almoravid rule, the Marinid expansion comes to represent a metanarrative that builds upon the city's original Idrisid foundations. In again dividing the city between the imperial and the popular, the Marinids appropriated the city's origin myth for itself, but in a manner that drew upon the recent architectural past for its physical expression.

Marrakesh remained an isolated and functionally independent city, far from imperial control or support, until the arrival of the Saʿadians in the early decades of the sixteenth century. Claiming sharifian ancestry, the Saʿadians had

historically resided within the alluvial plains between the High Atlas and the Anti-Atlas along the Draa and Sous Rivers, and they only took control of Marrakesh after earning their prestige in repelling the Portuguese from the Maghrib and marrying into the Hintata tribe (which still controlled the city). With their authority secured on two fronts, both religious and tribal, the Saʿadians continued their expansion across the Maghrib but notably relocated their capital to Marrakesh in 1521, embarking on a series of renovations and improvements to revitalize the city after two hundred years of neglect. This included resuscitating the system of *khettara*s that extended into the Atlas, silted over in the absence of large-scale hydraulic management and throttling the water's ability to reliably reach the city. It also involved restoring the Agdal garden, renamed the Rawd al-Masarra (Garden of Happiness), and reconstructing the Dar al-Hanaʾ, which had fallen into ruin during the intervening centuries. The garden pavilion's Saʿadian iteration appears to have been erected entirely anew from the original. It was pushed 5.7 meters to the west of the Almohad structure for some unknown reason likely related to the recovery process, but this interrupted the rest of the garden's strict axial and symmetrical arrangement.[5] The imperial support provided by the Saʿadian presence at Marrakesh sparked a period of urban revitalization that was able to restore many of the infrastructural projects that had originally been outlined by the Almoravid- and Almohad-era regimes.

Beyond these restoration projects, the Saʿadian dynasty also built upon and expanded those spaces that had been associated with the Almoravid congregational mosques as well as the Muʾminid royal quarter of Tamarrakusht, deepening their association with Marrakesh's founders and early patrons.[6] In the heart of the *madīna*, near the site of the Almoravid Masjid al-Sawmaʿat al-Tub and the Masjid al-Siqaya, the Saʿadians erected a madrasa in the ornamental and architectural style of the Marinids. It was known originally as the Madrasa al-Ghalibiyya, after its founder ʿAbd Allah al-Ghalib (d. 1574), and today as the Ben Youssef Madrasa, after its Almoravid neighbor. Though the practice of sponsoring a madrasa originated in the Maghrib with the Marinids, the Saʿadian iteration took into account the prevalent Sufi practices that had become popular in and around Marrakesh, folding them into their own comprehension of Sunni orthodoxy. Instead of competing with the religious elite, the Saʿadians' purported sharifian heritage gave them the ability to bridge the institutional/mystical divide in much the same way as Ibn Tumart had done in his original reformist message. In the vicinity of Tamarrakusht, the Saʿadians reoccupied the former Muʾminid *qaṣba*, adding a new palatial complex under the reign of Ahmad al-Mansur (d. 1603). It was known as the Al-Badiʿ (The Incomparable) for its rich ornamentation of gold leaf, onyx, marble, and *zillīj* tile (fig. 72). Nearby, a luxurious mausoleum for the Saʿadian royal family (Qubur al-Ashraf, or Tomb of the Sharifs) stood, quite literally monumentalizing the dynasty's religious authority. Surrounding this complex was a series of public buildings concerned with imperial functions, such as a prison for Christian captives, a munitions workshop and artillery building, a market, a congregational mosque, and residential quarters for servants and the military. European accounts from the period also note that a large open square was maintained in the quarter as well, hosting formal ceremonies and celebrations and likely occupying (or adjacent to) the space originally known as the *raḥba*.[7]

In the process of restoring and renewing Marrakesh's capital status, the Saʿadians consciously

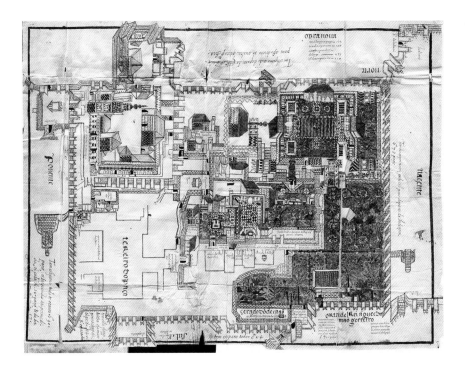

FIGURE 72
Map of the royal *qaṣba* of the
emperor of Morocco. Fr. Antonio de
la Concepción, ca. 1589. Real Biblio-
teca del Monasterio de El Escorial,
MS D. III. 27.

built on or near those spaces with the most reso-
nant historical associations. This in itself is per-
haps not so surprising, considering the pattern
of adaptation and reuse within the trajectory of
urbanism in the Islamic west, but what is notable
about Marrakesh is that it is not merely the
architectural spaces that are reoccupied but the
morphology of the city that is appropriated for
imperial purposes. By building in precisely those
spaces that had once served as public loci, the
Saʿadians recognized that those spaces were
ideologically charged in a manner that interwove
dynastic presence with the patterns of social life
in the city. In the context of the Maghrib, those
patterns went beyond merely the religious or
legal, as has been assumed for most other con-
texts in the period, but also included the distinctly
tribal ties that bound Marrakesh to the socio-
political life of its surroundings. Spaces such as
the *raḥba*, the Agdal, and even the urban heart
of the *madīna* near the Qubbat al-Barudiyyin

were all imbued with resonances and references
to Masmuda—or occasionally, more general Ber-
ber—practices, like the review of tribal represen-
tatives, ceremonial victory processions, and the
"election" of a new leader.

These resonances were carried beyond the
ceremonial into the very architecture of the city
itself. As I have argued throughout this book,
the intramural spaces that created thresholds
between different urban spheres blurred the dis-
tinctions between the city and its rural environs.
This allowed for a distinctly Maghribi form of
urban expression that did not force the dichot-
omy between rural and urban, tribal and impe-
rial, but rather placed these concepts on a spatial
spectrum that could be traversed by imperial
elite in an attempt to maintain a sociopoliti-
cal stasis. This happens subtly at Marrakesh,
thanks to the deep and intimate relationship
with the landscape around it, the incrementally
rising topography drawing a direct line to the
Atlas Mountains south of the city. Their ever-
present vigil activates the architecture of the city,
imbuing it with the social connotations of the
Masmuda, who continued to occupy the Atlas
Mountains well after the downfall of the Almo-
had Empire. For a group like the Saʿadians,
who did not have Masmuda origins, adapting
their own urban program to the preexisting
context (rather than interfering with or reject-
ing such associations outright) proved to be a
shrewd choice that granted them much-needed
legitimacy.

The effects of the landscape on the city and
its atmosphere were explicit as well as implicit,
and later writers and visitors to Marrakesh
made note of it. Speaking of the view from the
Kutubiyya's minaret, the sixteenth-century
traveler and writer Leo Africanus (himself of
Berber origin) described the view thus: "You may
plainly scry the promontory of Azaphi, which

notwithstanding is a hundred and thirty miles distant. But mountains (you will say) by reason of their huge bigness may easily be seen afar off; howbeit from this turret a man may in clear weather most easily see fifty miles into the plain countries."[8] Within the walls, Africanus notes, there are abundant gardens and palm trees as well as fruitful orchards and agricultural plots. This stands in stark contrast to the wide expanse of the Haouz Basin outside the walls, which Africanus says is untilled and unusable.[9] Granted, Africanus is writing some three hundred years after the fall of Marrakesh to the Marinids, and the city's infrastructure (particularly the *khettara*s that supplied water into the city's environs) had fallen into disrepair, thereby exaggerating the stark contrasts between the urban and rural spaces he describes. But it would appear from his account that the associations between the two were rooted in the city's earlier underlying plan, framing a lushly vegetated space within the city's walls and the wilderness—exemplified by the Atlas and extreme conditions—outside them.

Another outside perspective comes from Luis del Mármol y Carvajal, a Spanish writer and diplomat from Granada who worked at the court of the Saʿadian sultan Ahmad al-Mansur (d. 1603). He describes a city surrounded by strong walls, the construction of which he makes a particular point to emphasize, as well as their impregnability and extreme height.[10] He also notes the close proximity of the Atlas, which he calls "the ancient heart of the Masmudis," whose green mountains are visible from the rooftops of Marrakesh.[11] This is in comparison to the city founded by the "Lumptunes," whose origins or homeland go unremarked upon; meanwhile, the dynasty of ʿAbd al-Muʾmin is given its dynastic Almohad moniker. Only Yusuf ibn Tashfin is accorded any prominence in later

chronicles, as the mistaken sponsor of the Qubbat al-Barudiyyin or the remnants of the *qaṣba*. Meanwhile, ʿAbd al-Muʾmin, Abu Yaʿqub Yusuf, and Abu Yusuf Yaʿqub al-Mansur are regularly mentioned throughout the chapter on Marrakesh as patrons of various architectural sites, infrastructure projects, and the general plan of the city itself.

While this distinction between the Masmuda of the mountains and the Lamtuna of Marrakesh is somewhat anachronistic, given Mármol y Carvajal's sixteenth-century perspective, it does tell us something of the popular reception and understanding of the medieval period among Marrakesh's inhabitants. The connection the Masmuda retained to their Atlas homeland clearly persisted well into the early modern era, while the Lamtuna became mainly associated with a dynasty known only as the early founders of Marrakesh. This postmedieval connotation speaks to the powerful role of the landscape within the developing definition of belonging to a particular Berber tribe and the paramount importance of maintaining the connection with a tribal homeland in Maghribi identity creation. What is more, the distinction between the Masmuda and the Almohads by the sixteenth century intimates the success (perhaps overly so) of ʿAbd al-Muʾmin's urban and ceremonial programs. Intended to place a hereditary dynasty in stasis between their tribal rural past and their imperial urban present, twelfth-century Marrakesh became indelibly intertwined with the Almohads. Meanwhile, the Atlas Mountains remained omnipresent observers of the city, their connection to the Masmuda continually reinforced by successive generations of sociopolitical tension and agitation against Marrakesh's later rulers.

In terms of a sense of place, Marrakesh's *genius loci* is clearly embedded in the city's

relationship to its surrounding landscape, to the sharp contrasts between the flatness of the plain and the crown of mountains to the south. The city's walls help mitigate these contrasts in both formal and informal ways, but there is no escaping their presence. Their immediacy acts as a visually charged reminder of a particular identity and past—both real and constructed—that proved vital instruments for the expression of authority in the medieval Maghrib. The city's *genius loci* was not an incidental part of the city's layered constructions but an actively engaged force. It is this expression that is hinted at throughout the Arabic sources of the period, from Ibn Tumart's tirades against innovation to Ibn Khaldun's concerns about *aṣabiyya*, and informed the development of Marrakesh in its first century.

Introduction

1. Al-Idrisi, *Description de l'Afrique et de l'Espagne*, 78.
2. Rosser-Owen, "Andalusi *Spolia*," 154.
3. Balbale, "Bridging Seas," 357.
4. See Rouighi, *Inventing the Berbers*.
5. Ibid., 60.
6. Ibid., 64–66.
7. The works of these scholars are too numerous to list in a single footnote but are referred to throughout this work and in the bibliography. For a brief overview of their contributions, see Fierro, *Almohad Revolution*; Buresi, *Gouverner l'empire*; Bennison, *Almoravid and Almohad Empires*; Ghouirgate, *Ordre almohade*.
8. See Basset and Terrasse, *Sanctuaires et forteresses almohades*; Deverdun, *Marrakech* (1959); Meunié, *Recherches archéologiques*.
9. See Rosser-Owen, "Andalusi *Spolia*"; Robinson, "Power, Light, Intra-Confessional Discontent"; Marcos Cobaleda, *Almorávides*; Calvo Capilla, "Peregrination and Ceremonial."
10. Tabbaa, *Transformation of Islamic Art*, 117.
11. Robinson, "Power, Light, Intra-Confessional Discontent," 33.
12. Ibid., 34.
13. Ibid., 41–42.
14. I discuss the full ornamental register of the Kutubiyya's mihrab in chapter 2.
15. Streit, "Monumental Austerity," 128–29.
16. Ibn Sammak (attrib.), *Al-Ḥulal al-mawshiyya* (1936), 119.
17. Balbale, "Bridging Seas," 362–63.
18. Ahmed, *What Is Islam?*, 116.
19. On the origin of this concept, as well as an overview of the arguments critiquing the Islamic city, see Neglia, "Some Historiographical Notes."

20. W. Marçais, "Islamisme et la vie urbaine."
21. Bacharach, "Administrative Complexes."
22. G. Marçais, "Urbanisme musulman," 230–31.
23. Raymond, "Spatial Organization of the City," 48.
24. Deverdun, *Marrakech* (2004).
25. See Radoine, "French Territoriality and Urbanism."
26. Demerdash, "Mapping Myths," 28–31.
27. Abu-Lughod, "Islamic City," 172.
28. Eickelman, "Is There an Islamic City?," 275.
29. Gellner, "Cohesion and Identity," 208–11.
30. Ibn Khaldun, *Muqaddimah*, 1:103.
31. Antrim, "*Waṭan* Before *Waṭaniyya.*"
32. Antrim, *Routes and Realms*, 22.
33. Messier, "Rethinking the Almoravids," 59–60.
34. Fromherz, *Almohads*, 89.
35. Al-Azmeh, *Ibn Khaldun*, 74.
36. Antrim, *Routes and Realms*, 18–19.
37. Al-Marrakushi, *Al-Muʿjib* (1978), 262.
38. Cornell, "Understanding Is the Mother of Ability," 74.
39. Ibid.
40. Safran, "Politics of Book Burning." This narrative is widely cited in the primary sources, including Ibn Sammak's *Al-Ḥulal al-mawshiyya*, Ibn Abi Zarʿ's *Rawḍ al-qirṭās*, and in multiple works by Ibn Khaldun. The main source to reject this anecdote comes from Ibn al-Athir.
41. For the former, see Fletcher, "Ibn Tūmart's Teachers," 306–7. As to the latter, see García-Arenal, *Messianism and Puritanical Reform*, 163.
42. García-Arenal, *Messianism and Puritanical Reform*, 163.

43. Fierro, *Almohad Revolution*, 8–9.
44. García-Arenal, *Messianism and Puritanical Reform*, 127.
45. Ibid., 139. García-Arenal notes that the predicted date of 500 was undoubtedly influenced by messianic writings among the Andalusi Jewish community that filtered into Islamic eschatological thought (147–56). The *Ḥulal al-mawshiyya* records an anecdote that supports this theory. In it, the Almoravid emir Yusuf ibn Tashufin makes a trip to Lucena, a town almost exclusively inhabited by Jews, on the basis of a prophetic tradition that the Jews had committed to converting to Islam if their awaited Messiah had not arrived by the year AH 500. See Ibn Sammak, *Al-Ḥulal al-mawshiyya* (1936), 65.
46. The concurrence of each part of the phrase "commanding right" and "forbidding wrong" occurs no fewer than eight times throughout the Qur'an, in verses 3:104, 3:110, 3:114, 7:157, 9:71, 9:112, 22:41, and 31:17. This phrasing has formed an ethical duality underpinning generations of Islamic legal and ethical thought. For an extensive discussion of the precept, see Cook, *Commanding Right and Forbidding Wrong*.
47. Cook, *Commanding Right and Forbidding Wrong*, 430–32.
48. García-Arenal, *Messianism and Puritanical Reform*, 110.
49. Ibid., 164.
50. Ibid., 159. See also Fletcher, "Almohad *Tawḥīd*," 113.
51. Serrano Ruano, "Porque llamaron los almohades," 818.
52. Ibn Tumart, *Livre d'Ibn Toumert*, 30 of the Arabic text.
53. Cornell, "Understanding Is the Mother of Ability," 99.
54. Urvoy, "Pensée d'Ibn Tūmart," 30–31; Griffel, "Ibn Tūmart's Rational Proof," 770–75.
55. Meouak, *Langue berbère*, 164.

56. Ibid., 158.

57. Cornell, *Realm of the Saint*, 40. The episode with the Almoravid emir, ʿAli ibn Yusuf, is discussed in detail in chapter 2.

58. Van Staëvel, Fili, and Ettahiri, "Igiliz Hartha," 268–70.

59. These include Ibn Abi Zarʿ's *Rawḍ al-qirṭās* and Ibn al-Qattan's *Naẓm al-jumān*, and even to a certain extent al-Marrakushi's *Kitāb al-muʿjib*, while al-Baydhaq and Ibn Sammak's *Ḥulal al-mawshiyya* paint a more pious picture, with Ibn Tumart's followers recognizing the Mahdi's qualities in their leader as he spoke of them. See Bennison, *Almoravid and Almohad Empires*, 66–67.

60. I discuss the Council of Ten further in chapter 2, along with the significance of Tinmal for ʿAbd al-Muʾmin's early reign.

61. Fromherz, *Almohads*, 90–91.

62. Al-Baydhaq, *Kitāb akhbār al-mahdī Ibn Tūmart* (1975), 77.

Chapter 1

1. Bosworth, "Marrakesh," 319.

2. Bennison, "Power and the City," 65–95.

3. Bennison, *Almoravid and Almohad Empires*, 32.

4. The excavations in question have been spearheaded by Jean-Pierre van Staëvel, Ronald Messier, and Abdullah Fili. Their work has uncovered the remains of an Almoravid-era palace, a hammam, and a congregational mosque. See Ettahiri, Fili, and van Staëvel, "Nouvelles recherches archéologiques."

5. Bennison, *Almoravid and Almohad Empires*, 34.

6. Ibn ʿIdhari, *Al-Bayān al-mughrib*, 4:17.

7. Ibid., 4:16.

8. Ibid., 4:18.

9. Bennison, *Almoravid and Almohad Empires*, 33.

10. Ibn ʿIdhari, *Al-Bayān al-mughrib*, 16–19; Ibn Abi Zarʿ, *Rawḍ al-qirṭās*, 170; Ibn Khaldun, *Histoire des berbères* (1927), 2:71.

11. Fromherz, *Near West*, 132.

12. Deverdun, *Marrakech* (1959), 57.

13. Messier, "Rethinking the Almoravids," 62.

14. Bennison, *Almoravid and Almohad Empires*, 290; Ghouirgate, *Ordre almohade*, 96–97.

15. It was believed for a long time that the Almoravids first experimented with urban planning after their conquest of Sijilmasa, but Chloé Capel has recently demonstrated that the city's monumental walls and hydraulic works were both developed prior to the Almoravids' arrival. See Capel, "Sijilmassa," 536.

16. Ghouirgate, *Ordre almohade*, 98.

17. Bennison, *Great Caliphs*, 60–61.

18. Al-Tabari, *History of al-Tabarī*, 13:68.

19. Bennison, "Power and the City," 80.

20. Al-Idrisi, *Description de l'Afrique et de l'Espagne*, 77.

21. Triki, "Marrakech," 94.

22. Bennison, *Almoravid and Almohad Empires*, 289.

23. Deverdun, *Marrakech* (2004), 1:57.

24. Ibid., 1:58.

25. Messier and Miller, *Last Civilized Place*, 106.

26. Deverdun, *Marrakech* (2004), 1:78.

27. Cited in ibid., 1:73, quoting Ibn Hisham, 335.

28. Russell and Fentress, "Mud Brick," 134.

29. Glick, "Cob Walls Revisited," 149–50.

30. Russell and Fentress, "Mud Brick," 132.

31. Van Staëvel, "Réflexions," 95–109.

32. Wilbaux, *Médina de Marrakech*, 231.

33. Stockstill, "Tale of Two Mosques," 70–72.

34. Ibid., 70. Rius Piniés, "La orientación de las mezquitas," 2:787–90. It is worth noting here that al-Mittiji does not refer to Marrakesh by name but refers to it simply as the *madīnat al-sulṭān*, presumably indicating that Marrakesh was not considered a formal city under Yusuf ibn Tashfin.

35. Serrano Ruano, "Ibn Rushd al-Jadd," 301.

36. Stockstill, "Tale of Two Mosques," 72.

37. Deverdun and Allain, "Minaret almoravide," 130, plate 3.

38. Tabbaa, "Andalusian Roots and Abbasid Homage," 142.

39. Serrano Ruano, "Ibn Rushd al-Jadd," 307–8; Rius Piniés, *Alquibla*, 149–50.

40. Ibn Khaldun, *Histoire des berbères* (1847), 1:240.

41. Wilbaux, *Médina de Marrakech*, 230–32.

42. See Terrasse, *Kasbas berbères*.

43. Al-Bakri, *Description de l'Afrique*, 348.

44. Kahera, *Reading the Islamic City*, 12.

45. Lévi-Provençal, "Fondation de Fès," 23–52.

46. García-Arenal and Manzano Moreno, "Idrīssisme et villes idrīssides," 18–19.

47. Kahera, *Reading the Islamic City*, 17.

48. The al-Fihri sisters were the daughters of a wealthy merchant family that had emigrated from Kairouan in Tunisia (hence the name of the mosque in Fez). See Sibley, "Cities," 29–31.

49. Benchekroun, "Idrissides," 186.

50. Kahera, *Reading the Islamic City*, 18.

51. Johansen, "All-Embracing Town," 141.

52. Grabar, "Architecture," 38.

53. Johansen, "All-Embracing Town," 144–45.

54. Bennison, "Sectarianism in the Landscape," 12.

55. Anonymous, *Kitāb al-istibṣār fī ajāʾib al-amṣār* (1958), 187–88.

56. O'Meara, *Space and Muslim Urban Life*, 30–33.

57. Falahat, *Cities and Metaphors*, 88.

58. Sebti, "Remparts et dynamiques internes," 136.

59. The Dukkala consisted of smaller tribes such as the Abda, the Ahmar, the Rehamma, and the Sgharna. Allain and Deverdun, "Portes anciennes de Marrakech," 104.

60. Ibid., 107. Marcos Cobaleda, *Almorávides*, 124.

61. Marcos Cobaleda, *Almorávides*, 122.

62. Allain and Deverdun, "Portes anciennes de Marrakech," 110–14.

63. Bab Dabbag (Gate of the Tanners) is so named for the location of the tanneries sited near it during the Almohad era. The name Bab Aylan (or Bab Haylana, as it may originally have been called) refers to a Masmuda tribe that settled in proximity to the gate. The Haylana helped the Almoravids negotiate the territory to settle Marrakesh when Aghmat became too small for them. Marcos Cobaleda, *Almorávides*, 131; Bennison, *Almoravid and Almohad Empires*, 33.

64. Marcos Cobaleda, *Almorávides*, 130.

65. Allain and Deverdun, "Portes anciennes de Marrakech," 109. For a more recent exploration of the Almoravid fortifications at Tasghimout, see Capel, "Jebel Mudawwar," 101–22.

66. Ibn Sammak, *Al-Ḥulal al-mawshiyya: Crónica árabe*, 115–16.

67. Marcos Cobaleda, *Almorávides*, 112.

68. Falahat, *Cities and Metaphors*, 111.

69. Bennison, "Relations," 139–40; Brett, "Conversion of the Berbers," 194.

70. Bennison, "Relations," 140.

71. Madelung, "Notes," 88.

72. Le Tourneau, "Ḥā-Mīm b. Mann Allāh b. Ḥāfiz b. ʿAmr."

73. Ibn ʿIdhari al-Marrakushi, *Al-Bayān al-mughrib*, 4:9–11.

74. Bennison, "Relations," 142.

75. Ibid., 138.

76. Marmura, "Philosopher and Society," 316.

77. Al-Farabi, *Al-Fārābī on the Perfect State*, 231.

78. Ibid., 229–31.

79. Ibid., 239–41.

80. Ibn Bajja, *Rasaʾil Ibn Bajja al-Falsafiyya*, 41–42; Marmura, "Philosopher and Society," 317.

81. Levtzion and Hopkins, *Corpus of Early Arab Sources*, 22, 49.

82. Ibid., 311.

83. Cornell, "Understanding Is the Mother of Ability," 71–103.

84. Ibn Tumart, *Aʿazz mā yuṭlab*, 385.

85. Marín, "On Women and Camels," 486–87.

86. Al-Baydhaq, *Akhbār al-mahdī Ibn Tūmart* (1971), 27.

87. Marín, "Princess," 33–34.

88. Ibid., 40.

89. This is not to say that the Almohad court was entirely masculine. Rather, women's public appearances were curtailed, following a model whereby men and women socialized in parallel spheres. Women did play a prominent role in the construction of Almohad genealogies, which is discussed further in the next chapter. For more, see Bennison, *Almoravid and Almohad Empires*, 159–64.

90. Ghouirgate, *Ordre almohade*, 54.

91. Ibid.

92. Bennison, "Sectarianism in the Landscape."

93. Bloom, *Minbar from the Kutubiyya Mosque*, 21.

94. Ibid., 72–73.

95. Ibid., 4.

96. This excludes the feature of the *maqṣūra*; there is no evidence suggesting its role within Almoravid-era mosques. The *maqṣūra* is, however, notably a part of Almohad mosques like the Kutubiyya.

Chapter 2

1. Triki, "Marrakech," 100–101.

2. Bennison, *Almoravid and Almohad Empires*, 307.

3. Al-Idrisi, *Opus Geographicum*, fasc. 1–4.

4. Deverdun, *Marrakech* (2004), 1:172.

5. Ibid., 1:173.

6. Anonymous, *Kitāb al-istibṣār fī ajāʾib al-amṣār* (1985), 209. On the relationship between al-Bakri and the *Kitāb al-istibṣār*, see Levtzion, "Twelfth-Century Anonymous *Kitāb al-Istibṣār*," 201–17.

7. Basset and Terrasse, "Sanctuaires et forteresses almohades II," 201; Deverdun, *Marrakech* (2004), 1:181; G. Marçais, *Architecture musulmane d'occident*, 205.

8. Streit, "Monumental Austerity," 53; Bonine, "Sacred Direction," 52.

9. This mosque is addressed in chapter 3.

10. Stockstill, "Tale of Two Mosques," 72–73.

11. Rius Piniés, *Alquibla*, 257.

12. Deverdun, *Marrakech* (2004), 1:179.

13. Stockstill, "Tale of Two Mosques," 73. Ibn Abi Zarʿ's *Rawḍ al-qirṭās* attributes the minaret to Abu Yusuf Yaʿqub al-Mansur, but this is likely mistaken for renovations to the minaret and an extension of its height with a lantern structure in the late 1190s. See Basset and Terrasse, *Sanctuaires et forteresses almohades*, 188.

14. Al-Zarhuni, *Rihla du marabout de Tasaft*, 194–95.

15. Deverdun, *Marrakesh* (2004), 1:190. Deverdun also notes that the technique of letting the tower's base settle for a year was possibly adopted from the construction of ʿAli ibn Yusuf's minaret at the Masjid al-Siqaya, which ʿAli ibn ʿAtiyya likely witnessed. The Kutubiyya minaret's foundations became so stable through this method that it has remained standing since its twelfth-century establishment, despite a major earthquake in 1719 that damaged much of the city's infrastructure.

16. G. Marçais, *Architecture musulmane d'occident*, 8.

17. Terrasse, *Mosquée al-Qaraouiyin*, 9–10.

18. Rosser-Owen, "Andalusi *Spolia*," 168.

19. Basset and Terrasse, *Sanctuaires et forteresses almohades*, 87.

20. Anderson, "Early Mosque Architecture," 14.

21. Basset and Terrasse, "Sanctuaires et forteresses almohades (suite)," 160–61.

22. Streit, "Monumental Austerity," 57.

23. Rosser-Owen, "Andalusi *Spolia*," 157.

24. Bloom, *Minbar from the Kutubiyya Mosque*, 3.

25. Basset and Terrasse, *Sanctuaires et forteresses almohades*, 33; Boum and Park, *Historical Dictionary of Morocco*, 230.

26. Del Mármol y Carvajal, *Afrique*, 2:355; Ghouirgate, *Ordre almohade*, 440–41.

27. Ewert, "El registro ornamental almohada," 225.

28. Terrasse and Basset, *Sanctuaires et forteresses almohades*, 43–46.

29. Ewert, "El registro ornamental almohada," 122–31.

30. Ibid., 135.

31. Balbale, "Bridging Seas," 368.

32. Ewert, "El registro ornamental almohada," 228.

33. Ewert and Wisshak, *Forschungen zur almohadischen Moschee*, 17.

34. Ibid., 126.

35. Ewert, *Mosque at Tinmal*.

36. Calvo Capilla, "Peregrination and Ceremonial," 88.

37. Basset and Terrasse, *Sanctuaires et forteresses almohades*, 25n3. This claim is bolstered by al-Idrisi's account in *Description de l'Afrique et de l'Espagne*, 74.

38. Calvo Capilla, "Peregrination and Ceremonial," 85.

39. Kugle, *Sufis and Saints' Bodies*, 46–47.

40. Buresi, "Cultes rendus," 427.

41. Ibid., 392, 405.

42. Ibn Sammak, *Al-Ḥulal al-mawshiyya* (1911), 108.

43. Al-ʿUmari, *Masālik al-abṣār fī mamālik al-amṣār*, 181.

44. Bennison, "Power and the City," 85.

45. Deverdun, *Marrakech* (1959), 229.

46. Al-ʿUmari, *Masālik al-abṣār fī mamālik al-amṣār*, 184–85; Deverdun, *Marrakech* (2004), 1:230.

47. Bennison, "Power and the City," 86.

48. Gaudefroy-Demombynes, "Quelques passages," 271–73.

49. There are suggestions that the name of the gate, Bab al-Robb, instead refers to a type of date wine that had traditionally entered the city through this gate (and that later Muʾminid caliphs banned). This attribution is tenuous at best, deriving from an anecdote that discusses the wine in the Andalusi context, although there is mention of *robb* as a sweet wine drunk at ceremonies in the Agdal garden (see later in this chapter).

However, given the gate's privileged location both textually and spatially, it is more likely that a semantic shift has occurred within the naming of the gate.

50. Torres Balbás, *Ciudades hispano-musulmanas*, 1:295–301.

51. Al-Marrakushi, *Al-Muʿjib* (1978), 263 (Arabic); al-ʿUmari, *Masālik al-abṣār fī mamālik al-amṣār*, 182; Bennison, "Power and the City," 86. The term *qubba* refers both to a dome and to a specific kind of tent; see Stockstill, "Red Tent," 14–18.

52. Ghouirgate, "Palais en marche."

53. Fricaud, "*Ṭalaba* dans la société almohade," 348–51.

54. Al-Marrakushi, *Al-Muʿjib* (1881), 425.

55. Hopkins, "Almohad Hierarchy," 93.

56. Ibid., 96.

57. Ibid. Scholars like Hopkins have attributed the fluctuations in the sources between which tribes belonged to the *ahl al-khamsīn* and how many members they had to the fact that such lists represent the changes and shifts over time between one Muʾminid caliph and another.

58. Ibid., 107–8.

59. Al-Marrakushi, *Al-Muʿjib* (1978), 426.

60. Al-Baydhaq, *Akhbār al-mahdī Ibn Tūmart* (1971), 85; Le Tourneau, "Du mouvement almohade," 112–13.

61. Cornell, "Understanding Is the Mother of Ability," 83.

62. These court-sponsored sources include Ibn Sahib al-Salat's *Tārīkh al-mann bi'l-imāma*, ʿAbd al-Wahid al-Marrakushi's *Al-Muʿjib fī talkhīṣ akhbār al-Maghrib*, and the *Kitāb al-ḥulal al-mawshiyya* attributed to Ibn Sammak.

63. Lévi-Provençal, *Documents inédits*, 131 (French), 81 (Arabic).

64. Bennison, "Almohads and the Qurʾān," 143.

65. Lévi-Provençal, *Documents inédits*, 196 (French), 119 (Arabic).

66. Fromherz, *Almohads*, 96–99.

67. Al-Baydhaq, *Akhbār al-mahdī Ibn Tūmart* (1971), 112.

68. Lévi-Provençal, "Un recueil des lettres," 36.

69. Ibid., 35.

70. Bennison, "Almohads and the Qurʾān," 144.

71. Bennison, "Power and the City," 91.

72. This impression is undoubtedly encouraged by the strong bias in the sources against the Almoravids, but the fact that such encounters do not appear even in post-Almohad material is significant.

73. Navarro, Garrido, and Torres, "Agua, arquitectura y poder," 7.

74. El Faïz, "Garden Strategy," 95.

75. For a more in-depth analysis of the *agdāl* as an agro-pastoral practice, see Domínguez Gregorio, "Vers l'éco-anthropologie."

76. Navarro, Garrido, and Torres, "Agdāl of Marrakesh," 1.

77. Ibn Sammak, *Al-Ḥulal al-mawshiyya* (1979), 150; al-ʿUmari, *Masālik al-abṣār fī mamālik al-amṣār*, 181.

78. Navarro, Garrido, and Torres, "Agdāl of Marrakesh," 8. It should be noted that another famous Marrakesh *buḥayra* was an artificial lake that gave the Battle of Buhayra—a pivotal encounter between the Almoravids and the early Almohad forces in 1130—its name. The lake in question probably belonged to ʿAli Ibn Yusuf's palace, located to the east of the walled *madīna* and later razed to make way for the Kutubiyya Mosque.

79. Ibid., 1–2.

80. Ibid., 6–7.

81. El Faïz, "Garden Strategy," 95.

82. Ibid., 100.

83. Pascon, *Haouz de Marrakech*, 1:374–76.

84. Navarro, Garrido, and Torres, "Agdāl of Marrakesh," 16.

85. El Faïz, "Garden Strategy," 97.

86. Navarro, Garrido, and Torres, "Agdāl of Marrakesh," 53.

87. Ibid., 54.

88. Ibid., 55–56.

89. Deverdun, *Marrakesh* (2004), 1:197.

90. Ibn Sahib al-Salat, *Tārīkh al-mann bi'l-imāma ʿala al-mustaḍʿafīn*, quoted in El Faïz, "Garden Strategy," 103.

91. See Robinson, "Ubi Sunt," 20–31; Ruggles, "Islamic Landscape."

92. Bennison, "Almohads and the Qurʾān," 147–48.

93. Ibid., 149.

94. Ibn Hayyan, *Al-Muqatabas*, 257.

95. For an overview of these struggles, which he describes as "monotonous, contradictory, and hard to follow," see Lévi-Provençal, *Histoire de l'Espagne musulmane*, 2:79.

96. Ibn Abi Zarʿ, *Rawḍ al-qirṭās*, 237; Ibn Sahib al-Salat, *Tārīkh al-mann bi'l-imāma* (1987), 530.

97. Bennison, "Almohads and the Qurʾān," 149.

98. Fierro, "Sobre la adopción del título califa," 33–42.

99. Ibn Marzuq, *El Musnad*, 377.

100. Al-Marrakushi reports that the Qurʾan was part of a treaty negotiation with the king of Sicily during the reign of Abu Yaʿqub Yusuf, but the author of the *Ḥulal al-mawshiyya* attributes its acquisition to ʿAbd al-Muʾmin. I am inclined to follow the author of the *Ḥulal al-mawshiyya* in light of its earlier transmission. See Bennison, "Almohads and the Qurʾān," 150–51.

101. Al-Marrakushi, *Al-Muʿjib* (1978), 326. This description is confirmed by Ibn Sahib al-Salat's contemporaneous account, *Tārīkh al-mann bi'l-imāma* (1965), 467–68.

102. Bennison, "Almohads and the Qurʾān," 151–52.

103. Al-Maqqari, *Nafḥ al-ṭīb min ghuṣn al-Andalus al-raṭīb*, 1:611.

104. Cornell, "Understanding Is the Mother of Ability," 93.

105. Safran, "Ceremony and Submission," 191–201.

106. Lévi-Provençal, *Documents inédits*, 32–35 (French), 21–23 (Arabic).

107. Cited in Fierro, "Las genealogías de ʿAbd al-Muʾmin," 79.

108. Ibid., 96–97.

109. Ibid., 84–85.

110. Ibid., 84–85; Bennison, "Almohads and the Qurʾān," 146.

111. Lévi-Provençal, *Documents inédits*, 30–31 (French), 21 (Arabic).

112. Ibn Tumart, *Livre d'Ibn Toumert*, 240–54 (Arabic).

113. García-Arenal, *Messianism and Puritanical Reform*, 182.

114. Empey, "Mothers of Caliph's Sons," 146–47; Fromherz, *Almohads*, 102; Fletcher, "Anthropological Context," 45.

115. Streit, "Monumental Austerity," 126.

116. Fricaud, "*Ṭalaba* dans la société almohade," 332–33.

117. Shatzmiller, *Berbers and the Islamic State*, 17–27. On the role of genealogies in the expression of authority in the Maghrib, see Rhani, "Genealogy of Power."

118. Bennison, "Almohads and the Qurʾān," 145.

119. Buresi, "D'une péninsule à l'autre," 7.

120. Bennison, *Almoravid and Almohad Empires*, 91–92.

121. Ibid., 316, 321–22; al-Marrakushi, *Al-Muʿjib* (1978), 364–65.

122. Bacharach, "Administrative Complexes."

123. Ibid.; Sanders, *Ritual, Politics, and the City*, 39–44; Ruggles, "Mirador," 73–82; Ruggles, *Gardens, Landscape, and Vision*, 54–55.

124. Ruggles, *Gardens, Landscape, and Vision*, 92.

125. Sanders, *Ritual, Politics, and the City*, 39–42.

126. Bennison, "Power and the City," 91.

Chapter 3

1. Fierro, "Algunas reflexiones," 12.

2. Archaeological excavations have discovered human remains in the highlands above the river dating back as far as 300,000 years ago but little sign of occupation in the river valley itself, a sign of the Guadalquivir's danger. See Sánchez Mantero, *Short History of Seville*, 11.

3. Ibid., 12.

4. Denoix, "Founded Cities of the Arab World," 137.

5. Ruggles, *Gardens, Landscape, and Vision*, 142.

6. Marcos Cobaleda, *Almorávides*, 231.

7. Cabrera Tejedor, *From Hispalis to Ishbiliyya*, 19.

8. Ibid., 38.

9. Ibid., 166–67.

10. Valor Piechotta, *Sevilla almohade*, 61; Streit, "Monumental Austerity," 142–43.

11. Ibn ʿIdhari, *Al-Bayān al-mughrib*, 4:117. Translation by Amira

Bennison, *Almoravid and Almohad Empires*, 309.

12. For more on Ibn Mardanish and his struggles against the Almohads, see González Cavero, "Revisión de la figura de Ibn Mardanish," 95–110.

13. Arnold, *Islamic Palace Architecture*, 198.

14. Tabales Rodríguez, *El Alcázar de Sevilla*, 227–28.

15. Rodríguez Estévez, *El Alminar de Isbiliya*, 56; Streit, "Monumental Austerity," 67.

16. Cited in Rubiera Mata, *La arquitectura*, 139–40.

17. Ruggles, *Gardens, Landscape, and Vision*, 144.

18. Vera Reina, Amores Carredano, and Herrera Ruiz, "La Huerta del Rey," 105–6.

19. Ibn Sahib al-Salat, *Al-Mann bi'l-imama* (1969), 196.

20. Bennison, "Sectarianism in the Landscape," 19.

21. Valor Piechotta, *Sevilla almohade*, 126–27.

22. Ibn Sahib al-Salat, *Tārīkh al-mann bi'l-imama*, 196.

23. Streit, "Well-Ordered Growth," 312.

24. Tabales Rodríguez and Jiménez Sancho, "Intervención arqueológica," 432.

25. Streit, "Well-Ordered Growth," 316–19.

26. Ibn Sahib al-Salat, quoted in ibid., 298.

27. Valor Piechotta, *El último siglo*, 179–88.

28. Cabrera Tejedor, *From Hispalis to Ishbiliyya*, 143.

29. Ibn Sahib al-Salat, *Tārīkh al-mann bi'l-imama* (1965), 468.

30. Valor Piechotta, *Sevilla almohade*, 196.

31. Herencia Ruíz, *Los puentes*, 11, 48.

32. Valor Piechotta, *Sevilla almohade*, 194.

33. Domínguez Berenjena, "Sevilla y las fortificaciones fluviales," 239.

34. Cabrera Tejedor, *From Hispalis to Ishbiliyya*, 182–83.

35. Domínguez Berenjena, "Sevilla y las fortificaciones fluviales," 242.

36. Ibn Sahib al-Salat, *Tārīkh al-mann bi'l-imama* (1965), 64.

37. Cabrera Tejedor, *From Hispalis to Ishbiliyya*, 130.

38. Le Tourneau, "Disparition de la doctrine almohade," 194–97.

39. Pliny the Elder, *Pliny's Natural History*, 47.

40. Abu-Lughod, *Rabat*, 39; Guernier and Guieysse, *Encyclopédie coloniale et maritime*, 40–41.

41. Affaires indigènes et service des renseignements, *Rabat et sa région*, 3, 51–52.

42. Ibid., 54.

43. Abu-Lughod, *Rabat*, 44.

44. Ibn Hawqal, *Kitāb masālik wa al-mamālik*, 2:56. Here, I follow Vincent Cornell's definition of *ribāṭ*, which is discussed in the introduction.

45. Abu-Lughod, *Rabat*, 45n4.

46. Affaires indigènes et service des renseignements, *Rabat et sa région*, 27–28.

47. Belfquih and Fadloullah, *Mécanismes et formes*, 1:32; R. Basset, *Documents géographiques*, 26. In the *Documents géographiques*, Basset quotes a mid-twelfth-century author by the name of al-Fezari (referring to a native of Fez), who notes that Qasr Bani Targha was located on the site of ʿAbd al-Muʾmin's eventual construction. There are few other references to the Almoravid stage of the *ribāṭ*'s development, likely because most of the sources postdate the Almohads' arrival and thus reflect an Almohad bias. The consistency of the sources on the pre-Almohad narrative is suspicious, but further primary source research falls outside the purview of this particular work.

48. Affaires indigènes et service des renseignements, *Rabat et sá region*, 12.

49. Abu-Lughod, *Rabat*, 54.

50. Bennison, *Almoravid and Almohad Empires*, 77.

51. Ibn ʿIdhari, *Al-Bayān al-mughrib*, 4:122–23.

52. Abu-Lughod, *Rabat*, 54–55.

53. Caillé, *Ville de Rabat*, 1:58.

54. Ibid., 1:60.

55. Ibid., 1:63.

56. Ibn Khaldun, *Prolégomènes*, 2:51.

57. Ibn Sahib al-Salat, *Tārīkh al-mann bi'l-imama* (1965), 444.

58. Caillé, *Ville de Rabat*, 1:153.

59. Ibid., 1:154.

60. Ibid., 1:154; al-Marrakushi, *Histoire des Almohades*, 230.

61. Bonine, "Sacred Direction," 52.

62. Caillé, *Ville de Rabat*, 1:160–64.

63. Anonymous, *Al-Dhakira al-saniyya fi taʾrikh al-dawla al-marīniyya*, 66 and 70.

64. Caillé, *Ville de Rabat*, 1:155.

65. Ibid., 1:125.

66. Ibid., 1:542.

67. Thouvenout, "Une forteresse almohade," 62.

68. *Kitāb al-istibṣār* (1900), 53; del Mármol y Carvajal, *Afrique*, 2:142.

69. Sedra, "Ville de Rabat," 300.

70. Abu-Lughod, *Rabat*, 55–57.

Epilogue

1. These rebellions include those of Abu Amir, son of Marinid sultan Abu Yaʿqub Yusuf, in 1288; governor of Marrakesh Yusuf ibn Abu ʿAyad in 1307; and Abu ʿAli, son of Abu Saʿid ʿUthman, in 1320. See de Cénival, "Marrākush."

2. Shatzmiller, "Premiers Mérinides," 113–14.

3. Ibn Marzuq, *Un nouveau texte d'histoire mérinide*, 35, 69 (French).

4. Deverdun, *Marrakech* (2004), 1:320–23.

5. Navarro, Garrido, and Torres, "Agdāl of Marrakesh," 33.

6. For a more thorough and recent examination of the Saʿadians' contributions at Marrakesh, see Almela, "Religious Architecture as an Instrument," 272–302.

7. Ibid., footnote 16.

8. Leo Africanus, *History and Description of Africa*, 2:264.

9. Ibid.

10. Del Mármol y Carvajal, *Afrique*, 2:51.

11. Ibid., 2:59.

Primary Sources

Anonymous. *Al-Dhakīra al-saniyya fī taʾrīkh al-dawla al-marīniyya*. Edited by Abdelwahab Benmansour. 2nd ed. Rabat: Dār al-Manṣūr, 1972.

———. *Kitāb al-istibṣār fī ajāʾib al-amṣār*. Edited by ʿAbd al-Hamid Saʿd Zaghlul. Alexandria: Imprimerie Université, 1958.

———. *Kitāb al-istibṣār fī ajāʾib al-amṣār*. Edited by ʿAbd al-Hamid Saʿd Zaghlul. Casablanca: Dār al-nashr al-Maghribīya, 1985.

———. *Kitāb al-istibṣār: L'Afrique septentrionale au XIIᵉ siècle de notre ère*. Edited by A. Fagnan. Paris: Constantine, 1900.

Bakri, Abu ʿUbayd ʿAbd Allah al-. *Description de l'Afrique septentrionale*. Translated by William MacGuckin de Slane. Paris: Imprimerie impériale, 1859.

Basset, René, trans. *Documents géographiques sur l'Afrique septentrionale*. Paris: Éditions Leroux, 1898.

Baydhaq, Abu Bakr ibn ʿAli al-Sanhaji al-. *Akhbār al-mahdī Ibn Tūmart wa bidāyat dawlat al-muwaḥḥidīn*. Rabat: Dār al-Manṣūr lil-Ṭibāʿa wa al-Wirāqa, 1971.

———. *Kitāb akhbār al-mahdī Ibn Tūmart*. Edited by ʿAbd al-Hamid Hajiyat. Algiers: al-Sharika al-qaraniya li'l-nashr wa'l-tawzi, 1975.

Farabi, Abu Nasr al-. *Al-Fārābī on the Perfect State: Abu Nasr al-Fārābī's Mabādī Ārāʾ Ahl al-Madīna al-Fāḍila*. Edited and translated by Richard Walzer. Oxford: Clarendon Press, 1985.

Hayyan, Abu Marwan b. Khalaf b. Husayn ibn. *Al-Muqatabas: al-Juzʾ al-khamīs*. Edited by Pedro Chalmeta Gendrón. Madrid: al-Maʿhad al-isbānī al-arabī lil-thaqāfa, 1979.

Ibn Abi Zarʿ, Abu-l-Hasan ʿAli. *Al-Anīs al-muṭrib bi-rawḍ al-qirṭās fī akhbār mulūk al-Maghrib wa-tārīkh madīnat Fās*. Edited by ʿAbd al-Wahhab Bin Mansur. Rabat: al-Maṭbaʿa al-Malikiyya, 1999.

Ibn Bajja, Abu Bakr Muhammad. *Rasaʾil Ibn Bajja al-Falsafiyya*. Edited by Majid Fakhry. Beirut: Dār al-Nahar, 1968.

Ibn Hawqal, Muhammad Abu al-Qasim. *Kitāb masālik wa al-mamālik*. Edited by Michael Jan de Goeje. Leiden: Brill, 1893.

Ibn ʿIdhari al-Marrakushi, Muhammad. *Al-Bayān al-mughrib fī akhbār al-Andalus wa-l-Maghrib*. Edited by G. S. Colin and Évariste Lévi-Provençal. 4 vols. Beirut: Dār al-Kutub al-ʿIlmiyya, 2009.

Ibn Khaldun, ʿAbd al-Rahman ibn Muhammad. *Histoire des berbères et des dynasties musulmanes de l'Afrique septentrionale*. Edited and translated by William MacGuckin de Slane. 2 vols. Algiers: Imprimerie du gouvernement, 1847–51.

———. *Histoire des berbères et des dynasties musulmanes de l'Afrique septentrionale (Kitāb al-ʿIbār)*. Edited by Paul Casanova. Translated by William MacGuckin de Slane. Paris: Geuthner, 1927.

———. *The Muqaddimah: An Introduction to History*. Translated by Franz Rosenthal. 3 vols. Bollingen 43. Princeton, NJ: Princeton University Press, 1967.

———. *Les prolégomènes d'Ibn Khaldoun*. Translated by William MacGuckin de Slane. 3 vols. Paris: Geuthner, 1934–38.

Ibn Marzuq, Shams al-Din Abu ʿAbd Allah Muhammad. *El Musnad: Hechos memorables de Abu'l Hasan Sultan de los Benimerines*. Edited and translated by María Jesús Viguera Molins. Madrid: Instituto Hispano-Arabe de Cultura, 1977.

———. *Un nouveau texte d'histoire mérinide: Le Musnad d'Ibn Marzuk*. Edited by Évariste Lévi-Provençal. Paris: Larose, 1925.

Ibn Sahib al-Salat, Abu Marwan ʿAbd al-Malik. *Al-Mann bi'l-imāma*. Edited and translated by Ambrosio Huici Miranda. Valencia: Anúbar, 1969.

———. *Tārīkh al-mann bi'l-imāma*. Edited by Abdul Hadi Attazi. Beirut: Dār al-Andalus, 1965.

———. *Tārīkh al-mann bi'l-imāma ʿala al-mustaḍʿafin bi-an jaʿalahum al-wārithīn*. Edited by Abd el-Hadī al-Tāzī. Beirut: Dār al-Andalus lil-ṭibāʿah wa al-Nashr, 1987.

Ibn Sammak, Abu ʿAbd Allah Muhammad (attributed). *Al-Ḥulal al-mawshiyya*. Edited by I. S. Allouche. Rabat: Institut des hautes études marocaines, 1936.

———. *Al-Ḥulal al-mawshiyya*. Edited by Suhayl Zakkār and Abd al-Qādir Zamāma. Casablanca: Dār al-rashād al-ḥadītha, 1979.

———. *Al-Ḥulal al-mawshiyya: Crónica árabe de las dinastías almorávide, almohada y benimerín*. Translated by Ambrosio Huici Miranda. Tetouan: Editorial Marroquí, 1951.

———. *Al-Ḥulal al-mawshiyya fī dhikr al-akhbār al-marrākush-iyya*. Edited by Bashir al-Fawrati. Tunis: al-Taqaddum al-Islāmiyya, 1911.

Ibn Tumart, Abu ʿAbd Allah Amghar. *Aʿazz mā yuṭlab*. Edited by ʿAbd al-Ghanī Abuʾl-ʿAzm. Rabat: Muʾassasat al-Ghanī li-l-Nasr, 1997.

———. *Le livre d'Ibn Toumert, mahdi des almohades (Kitāb al-aʿazz mā yuṭlab)*. Edited by J. D. Luciani. Algiers: P. Fontana, 1903.

Idrisi, Muhammad b. Muhammad al-. *Description de l'Afrique et de l'Espagne*. Translated by Reinhart Pieter Anne Dozy and Michael Jan de Goeje. Leiden: Brill, 1866.

———. *Opus Geographicum (Nuzhat al-mushtāq fī ikhtirāq al-āfāq)*. Edited by E. Cerulli. Naples: Instituto Universitario orientale di Napoli, Instituto Italiano per il Medio ed Estremo Oriente, 1970.

Leo Africanus. *The History and Description of Africa, and of the Notable Things Therein Contained*. Edited by Robert Brown. Translated by John Pory. London: Hakluyt Society, 1896.

Lévi-Provençal, Évariste, ed. *Documents inédits d'histoire almohade*. Paris: Geuthner, 1928.

Levtzion, Nehemia, and J. F. P. Hopkins, eds. *Corpus of Early Arab Sources for West African History*. Translated by Nehemia Levtzion and J. F. P. Hopkins. Cambridge: Cambridge University Press, 1981.

Maqqari, Ahmad ibn Muhammad al-. *Nafḥ al-ṭib min ghuṣn al-Andalus al-raṭīb*. Edited by Ihsan Abbas. Beirut: Dār Ṣādir, 1968.

Mármol y Carvajal, Luis del. *L'Afrique de Marmol*. Translated by Nicholas Perrot. Paris: Lovis Billaine, 1667.

Marrakushi, ʿAbd al-Wahid al-. *Histoire des almohades*. Translated by E. Fagnan. Algiers: A. Jourdan, 1893.

———. *Al-Muʿjib fī talkhīs akhbār al-Maghrib*. Edited by Reinhart Pieter Anne Dozy. Leiden: Brill, 1881.

———. *Al-Muʿjib fī talkhīs akhbār al-Maghrib*. Casablanca: Dār al-Kitāb, 1978.

Pliny the Elder. *Pliny's Natural History in Thirty-Seven Books*. Translated by Philemon Holland. Vol. 1. London: George Barclay, 1847.

Tabari, Abu Jaʿfar Muhammad al-. *The History of al-Tabarī (Taʾrīkh al-rusūl wa al-mulūk)*. Translated by Gautier H. A. Juynboll. Vol. 13. Albany: State University of New York Press, 1965.

ʿUmari, Ibn Fadl Allah al-. *Masālik al-abṣār fī mamālik al-amṣār: L'Afrique moins l'Egypte*. Edited and translated by Maurice Gaudefroy-Demombynes. Paris: Geuthner, 1927.

Zarhuni, Muhammad ibn al-Haj Ibrahim al-. *La rihla du marabout de Tasaft, notes sur l'histoire de l'Atlas; Texte arabe du XIIIᵉ siècle*. Translated by Léopold-Victor Justinard. Paris: Geuthner, 1940.

Secondary Sources

Abu-Lughod, Janet. "The Islamic City—Historic Myth, Islamic Essence, and Contemporary Relevance." *International Journal of Middle East Studies* 19, no. 2 (1987): 155–76.

———. *Rabat: Urban Apartheid in Morocco*. Princeton, NJ: Princeton University Press, 1980.

Affaires indigènes et service des renseignements. *Rabat et sa région*. 4 vols. Paris: Éditions Leroux, 1920.

Ahmed, Shahab. *What Is Islam? The Importance of Being Islamic*. Princeton, NJ: Princeton University Press, 2016.

Allain, Charles, and Gaston Deverdun. "Les portes anciennes de Marrakech." *Hespéris-Tamuda* 44 (1957): 85–126.

Allain, Charles, and Jacques Meunié. "Recherches archéologiques au Tasghimout des Mesfouia." *Hespéris* 38 (1951): 381–405.

Almela, Iñigo. "Religious Architecture as an Instrument for Urban Renewal: Two Religious Complexes from the Saadian Period in Marrakesh." *Al-Masāq* 31, no. 3 (2019): 272–302. https://doi-org/10.1080/09503110.2019.1589973.

Anderson, Glaire D. "Early Mosque Architecture in Al-Andalus and the Maghreb." In *The Religious Architecture of Islam*, edited by Kathryn Moore and Hasan-Uddin Khan, 10–21. Turnhout: Brepols, 2022.

Antrim, Zayde. *Routes and Realms: The Power of Place in the Early Islamic World*. Oxford: Oxford University Press, 2012.

———. "*Waṭan* Before *Waṭaniyya*: Loyalty to Land in Ayyubid and Mamluk Syria." *Al-Masāq* 22, no. 2 (2010): 173–90.

Arnold, Felix. *Islamic Palace Architecture in the Western Mediterranean: A History*. Oxford: Oxford University Press, 2017.

Azmeh, Aziz al-. *Ibn Khaldun: An Essay in Reinterpretation*. London: Frank Cass, 1982.

Bacharach, Jere L. "Administrative Complexes, Palaces and Citadels: Changes in the Loci of Medieval Muslim Rule." In *The Ottoman City and Its Parts: Urban Structure and Social Order*, edited by Irene A. Bierman, Rifaʿat A. Abou-El-Haj, and Donald Preziosi, 111–28. Rochelle, NY: Caratzas, 1991.

Balbale, Abigail. "Bridging Seas of Sand and Water: The Berber Dynasties of the Islamic Far West." In *A Companion to Islamic Art and Architecture*, edited by Finbarr Barry Flood and Gülru Necipoğlu, 1:356–77. Hoboken, NJ: Wiley-Blackwell, 2017.

Basset, Henri, and Henri Terrasse. *Sanctuaires et forteresses almohades*. Paris: Maisonneuve & Larose, 2001.

———. "Sanctuaires et forteresses almohades II. Les deux Kotobiya." *Hespéris-Tamuda* 4 (1924): 181–203.

———. "Sanctuaires et forteresses almohades (suite)." *Hespéris-Tamuda* 7 (1927): 117–73.

Belfquih, M'hammed, and Abdallatef Fadloullah. *Mécanismes et formes de croissance urbaine au Maroc: Cas de l'agglomeration de Rabat-Sale*. Rabat: Librairie El Maârif, 1986.

Benchekroun, Chafik T. "Les Idrissides: L'histoire contre son histoire." *Al-Masāq* 23, no. 3 (2011): 171–88.

Bennison, Amira. "The Almohads and the Qurʾān of ʿUthmān: The Legacy of the Umayyads of Cordoba in the Twelfth Century Maghrib." *Al-Masāq* 19, no. 2 (2007): 131–54.

———. *The Almoravid and Almohad Empires*. Edinburgh: Edinburgh University Press, 2016.

———. *The Great Caliphs*. London: I. B. Tauris, 2009.

———. "Power and the City in the Islamic West from the Umayyads to the Almohads." In *Cities in the*

Pre-Modern Islamic World: The Urban Impact of Religion, State and Society, edited by Amira Bennison and Alison Gascoigne, 65–95. London: Routledge Curzon, 2007.

———. "Relations Between the Ruler and the Ruled in the Medieval Maghrib: The 'Social Contract' in the Almoravid and Almohad Centuries (1050–1250)." *Comparative Islamic Studies* 10, no. 2 (2014): 137–56.

———. "Sectarianism in the Landscape: The Transfer of the *Khuṭba* of Fes from the Mosque of the Shurafāʾ to the Qarawiyyin Mosque in 933 (321 AH)." *Maghreb Review* 40, no. 1 (2015): 12–27.

Bloom, Jonathan M. *The Minbar from the Kutubiyya Mosque*. New York: Metropolitan Museum of Art in association with Ediciones El Viso and the Ministry of Cultural Affairs of the Kingdom of Morocco, 1998.

Bonine, Michael. "The Sacred Direction and City Structure: A Preliminary Analysis of the Islamic Cities of Morocco." *Muqarnas* 7 (1990): 50–72.

Bosworth, C. E., ed. "Marrakesh." In *Historic Cities of the Islamic World*, 319. Leiden: Brill, 2007.

Boum, Aomar, and Thomas K. Park. *Historical Dictionary of Morocco*. New York: Rowman & Littlefield, 2016.

Brett, Michael. "Conversion of the Berbers to Islam/Islamisation of the Berbers." In *Islamisation: Comparative Perspectives from History*, edited by Andrew C. S. Peacock, 189–98. Edinburgh: Edinburgh University Press, 2017.

Buresi, Pascal. "Les cultes rendus à la tombe du mahdî Ibn Tûmart à Tinmâl (XIIᵉ–XIIIᵉ S.)." *Comptes rendus des séances de l'académie des inscriptions et belles-lettres* 152, no. 1 (2008): 391–438.

———. "D'une péninsule à l'autre: Cordoue, ʿUṯmān (644–656), et les arabes à l'époque almohade (XIIᵉ–XIIIᵉ siècle)." *Al-Qanṭara* 31, no. 1 (2010): 7–29.

———. *Gouverner l'empire: La nomination des fonctionnaires provinciaux dans l'empire almohade (Maghreb, 1224–1269)*. Madrid: Casa de Velázquez, 2013.

Cabrera Tejedor, Carlos. *From Hispalis to Ishbiliyya: The Ancient Port of Seville, from the Roman Empire to the End of the Islamic Period (45 BC–AD 1248)*. Oxford: Archaeopress, 2019.

Caillé, Jacques. *La ville de Rabat jusqu'au protectorat français*. 2 vols. Paris: Vanoest, 1945.

Calvo Capilla, Susana. "Peregrination and Ceremonial in the Almohad Mosque of Tinmal." *Beiträge zur islamischen Kunst und Archäologie* 6 (2020): 81–106.

Capel, Chloé. "Jebel Mudawwar: Une montagne fortifiée au Sahara. Site étatique ou site communitaire?" In *Appréhension et qualification des espaces au sein du site archéologique*, edited by Antoine Bourrouilh, Paris Pierre-Emmanuel, and Nairusz Haidar Vela, 101–22. Paris: Éditions de la Sorbonne, 2016.

———. "Sijilmassa in the Footsteps of the Aghlabids: The Hypothesis of a Ninth-Century New Royal City in Tafilalt Plain (Morocco)." In *The Aghlabids and Their Neighbors: Art and Material Culture in Ninth-Century North Africa*, edited by Glaire D. Anderson, Corisande Fenwick, Mariam Rosser-Owen, and Sihem Lamine, 531–50. Leiden: Brill, 2018.

Cénival, P. de. "Marrākush." In *Encyclopaedia of Islam*, edited by P. J. Bearman, Th. Bianquis, C. E. Bosworth, E. van Donzel, and W. P. Heinrichs. Leiden: Brill, 2012.

Cook, Michael. *Commanding Right and Forbidding Wrong in Islamic Thought*. Cambridge: Cambridge University Press, 2000.

Cornell, Vincent J. *Realm of the Saint: Power and Authority in Moroccan Sufism*. Austin: University of Texas Press, 1998.

———. "Understanding Is the Mother of Ability: Responsibility and Action in the Doctrine of Ibn Tūmart." *Studia Islamica* 66 (1987): 71–103.

Demerdash, Nancy. "Mapping Myths of the Medina: French Colonial Urbanism, Oriental Brandscapes and the Politics of Tourism in Marrakesh." MS thesis, Massachusetts Institute of Technology, 2009.

Denoix, Sylvie. "Founded Cities of the Arab World from the Seventh to the Eleventh Centuries." In *The City in the Islamic World*, edited by Salma K. Jayyusi, Renata Holod, Attilio Petruccioli, and André Raymond, 1:115–39. Leiden: Brill, 2008.

Deverdun, Gaston. *Marrakech des origines à 1912*. Rabat: Éditions techniques nord-africaines, 1959.

———. *Marrakech des origines à 1912*. 2 vols. Casablanca: Éditions frontispice, 2004.

Deverdun, Gaston, and Charles Allain. "Le minaret almoravide de la mosquée Ben Youssef à Marrakech." *Hespéris-Tamuda* 2 (1961): 129–33.

Domínguez Berenjena, Enrique Luis. "Sevilla y las fortificaciones fluviales del Guadalquivir." In *Las fortificaciones y el mar: 4 Congreso Internacional sobre Fortificaciones*, edited by Fernando Amores Carredano and Enrique Luis Domínguez Berenjena, 231–50. Alcalá de Guadaíra: Ayuntamiento de Alcalá de Guadaíra, 2008.

Domínguez Gregorio, P. "Vers l'éco-anthropologie. Une approche multidisciplinaire de l'agdalpastoral du Yagour (haut atlas de Marrakech)." PhD diss., Universidad Autónoma de Barcelona, 2011.

Eickelman, Dale F. "Is There an Islamic City? The Making of a Quarter in a Moroccan Town." *International Journal of Middle East Studies* 5, no. 3 (1974): 274–94.

El Faïz, Mohammed. "The Garden Strategy of the Almohad Sultans and Their Successors (1157–1900)." In *Middle East Garden Traditions: Unity and Diversity*, edited by Michel Conan, 96–111. Cambridge, MA: Harvard University Press, 2007.

Empey, Heather J. "The Mothers of Caliph's Sons: Women as Spoils of War During the Early Almohad Period." In *Concubines and Courtesans: Women and Slavery in Islamic History*, edited by Matthew S. Gordon and Kathryn A. Hain, 143–62. Oxford: Oxford University Press, 2017.

Ettahiri, Ahmed Saleh, Abdallah Fili, and Jean-Pierre van Staëvel. "Nouvelles recherches archéologiques sur la période islamique au Maroc: Fès, Aghmat et Îgîlîz." In *Histoire et archéologie de l'occident musulman (VIIᵉ–XVᵉ siècles): al-Andalus, Maghreb, Sicile, Tolosa*, edited by Philippe Sénac, 157–82. Toulouse: CNRS-Université de Toulouse, 2012.

Ewert, Christian. *The Mosque at Tinmal (Morocco) and Some New Aspects of Islamic Architectural Typology*. London: British Academy, 1986.

———. "El registro ornamental almohada y su relevancia." In *Los almohades: Problemas y perspectivas*, edited by Patrice Cressier, Maribel Fierro, and Luis Molina, 223–47. Madrid: Consejo Superior de Investigaciones Científicas, 2005.

Ewert, Christian, and Jens-Peter Wisshak. *Forschungen zur almohadischen Moschee. II: Die Moschee von Tinmal*. Mainz: Philipp von Labern, 1984.

Falahat, Somaiyeh. *Cities and Metaphors: Beyond Imaginaries of Islamic Urban Space*. New York: Routledge, 2018.

Fierro, Maribel. "Algunas reflexiones sobre el poder itinerante almohade." *E-Spania* 8 (2009). http://journals.openedition.org/e-spania/18653.

———. *The Almohad Revolution: Politics and Religion in the Islamic West During the Twelfth–Thirteenth Centuries*. Burlington: Ashgate, 2012.

———. "Las genealogías de ʿAbd al-Muʾmin, primer califa almohade." *Al-Qanṭara* 24 (2003): 77–107.

———. "Sobre la adopción del título califa por ʿAbd al-Rahman III." *Sharq al-Andalus* 6 (1989): 33–42.

Fletcher, Madeleine. "The Almohad *Tawḥīd*: Theology Which Relies on Logic." *Numen* 38 (1991): 110–27.

———. "The Anthropological Context of Almohad History." *Hespéris-Tamuda* 26 (1988): 25–52.

———. "Ibn Tūmart's Teachers: The Relationship with al-Ghazālī." *Al-Qanṭara* 18, no. 2 (1997): 305–30.

Fricaud, Emile. "Les *ṭalaba* dans la société almohade (Le temps d'Averroès)." *Al-Qanṭara* 18 (1997): 331–88.

Fromherz, Allen J. *The Almohads: The Rise of an Islamic Empire*. New York: I. B. Tauris, 2013.

———. *The Near West: Medieval North Africa, Latin Europe and the Mediterranean in the Second Axial Age*. Edinburgh: Edinburgh University Press, 2016.

García-Arenal, Mercedes. *Messianism and Puritanical Reform: Mahdis of the Muslim West*. Translated by Martin Beagles. Leiden: Brill, 2005.

García-Arenal, Mercedes, and Eduardo Manzano Moreno. "Idrīssisme et villes idrīssides." *Studia Islamica* 82 (1995): 5–34.

Gaudefroy-Demombynes, Maurice. "Quelques passages du *Masalik el Absar* relatifs au Maroc." In *Mémorial Henri Basset: Nouvelles études nord-africaines et orientales*, 269–80. Paris: Geuthner, 1928.

Gellner, Ernest. "Cohesion and Identity: The Maghreb from Ibn Khaldun to Emile Durkheim." *Government and Opposition* 10, no. 2 (1975): 203–18.

Ghouirgate, Mehdi. *L'Ordre almohade (1120–269): Une nouvelle lecture anthropologique*. Toulouse: Presses universitaires du Midi, 2014.

———. "Un palais en marche: Le camp caliphal almohade." In *Las Navas de Tolosa 1212–2012: Miradas cruzadas*, edited by Patrice Cressier and Vicente Salvatierra Cuenca, 159–70. Jaén: Universidad de Jaén, 2014.

Glick, Thomas. "Cob Walls Revisited: The Diffusion of Tabby Construction in the Western Mediterranean World." In *On Pre-Modern Technology and Science: Studies in Honor of Lynn White*, edited by B. Hall and D. West, 147–59. Malibu: Undena Publications, 1976.

González Cavero, Ignacio. "Una revisión de la figura de Ibn Mardanish: Su alianza con el reino de Castilla y la oposición frente a los Almohades." *Miscelánea Medieval Murciana* 31 (2007): 95–110.

Grabar, Oleg. "The Architecture of the Middle Eastern City from Past to Present: The Case of the Mosque." In *Middle Eastern Cities*, edited by Ira Lapidus, 26–46. Berkeley: University of California Press, 1969.

Griffel, Frank. "Ibn Tūmart's Rational Proof for God's Existence and Unity, and His Connection to the Niẓāmiyya *Madrasa* in Baghdad." In *Los Almohades: Problemas y perspectivas*, edited by Patrice Cressier, Maribel Fierro, and Luis Molina, 2:753–813. Madrid: Consejo Superior de Investigaciones Científicas, 2005.

Guernier, Eugène Léonard, and Paul Guieysse, eds. *L'encyclopédie coloniale et maritime: Maroc*. Paris: Éditions de l'empire français, 1948.

Herencia Ruíz, Antonio. *Los puentes sobre el Guadalquivir en Sevilla*. Seville: Colegio de Ingenieros de Caminos, Canales y Puertos, 1999.

Hopkins, J. F. P. "The Almohad Hierarchy." *Bulletin of the School of Oriental and African Studies, University of London* 16, no. 1 (1954): 93–112.

Johansen, Baber. "The All-Embracing Town and Its Mosques." *Revue de l'Occident musulman et de la Méditerranée* 32 (1981): 139–61.

Kahera, Akel Ismaʾil. *Reading the Islamic City: Discursive Practices and Legal Judgment*. Lanham, MD: Lexington Books, 2012.

Kugle, Scott. *Sufis and Saints' Bodies: Mysticism, Corporeality, and Sacred Power in Islam*. Chapel Hill: University of North Carolina Press, 2007.

Le Tourneau, Roger. "Du mouvement almohade a la dynastie muʾminide: La révolte des frères d'Ibn Tumart de 1153 à 1156." In *Mélanges d'histoire et d'archéologie de l'Occident musulman*, vol. 2, *Hommage à Georges Marçais*, edited by René Crozet, 111–16. Algiers: Imprimerie Officielle, 1957.

———. "Ḥā-Mīm b. Mann Allāh b. Ḥāfiz b. ʿAmr, Known as al-Muftarī." In *Encyclopaedia of Islam*, 2nd ed., edited by P. J. Bearman, Th. Bianquis, C. E. Bosworth, E. van Donzel, and W. P. Heinrichs. Leiden: Brill, 2005. http://dx.doi.org/10.1163/1573-3912_islam_SIM_2677.

———. "Sur la disparition de la doctrine almohade." *Studia Islamica* 32 (1970): 193–201.

Lévi-Provençal, Évariste. "La fondation de Fès." *Annales de l'Institut des Études Orientales* 4 (1938): 23–52.

———. *Histoire de l'Espagne musulmane.* 2 vols. Paris: Maisonneuve, 1950.

———. "Un recueil des lettres officielles almohades: Introduction et étude diplomatique. Analyse et commentaire historique." *Hespéris* 28 (1941): 1–70.

———. *Séville musulmane au début du XIIᵉ siècle: Le Traité d'Ibn 'Abdun sur la vie urbaine et les corps de métiers.* Paris: Maisonneuve, 1947.

Levtzion, Nehemia. "The Twelfth-Century Anonymous *Kitāb al-Istibṣār*: A History of a Text." *Journal of Semitic Studies* 24 (1979): 201–17.

Madelung, Wilferd. "Notes on Non-Ismā'īlī Shiism in the Maghrib." *Studia Islamica* 44 (1976): 87–97.

Marçais, Georges. *L'architecture musulmane d'occident: Tunisie, Algérie, Maroc, Espagne, et Sicile.* Paris: Arts et métiers graphiques, 1955.

———. "L'urbanisme musulman." In *Mélanges d'histoire et d'archéologie de l'Occident musulman*, 1:219–31. Algiers: Imprimerie Officielle, 1957.

Marçais, William. "L'islamisme et la vie urbaine." *Comptes rendus des séances de l'Académie des inscriptions et belles-lettres* 71, no. 1 (1928): 86–100.

Marcos Cobaleda, María. *Los almorávides: Arquitectura de un imperio.* Granada: Editorial universidad de Granada, 2015.

Marín, Manuela. "On Women and Camels: Some Comments on a Ḥadīth." In *O Ye Gentlemen: Arabic Studies on Science and Literary Culture in Honour of Remke Kruk*, edited by Arnoud Vrolijk and Jan Hogendijk, 485–94. Leiden: Brill, 2007.

———. "The Princess and the Palace: On Hawwa' bint Tashufin and Other Women from the Almoravid Royal Family." In *In and Of the Mediterranean: Medieval and Early Modern Iberian Studies*, edited by Michelle M. Hamilton and Nuria Silleras-Fernandez, 29–48. Nashville, TN: Vanderbilt University Press, 2015.

Marmura, Michael E. "The Philosopher and Society: Some Medieval Arab Discussions." *Arab Studies Quarterly* 1, no. 4 (1979): 309–23.

Meouak, Mohamed. *La langue berbère au Maghreb médiéval: Textes, contextes, analyses.* Leiden: Brill, 2016.

Messier, Ronald. "Rethinking the Almoravids, Rethinking Ibn Khaldun." *Journal of North African Studies* 6, no. 1 (2001): 59–80.

Messier, Ronald, and James Miller. *The Last Civilized Place: Sijilmasa and Its Saharan Destiny.* Austin: University of Texas Press, 2015.

Meunié, Jacques. *Recherches archéologiques à Marrakech.* Paris: Arts et métiers graphiques, 1952.

Meunié, Jacques, and Charles Allain. "La forteresse almoravide de Zagora." *Hespéris-Tamuda* 43 (1956): 305–24.

Navarro Palazón, Julio, Fidel Garrido, and José M. Torres. "The Agdāl of Marrakesh (12th to 20th Centuries): An Agricultural Space for the Benefit and Enjoyment of the Caliphs and Sultans." *Muqarnas* 35 (2018): 23–42.

———. "Agua, arquitectura y poder en una capital del Islam: La finca real del Agdal de Marrakech (ss. XII–XX)." *Arqueología de la arquitectura* 10 (2013): 1–44.

Neglia, Giulia Annalinda. "Some Historiographical Notes on the Islamic City with Particular Reference to the Visual Representation of the Built City." In *The City in the Islamic World*, edited by Salma K. Jayyusi, Renata Holod, Attilio Petruccioli, and André Raymond, 1:3–46. Leiden: Brill, 2008.

O'Meara, Simon. *Space and Muslim Urban Life: At the Limits of the Labyrinth of Fez.* London: Routledge, 2007.

Pascon, Paul. *Le haouz de Marrakech.* 2 vols. Rabat: P. Pascon, 1977.

Radoine, Hassan. "French Territoriality and Urbanism: General Lyautey and Architect Prost in Morocco (1912–1925)." In *Colonial Architecture and Urbanism in Africa: Intertwined and Contested Histories*, edited by Fassil Demissie, 11–31. Burlington: Ashgate, 2012.

Raymond, André. "The Spatial Organization of the City." In *The City in the Islamic World*, edited by Salma K. Jayyusi, Renata Holod, Attilio Petruccioli, and André Raymond, 1:47–70. Leiden: Brill, 2008.

Rhani, Zakaria. "The Genealogy of Power and the Power of Genealogy in Morocco: History, Imaginary, and Politics." In *Genealogy and Knowledge in Muslim Societies: Understanding the Past*, edited by Sarah Bowen Savant and Helena de Felipe, 37–51. Edinburgh: Edinburgh University Press, 2014.

Rius Piniés, Mònica. *La alquibla en al-Andalus y al-Magrib al-Aqsa.* Barcelona: Instituto Millás Vallicrosa, 2000.

———. "La orientación de las mezquitas según el *Kitāb dalā' al-qibla* de al-Mattīyī (s. XII)." In *From Baghdad to Barcelona: Studies in the Islamic Exact Sciences in Honor of Prof. Juan Vernet*, 781–830. Barcelona: Instituto Millás Vallicrosa, 1996.

Robinson, Cynthia. "Power, Light, Intra-Confessional Discontent, and the Almoravids." In *Envisioning Islamic Art and Architecture: Essays in Honor of Renata Holod*, edited by David J. Roxburgh, 22–45. Leiden: Brill, 2014.

———. "Ubi Sunt: Memory and Nostalgia in Taifa Court Culture." *Muqarnas* 15 (1998): 20–31.

Rodríguez Estévez, Juan Clemente. *El Alminar de Isbiliya: La Giralda en sus orígenes (1184–1198).* Seville: Área de Cultura, Ayuntamiento de Sevilla, 1998.

Rosser-Owen, Mariam. "Andalusi *Spolia* in Medieval Morocco: Architectural Politics, Political Architecture." *Medieval Encounters* 20, no. 2 (2014): 152–98.

Rouighi, Ramzi. *Inventing the Berbers: History and Ideology in the Maghrib.* Philadelphia: University of Pennsylvania Press, 2019.

Rubiera Mata, María Jesús. *La arquitectura en la literatura árabe*. Madrid: Editora Nacional, 1981.

Ruggles, D. Fairchild. *Gardens, Landscape, and Vision in the Palaces of Islamic Spain*. University Park: Penn State University Press, 2000.

———. "The Islamic Landscape: Place and Memory." In *Islamic Gardens and Landscapes*, 3–12. Philadelphia: University of Pennsylvania Press, 2008.

———. "The Mirador in Abbasid and Hispano-Umayyad Garden Typology." *Muqarnas* 7 (1990): 73–82.

Russell, Ben, and Elizabeth Fentress. "Mud Brick and *Pisé de Terre* Between Punic and Roman." In *Arqueología de la Construcción: Proceedings of the 5th International Workshop on the Archaeology of Roman Construction, Oxford, April 11–12, 2015; V. Man-Made Materials, Engineering and Infrastructure*, edited by Janet DeLaine, Stefano Camporeale, and Antonio Pizzo, 131–43. Madrid: Anejos de Archivo Español de Arqueología, 2015.

Safran, Janina. "Ceremony and Submission: The Symbolic Representation and Recognition of Legitimacy in Tenth-Century al-Andalus." *Journal of Near Eastern Studies* 48, no. 3 (1999): 191–201.

———. "The Politics of Book-Burning in al-Andalus." *Journal of Medieval Iberian Studies* 6, no. 2 (2014): 155–62.

Sánchez Mantero, Rafael. *A Short History of Seville*. Translated by Martin Smith. Madrid: Silex, 1992.

Sanders, Paula. *Ritual, Politics, and the City in Fatimid Cairo*. Albany: State University of New York Press, 1994.

Sebti, Mohamed. "Remparts et dynamiques internes à Marrakech." In *Aʿmāl nadwat aswār al-mudun fī Tānsīft*. Marrakesh: Kulliyyat al-adab wa-l-ʿulūm al-insāniyya, 2002.

Sedra, Moulay Driss. "La ville de Rabat au VIᵉ/XIIᵉ siècles: Le projet d'une nouvelle capitale de l'Empire Almohade?" *Al-Andalus Magreb* 15 (2008): 275–303.

Serrano Ruano, Delfina. "Ibn Rushd Al-Jadd (d. 520/1126)." In *Islamic Legal Thought: A Compendium of Muslim Jurists*, 295–322. Leiden: Brill, 2013.

———. "Porque llamaron los almohades a los almoravides antropomorfistas?" In *Los Almohades: Problemas y perspectivas*, edited by Patrice Cressier, Maribel Fierro, and Luis Molina, 2:815–52. Madrid: Consejo Superior de Investigaciones Científicas, 2005.

Shatzmiller, Maya. *The Berbers and the Islamic State*. Princeton, NJ: Marcus Weiner, 2000.

———. "Les premiers mérinides et le milieu religieux de Fès: L'introduction de médersas." *Studia Islamica* 43 (1976): 109–18.

Sibley, Magda. "Cities: Urban Built Environments; North Africa." In *Encyclopedia of Women and Islamic Cultures*, vol. 4, *Economics, Education, Mobility and Space*, edited by Suad Joseph, 29–31. Boston: Brill, 2004.

Staëvel, Jean-Pierre van. "Réflexions à propos de la nomenclature médiévale de l'architecture de terre en Occident musulman: L'exemple du *tâbiya*." In *L'architecture en terre en Méditerranée: Histoire et perspectives; Actes du colloque international de Rabat (Université Mohamed V, 27 au 29 novembre, 1996)*, edited by M. Hammam, 95–109. Rabat: Université Mohammad V, 1999.

Staëvel, Jean-Pierre van, Abdallah Fili, and Ahmed Saleh Ettahiri. "Igiliz Hartha, lieu de naissance du mahdi Ibn Tumart, et la genèse de l'empire almohade." In *Le Maroc médiéval: Un empire de l'Afrique à l'Espagne*. Paris: Louvre, 2014.

Stockstill, Abbey. "The Red Tent in the Red City: The Caliphal Qubba in Almohad Marrakesh." In *Textile in Architecture: From the Middle Ages to Modernism*, edited by Didem Ekici, Patricia Blessing, and Basile Baudez, 12–26. New York: Routledge, 2023.

———. "A Tale of Two Mosques: Marrakesh's Masjid al-Jamiʿ al-Kutubiyya." *Muqarnas* 35, no. 1 (2018): 65–82.

Streit, Jessica R. "Monumental Austerity: The Meanings and Aesthetic Development of Almohad Friday Mosques." PhD diss., Cornell University, 2013.

———. "Well-Ordered Growth: Meanings and Aesthetics of the Almohad Mosque of Seville." In *"His Pen and Ink Are a Powerful Mirror": Andalusi, Judaeo-Arabic, and Other Near Eastern Studies in Honor of Ross Brann*, edited by Adam Bursi, S. J. Pearce, and Hamza Zafer, 298–325. Leiden: Brill, 2020.

Tabales Rodríguez, Miguel Ángel. *El Alcázar de Sevilla: Reflexiones sobre su origen y transformación durante la Edad Media. Memoria de Investigación Arqueológica 2000–2005*. Seville: Junta de Andalucía, 2010.

Tabales Rodríguez, Miguel Ángel, and Álvaro Jiménez Sancho. "Intervención arqueológica en el Pabellón de oficinas de la Catedral de Sevilla (1997–1998)." *Anuario arqueológico de Andalucía* 3 (2001): 429–43.

Tabbaa, Yasser. "Andalusian Roots and Abbasid Homage in the Qubbat Al-Barudiyyin in Marrakech." *Muqarnas* 25 (2008): 133–46.

———. *The Transformation of Islamic Art During the Sunni Revival*. Seattle: University of Washington Press, 2001.

Terrasse, Henri. *Kasbas berbères de l'Atlas et des oases*. Paris: Éditions des horizons de France, 1938.

———. *La mosquée al-Qaraouiyin à Fès: Avec une étude de Gaston Deverdun sur les inscriptions historiques de la mosquée*. Paris: C. Klincksieck, 1968.

Thouvenout, Raymond. "Une forteresse almohade près de Rabat, Dchîra." *Hespéris* 17, no. 3 (1933): 59–88.

Torres Balbás, Leopoldo. *Ciudades hispano-musulmanas*. 2 vols. Madrid: Instituto Hispano-Arabe de Cultura, 1971.

Triki, Hamid. "Marrakech: Retrato histórico de una metrópolis medieval, siglos XI–XII." In *La arquitectura del Islam occidental*, edited by Rafael López Guzmán, 93–106. Granada: Legando Andalusí, 1995.

Urvoy, Dominique. "La pensée d'Ibn Tūmart." *Bulletin d'études orientales* 27 (1974): 19–44.

Valor Piechotta, Magdalena, ed. *Sevilla almohade*. Malaga: Editorial Sarriá, 2008.

———. *El último siglo de la Sevilla islámica*. Seville: Universidad de Sevilla, 1995.

Vera Reina, Manuel, Fernando Amores Carredano, and Carmen Herrera Ruiz. "La Huerta del Rey: El espacio y sus usos a través de las historia." In *Sevilla extramuros: La huella de la historia en el sector oriental de la ciudad*, edited by Magdalena Valor Piechotta and Carlos Romero Moragas, 103–48. Seville: Editorial universidad de Sevilla, 2016.

Wilbaux, Quentin. *La médina de Marrakech: Formation des espaces urbains d'une ancienne capitale du Maroc*. Paris: L'Harmattan, 2001.

INDEX